COVERED
BRIDGES
OF VERMONT

COVERED BRIDGES
OF VERMONT

Ed Barna

THE COUNTRYMAN PRESS
Woodstock, Vermont

Library of Congress Cataloging-in-Publication Data

Barna, Ed, 1947–
 Covered Bridges of Vermont / Ed Barna.
 p. cm.
 Includes index.
 ISBN 0-88150-373-8 (alk. paper)
 1. Covered bridges—Vermont. I. Title
TG24.V5B37 1996
624'.2'09743—dc20 95-53031
 CIP

Cover and text design by Trina Stahl
Interior photographs by Ed Barna
Maps by XNR Productions, © 1996 The Countryman Press

Printed in the United States
10 9 8 7 6 5 4 3 2 1

Published by The Countryman Press
PO Box 748
Woodstock, VT 05091

Distributed by W.W. Norton & Company, Inc.
500 Fifth Avenue
New York, NY 10110

To the memory of Nicholas Montgomery Powers,
Vermont's greatest covered-bridge builder, with the hope
that his work will always remain for us to admire;
and to the memory of Robert Francis Barna, 1918–1995:
father, English teacher, and mentor.

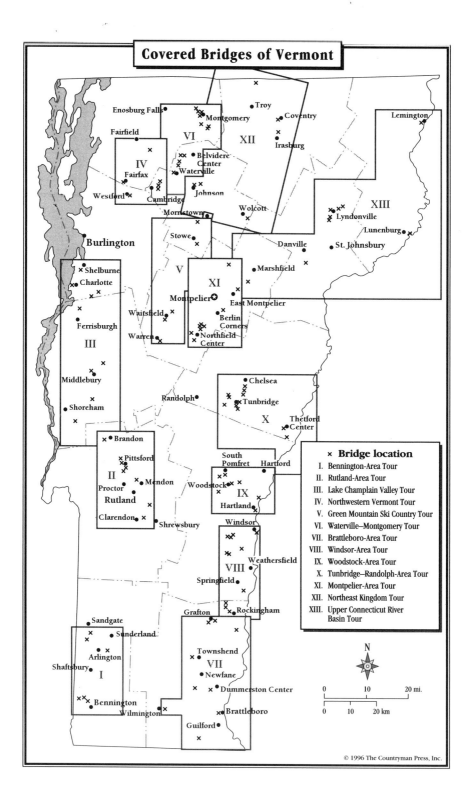

Covered Bridges of Vermont

Enosburg Falls
Troy
Coventry
Lemington
Fairfield
Montgomery
VI
XII
Irasburg
IV
Belvidere
Center
Fairfax
Waterville
Johnson
Westford
Cambridge
Wolcott
XIII
Lyndonville
Morristown
Lunenburg
Burlington
Stowe
Danville
St. Johnsbury
Shelburne
Marshfield
Charlotte
V
XI
Ferrisburg
Montpelier
East Montpelier
III
Waitsfield
Berlin
Corners
Warren
Northfield
Center
Middlebury
Randolph
Chelsea
Shoreham
Tunbridge
X
Thetford
Center
Brandon
Pittsford
South
Pomfret
Hartford
II
Mendon
Woodstock
IX
Proctor
Rutland
Hartland
Clarendon
Shrewsbury
Windsor
Weathersfield
VIII
Springfield
Sandgate
Sunderland
Grafton
Rockingham
Arlington
Townshend
Shaftsbury
I
VII
Newfane
Bennington
Dummerston Center
Wilmington
Brattleboro
Guilford

× Bridge location

I. Bennington-Area Tour
II. Rutland-Area Tour
III. Lake Champlain Valley Tour
IV. Northwestern Vermont Tour
V. Green Mountain Ski Country Tour
VI. Waterville–Montgomery Tour
VII. Brattleboro-Area Tour
VIII. Windsor-Area Tour
IX. Woodstock-Area Tour
X. Tunbridge–Randolph-Area Tour
XI. Montpelier-Area Tour
XII. Northeast Kingdom Tour
XIII. Upper Connecticut River
 Basin Tour

N

0 10 20 mi.

0 10 20 km

Contents

Introduction to Vermont's Covered Bridges • 11

Ways of Looking at Covered Bridges
How Covered Bridges Carry Their Loads • The Great Truss Race
The Battle of the Bridge • How This Guide Is Organized

I. Bennington-Area Tour • 31

1. *Silk Bridge*—Bennington • 2. *Paper Mill Village Bridge*—Bennington
3. *Henry Bridge*—Bennington • 4. *Chiselville Bridge*—Sunderland
5. *West Arlington Bridge*—Arlington

II. Rutland-Area Tour • 41

6. *Kingsley Bridge*—Clarendon • 7. *Brown Bridge*—Shrewsbury
8. *Twin Bridge*—Rutland • 9. *Gorham Bridge*—Pittsford-Proctor
10. *Cooley Bridge*—Pittsford • 11. *Depot Bridge*—Pittsford
12. *Hammond Bridge*—Pittsford • 13. *Sanderson Bridge*—Brandon

III. Lake Champlain Valley Tour • 55

14. *Shoreham Covered Railroad Bridge*—Shoreham
15. *Cornwall-Salisbury Bridge*—Cornwall-Salisbury
16. *Pulp Mill Bridge*—Middlebury-Weybridge
17. *Halpin Bridge*—Middlebury • 18. *Spade Farm Bridge*—Ferrisburgh
19. *Quinlan Bridge*—Charlotte • 20. *Sequin Bridge*—Charlotte
21. *Holmes Bridge*—Charlotte • 22. *Shelburne Museum Bridge*—Shelburne

IV. Northwestern Vermont Tour • 71

23. *Maple Street Bridge*—Fairfax • 24. *Brown's River Bridge*—Westford
25. *Gates Farm Bridge*—Cambridge • 26. *Poland Bridge*—Cambridge
27. *Scott Bridge*—Cambridge • 28. *East Fairfield Bridge*—Fairfield

V. Green Mountain Ski Country Tour · 83

29. *Warren Bridge*—Warren · 30. *Village Bridge*—Waitsfield
31. *Pine Brook Bridge*—Waitsfield · 32. *Emily's Bridge*—Stowe
33. *Red Bridge*—Morristown

VI. Waterville–Montgomery Tour · 93

34. *Church Street Bridge* Waterville · 35. *Montgomery Bridge*—Waterville
36. *Codding or Kissin' Bridge*—Waterville · 37. *Mill Bridge*—Belvidere
38. *Morgan Bridge*—Belvidere · 39. *Gibou Road Bridge*—Montgomery
40. *Hutchins Bridge*—Montgomery · 41. *Fuller Bridge*—Montgomery
42. *Comstock Bridge*—Montgomery · 43. *Longley Bridge*—Montgomery
44. *Hopkins Bridge*—Enosburg · 45. *Creamery Bridge*—Montgomery

VII. Brattleboro-Area Tour · 109

46. *Green River Bridge*—Guilford · 47. *Creamery Bridge*—Brattleboro
48. *High Mowing Farm Bridge*—Wilmington
49. *West Dummerston Bridge*—Dummerston
50. *Williamsville Bridge*—Newfane · 51. *Scott Bridge*—Townshend
52. *Kidder Hill Bridge*—Grafton · 53. *Hall Bridge*—Rockingham

VIII. Windsor -Area Tour · 125

54. *Victorian Village Bridge*—Rockingham · 55. *Worrall Bridge*—Rockingham
56. *Bartonsville Bridge*—Rockingham · 57. *Baltimore Bridge*—Springfield
58. *Titcomb Bridge*—Weathersfield · 59. *Upper Falls Bridge*—Weathersfield
60. *Salmond Bridge*—Weathersfield · 61. *Best Bridge*—West Windsor
62. *Twigg-Smith Bridge*—West Windsor · 63. *Bowers Bridge*—West Windsor
64. *Cornish-Windsor Bridge*—Cornish, New Hampshire, and Windsor, Vermont

IX. Woodstock -Area Tour · 143

65. *Martinsville Bridge*—Hartland · 66. *Willard Bridge*—Hartland
67. *Taftsville Bridge*—Woodstock · 68. *Middle Bridge*—Woodstock
69. *Frank Lewis Bridge*—Woodstock · 70. *Smith Bridge*—Pomfret
71. *Lincoln Bridge*—Woodstock

X. Tunbridge–Randolph -Area Tour • 157

72. *Union Village Bridge*—Thetford • 73. *Thetford Center Bridge*—Thetford
74. *Moxley Bridge*—Chelsea • 75. *Flint Bridge*—Tunbridge
76. *Larkin Bridge*—Tunbridge • 77. *Mill Bridge*—Tunbridge
78. *Cilley Bridge*—Tunbridge • 79. *Howe Bridge*—Tunbridge
80. *Kingsbury Bridge*—Randolph • 81. *Gifford Bridge*—Randolph
82. *Braley Bridge*—Randolph

XI. Montpelier-Area Tour • 171

83. *Moseley Bridge*—Northfield • 84. *Chamberlin Bridge*—Northfield
85. *Slaughter House Bridge*—Northfield • 86. *Station Bridge*—Northfield
87. *Second Bridge*—Northfield • 88. *Third Bridge*—Northfield
89. *Robbin's Nest Bridge*—Barre Town • 90. *Coburn Bridge*—East Montpelier
91. *Kent's Corner Bridge*—Calais

XII. Northeast Kingdom Tour • 185

92. *Power House Bridge*—Johnson • 93. *Scribner Bridge*—Johnson
94. *River Road Bridge*—Troy • 95. *Orne Bridge*—Irasburg
96. *Lord's Creek Bridge*—Irasburg • 97. *Fisher Bridge*—Wolcott

XIII. Upper Connecticut River Basin Tour • 195

98. *Martin Bridge*—Marshfield • 99. *Greenbanks Hollow Bridge*—Danville
100. *School House Bridge*—Lyndon • 101. *Chamberlin Mill Bridge*—Lyndon
102. *Miller's Run Bridge*—Lyndon • 103. *Randall Bridge*—Lyndon
104. *Sanborn Bridge*—Lyndon
105. *Mount Orne Bridge*—Lunenburg, Vermont, and Lancaster, New Hampshire
106. *Columbia Bridge*—Lemington, Vermont, and Columbia, New Hampshire

A Checklist for Looking at Covered Bridges • 208
Acknowledgments • 210
Index • 212

Introduction to Vermont's Covered Bridges

VERMONT'S COVERED BRIDGES stand as symbols of an honored past and as proof of that past's enduring relevance. These tunnels into yesteryear recall the days when town selectmen would specify that a bridge be built "a load of hay high and wide" and when the resulting barnlike structure would become, by turns, a kiosk for advertisements, a clubhouse for the neighborhood children, and an excuse for courting couples to steal a kiss while out on a drive. They are a delight to the eye, an almost natural expression of the forested landscape roundabout and an ornament to the hilly terrain's many splendid streams. Yet they are not simply quaint relics; the great majority continue to perform their original function, now carrying traffic even heavier than their designers had anticipated.

Vermont has 106 covered bridges, including those it shares with New Hampshire and those built according to historic principles in the modern era, all of which are included in this guide. Vermont being a small state dotted with old villages, the bridges are clustered in a way that makes them easy to visit. To help you plan your expeditions, the chapters organize them into groups that could be the basis for day trips. Some chapters point out nearby historic sites that might add to a visitor's understanding of the covered-bridge era. This book is both a history and a guide: It will help you find, photograph, and interpret this wealth of historic resources.

Along main roads, most covered bridges have long since given way to larger structures. That means the surviving bridges tend to be located on out-of-the-way back roads. There is a classic yarn about a traveler who asks a native Vermonter for directions, only to have the informant hem and haw and interrupt himself and finally declare, "You know, you can't get there from here!" This book's directions will be as detailed as possible. We have tried to

indicate any potential parking problems at the bridge itself. Nevertheless, it would be a good idea to buy a state road atlas to supplement the official state map and the maps in this guide—and to bear in mind that some landmarks and parking situations may change with time.

We give the approximate compass orientations of bridges for the benefit of photographers, along with specific picture-taking tips for some of them. In planning an itinerary, someone hoping to take pictures might want to visit a bridge running northeast–southwest to catch the morning light, and so on.

Much of the information we provide for each bridge is historical, taken from town records and the research of historic-bridge specialists. In the interest of identifying authenticity, later additions and renovations made to the bridges are chronicled where possible.

The introductory chapters that follow present historical perspectives common to all the bridges, explain bridge design and construction, and tell what we know of some of Vermont's bridge builders.

There are gaps in the historical record, perhaps inevitably since wooden bridges were so common during their heyday. But if, for instance, we know very little about many of the local builders who brought covered bridges into being, in some ways that is a measure of their success. Their expertise was trusted, they built well, and their results were quickly taken for granted. If alive today and brought to a ceremony honoring their contributions, they would probably mumble something about just doing their job. Our role now is to treasure what remains of their ingenuity and craftsmanship.

Note: Anyone with further information on the history of any of Vermont's covered bridges is welcome to correspond with the author, at 80 Park Street, Brandon, VT 05733-1149.

WAYS OF LOOKING AT COVERED BRIDGES

IN A WAY, covered bridges are almost too scenic. It's easy for a viewer to say "That sure looks old!" or "Isn't that picturesque?" and then drive along to look at something else, missing much of what makes a covered bridge so interesting.

Everyone will have a particular way of looking at covered bridges, and this chapter does not pretend to be the last or best word on the subject. But for those who have made an effort to reach Vermont's bridges and wouldn't mind lingering longer, here are a few perspectives that may help make a visit more memorable. (Please also see, at the back of the book, "A Checklist for Looking at Covered Bridges.")

Look first at the surroundings and try to imagine what justified expending scarce resources to build a bridge at that location. Perhaps it was to connect two sides of a village that, like many early Vermont communities, depended on

waterpower for its mills and thus was divided by a river. Or it may have linked two hamlets that, like Plymouth's Frog City and Pittsford's Wheelerville, no longer exist. Did the bridge join two now forgotten school districts after one school failed to thrive? (Look at crossroads for those one-room schoolhouses, many of which survive.) Or was it to get people to church, in a quieter age when the sound of a church bell traveled far and often tolled an urgent call? Perhaps a bridge was needed to bring enough voters to Town Meetings. Sometimes the idea was just to join a few outlying farms with everyone else—one indication of how adept the early bridge builders were. Let your imagination roam. For instance, perhaps it was a woman who died in childbirth for lack of the doctor's or midwife's prompt assistance that spurred the town to build a bridge.

Certainly New England's covered bridges should be viewed in the context of the 19th century's mania for transportation, part of the rush to reach frontiers and build a new nation. Spanning the "crik" may not have had the same glamour as opening the Erie Canal or driving the golden spike that completed the transcontinental railroad, but in its humble way the covered bridge partook of the same impulse and shared in the same pride.

Look at the massive timbers inside the bridge, and underneath it, if that's possible. Consider the size of the trees that had to be cut or hewed (look for ax and adze marks) to make them. Covered bridges are our best reminders of the glory of New England's virgin forests, where trees routinely grew higher than 100 feet. The best were reserved for use as masts by the king's navy, although one may suspect that more than a few of these giants instead went to ride the waters of the streams they still help to bridge. These trees had such girth that bridge chords (the horizontal timbers that spanned the stream) could be taken strictly from the inner heartwood. Their strength also came from their long, slow growth that left closely spaced rings—the opposite of trees grown by modern timber companies. One story passed down tells of a match company paying a large sum for the pine frame of an old bridge, only to find the wood was too hard to use. Similar aged strength in its oak planking gave the USS *Constitution* the name "Old Ironsides." The pegs securing the joints of covered bridges were also made of such oak, or other hardwoods.

Put another way, covered bridges are one of the finest expressions of America's golden age of woodworking. They were known in Europe back at least to the late Middle Ages, but it was in the northeastern United States, in the early 19th century, that the art of their design and the craft of their construction took the greatest leaps forward. This was not by accident: Blessed with the resources of a seemingly limitless wilderness—Europe's great forests had long since been harvested—and for many years denied the right to create a colonial iron industry, the carpenters and cabinetmakers and coopers of early America developed a culture of wood that today's artisans still draw upon. In that presteel era, they needed to understand the fine points of seasoning logs, sawing them for greatest strength, choosing the best for the

right uses, and making and employing hand tools (now avidly collected and often still in service). If you would like to learn more about wood and tools, stop at antiques shops along the way and ask their proprietors. Admire the multistory barns and rambling farmhouses and stately churches that are so much a part of Vermont's landscape and that all benefit from the same timber-framing wisdom as the covered bridges. If you envision all these structures as part of an Age of Wood, covered bridges will come to seem more natural than quaint, more at home than outdated.

Try to envision what the construction site looked like while the bridge was going up. Where would the workers have piled the seasoning timbers? Where would the master builder have carefully measured and cut the beams and joints for his templates so that less-skilled production workers could simply imitate him? Perhaps a worker would be using a drawknife or broadax to prepare the treenails—or "trunnels," as the word was pronounced—long pegs that had to fit into hand-drilled holes through the assembled mortise-and-tenon joints. Or he might be boiling factory-made treenails in oil to make them easier to drive in, although this was not always done. The hole driller would probably have been seated at a rig that allowed him to turn the drill with both hands, a necessity for an arduous and—dare we say?—boring job involving hundreds of repetitions. When looking at all those pegged joints today, remember the exacting demands of this task: If a treenail was too big, a joint might crack; if it was too small, a joint might shift, weakening everything.

In the early days, one of the workers would have been using a large wooden mallet to drive a wedge-shaped cutting tool called a froe through a round of cedar wood, splitting off shakes in preparation for roofing the bridge. Masons would be preparing the abutments; if these haven't been replaced with concrete, check and see if the builders used rounded stones from the streambed—a less stable alternative—or carefully laid courses of prepared and fitted rock. Least enviable of all was the work of the adze men, who stood atop round tree trunks and squared them by swinging their mattocklike tools toward themselves, between their feet. It was said that a contractor could tell whether a man seeking adze work was truly an experienced craftsman by whether he still had all his toes.

Is there a flat area where the sides of the bridge—the trusses—which are the key to it bearing its load, could be assembled before being raised over the river? A bridge, or just its trusses, could be built entirely at streamside, or the whole bridge could be created while spanning the water, depending on the situation. If there was any danger of a summer thunderstorm creating a flash flood, chances are that most of the work took place on the banks. Then, in a rush of a few days or weeks, the laborers would assemble the "falsework," an arrangement of angled vertical timbers and horizontal crossbraces somewhat like those that hold up many railroad trestles.

It's a pity more pictures weren't taken of these races against time and weather, during which the bridge parts were installed on the falsework.

Imagine the trusses on rollers, oxen or men straining to pull them slowly but surely over the stream, then daredevil timber framers ignoring the drop below and pegging it all together, hoping the carefully measured and cut timbers would really fit. (If you stop at Quechee Gorge in Quechee, remember they worked on such a trestle there, too, for the railroad bridge that preceded today's Route 4 highway bridge.)

Finally came the dramatic moment when the laborers pulled away the falsework, and everyone watched to see if the creaking, straining, settling bridge would retain its "camber," a slight upward curve of the middle of the span. If it did, that somewhat arching bend meant the bridge was carrying its load well. The absence of camber meant the joints weren't tight, and the bridge was already in trouble.

Once the bridge was in place, the builder could complete the two entryways—the portals. Unlike most of a covered bridge's form, the shape of a portal is not strictly dictated by function and can express a builder's sense of design as well as serve to keep water away from key timbers. The portals on Vermont bridges tend to be more reserved and conservative than those of some other areas of the country—no surprise to anyone familiar with the Vermont character—but they can be inviting and appealing nonetheless.

Why were wooden bridges covered? To keep the wood dry and thereby avoid rot. After Timothy Palmer's 1805 Permanent Bridge in Philadelphia proved more durable with a roof, that became the trend. For a while there were also many "pony" bridges, which had their side trusses covered but were not roofed. Today they are gone, while covered bridges remain. Not for nothing is a house sometimes described as "a roof over your head."

As a side benefit, horses skittish about crossing a high bridge were shielded from the view of the drop by a familiar, barnlike structure. But that was never the reason for going to the extra expense of adding a roof.

The interiors of covered bridges doubled as local bulletin boards. Travelers stopping to wait out rainstorms or rest their teams could inspect the bills and placards advertising circuses, religious gatherings, city employment in the woolen mills, and nostrums like Kendall's Spavin Cure and Dr. Flint's Powder, two widely known remedies for equine ills produced in Enosburg Falls, Vermont. Signs for these two products are still legible in several Vermont covered bridges. Kendall, by the way, was a horse, whose prowess as a racer helped inspire the weekend downtown races in Lyndon (see the introduction to Tour XIII).

In an era before there were many public buildings, covered bridges are known to have hosted many kinds of meetings: political rallies, church suppers, militia meetings. In particular, they served as children's clubhouses and playgrounds, especially on rainy days. A 100-foot span was plenty long enough for a game of one-o'-cat—a version of baseball using only one base—or for foot races or perhaps for play soldiering. A crack in the floorboards or a missing side board might provide young anglers a way to reach that lunker

hiding in the shadow of the bridge. Interconnecting roof timbers substituted for jungle gyms and treehouses, and sometimes became hiding places to spy on the couples honoring the custom of kissing while inside the darkened tunnel of love. The classic story in that regard is of the boy who witnessed his sister Mehitabel, nicknamed "Hitty," being proposed to by a nervous young man: "Marry, will you hitty me?"

Actually, there was an original Kissing Bridge, according to Eric Sloane, and it is not the one in Madison County, Iowa. It crossed De Voor's Mill Stream, at what is now the intersection of 52nd Street and Second Avenue, in New York City, believe it or not. Another custom now in abeyance is that of making a wish while crossing a covered bridge. From Pittsford town history author Jean Davies comes this contemporary account of how to make sure a covered-bridge wish comes true: Make your wish before entering the bridge; lift your feet off the floor of your vehicle, take a deep breath, and say, "Bunny, bunny, bunny, bunny . . ." all the way through the bridge while thinking of your wish; then, upon coming out the other side, say, "Rabbit!"

Not all incidents in covered-bridge history have been idyllic. Early travelers must have shuddered while passing through their local bridges at night after learning how Isaac Kelly had been beaten and murdered by robbers lurking at one end of the Billings Bridge outside Rutland—a bridge no longer in existence. A Wallingford bridge, now gone as well, served as a gallows for a man bent on hanging himself. A West Hartford two-lane bridge, also lost to time, left young John Steele permanently injured when the boy tried to hide there after a melon-stealing expedition, forgetting that the floorboards had been removed for repairs and there was nothing to stop him from crashing to the rocks 15 feet below.

But as the above list suggests, covered bridges themselves have most often been the victims. Floods—the very reason for having a bridge truss above rather than below the roadway—have taken the biggest toll. Early inhabitants watched the water levels in the spring and fall, the two great flood seasons, to decide whether to knock the wallboards off the upstream side of the bridge. That tactic often let the high waters pour through the bridge with little effect on the truss timbers (the flood itself could be left to do the work of removing the downstream-side boards). If a bridge did float away and fetch up in someone's pasture, sometimes it could be towed back and reset if collisions with trees had not damaged it. So sturdy were these structures that when a bridge in Arlington was blown into the river, area residents simply walked across on the sidewall until it was righted and put back in place.

Fires have played the devil, especially with railroad bridges, which were repeatedly set ablaze by sparks from steam locomotives. In the case of one Jeffersonville covered bridge, a farmer's wagonload of hay caught fire in the field, perhaps from spontaneous combustion, and the terrified horses bolted and ran until the load jammed in the bridge, destroying wagon, bridge, horses, and all. Arson has taken its toll. In some cases, as with the 1986 burning of

Dean's Bridge in Brandon, vandals were simply up to no good. In others it was strongly suspected that the arsonist hoped a more modern bridge might supplant the wooden one, as is reputed to have been the case with the 1952 torching of Three Mile Bridge in Middlebury—which has never been replaced.

The unwitting, official vandals of years past were highway departments, which, seeking to upgrade the roads, routinely dismantled covered bridges and replaced them with modern, two-lane structures. The bridges were not entirely destroyed: Frugal Vermonters found new purposes for their timbers in barns and sheds, and violin makers and other craftsmen who kept a weather eye for unblemished and seasoned spruce wood at times found material in the time-worn beams.

Today, it would be unthinkable simply to break up a covered bridge and put a concrete-and-steel bridge in its place. Federal and state laws both prohibit any such action without a public hearing, and the use of federal funds depends on conserving historic resources. Most of Vermont's covered bridges are now on the National Register of Historic Places. Sadly, it is not unthinkable for towns to neglect the maintenance of functional covered bridges until they are imperiled, and even when the necessary work is done, it may be at the expense of historical authenticity. If you find a bridge that has its original stone abutments, a cedar shake roof rather than asphalt or metal, bottom chords (the main timbers) that carry the load with no help from steel I beams, and no windows punched out of the sides in the interest of traffic safety, get out the camera because chances are you're looking at an original. Covered bridges are survivors—but all too often wounded survivors.

Still, they have proven surprisingly durable, in part because no modern, quickly grown wood can compare in density and strength with that of the ancient trees of New Engand's old forests. Their wonderful timbers—interlaced like the cross-stitching of an old farmhouse sampler, or the interplay of square dancers and their fiddler—have been the arks to carry older values across the troubled waters of the last century, and they promise to do so into a new millenium.

HOW COVERED BRIDGES CARRY THEIR LOADS

THE FIRST BRIDGE was probably a tree that fell across a stream or chasm. The first human-made bridge may have been the so-called stringer bridge, two logs placed side-by-side with smaller logs or planks laid crossways on the two stringers.

Such bridges tend to sag, and it was not long before people thought of propping them up in the middle. But supports rising from streambeds washed away during floods or rotted quickly. A better way was to have the center

supports angled out diagonally to the sides so that they were propped up by the riverbank. Such a bridge could be made even sturdier if the diagonal support timbers were part of a rectangular wooden frame holding them in place.

Sometime in the Middle Ages, an unknown genius in central Europe made a great imaginative leap and discovered the principle of the truss. The key was realizing that the framework of timbers under the bridge would be just as effective in supporting loads if it were placed above the bridge floor—where it was much less likely to be swept away by the river.

How could something on top of a bridge help support the middle? The answer has to do with the way the timbers transfer stress from the weaker center of the bridge to the ends, which are resting securely on foundations. This works effectively in a type of bridge used successfully since antiquity: the stone arch bridge. As will be seen, some of the more advanced types of covered bridges combine the idea of the arch with the idea of a unified arrangement of the beams—what is called a truss.

To quote a Random House collegiate dictionary, a truss is "any of various structural frames usually based on the geometric rigidity of the triangle and composed of straight members subject to longitudinal compression, tension, or both, so disposed as to function as a beam or cantilever to support bridges, roofs, etc." Covered bridges have two large trusses—the two sides. The roof and its bracing timbers keep winds from tipping over those two side pieces, while keeping the weather from rotting the wood.

As might be gathered from the dictionary definition, the rigidity of the triangle is another important engineering principle behind covered bridges. As an experiment, try taping four sticks of the same length together to make a square; then try changing its shape. Easy, because opposite corners will squash together. Tape three sticks of equal length together to make a triangle, then try changing its shape. Impossible, without breaking one of the joints.

Another key principle is what car makers today might call unibody construction. In raising barns or timber-framed houses, builders drew on a technique known since the great cathedrals of the Middle Ages: notching timbers so they fit tightly together, then drilling holes in those joints and driving in round wooden pegs to keep the joints from coming apart.

Strong joints are critical to the success of any wooden bridge. Some later designs used metal reinforcing rods as well as wooden pegs to help hold timbers together, although iron lacks wood's resistance to rust. Hybrid wood-and-iron designs were especially useful for covered railroad bridges, which had to carry much heavier loads.

Timber-frame construction, still used by some especially quality-conscious house builders, has become the stuff of legends. There are tales of wrecking balls literally bouncing off early New England houses, and of barns standing for years with corners broken off by errant farm machines. Back before "mobile homes," houses were themselves mobile: Being so solidly built, they could be towed around on rollers—and often were. Several covered bridges

BRIDGE TRUSS FRAMES

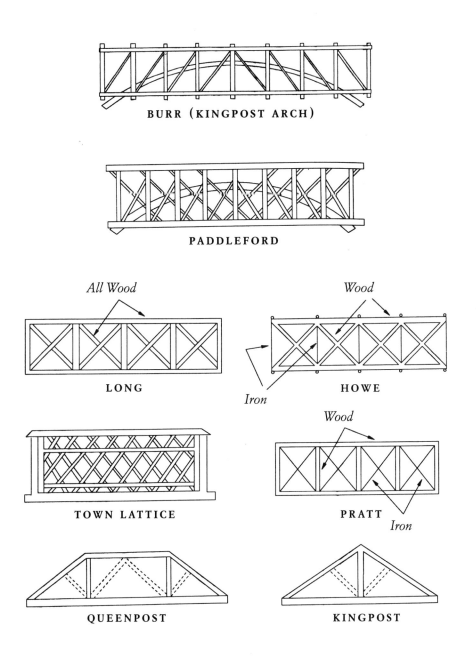

BURR (KINGPOST ARCH)

PADDLEFORD

All Wood

LONG

Wood

Iron

HOWE

TOWN LATTICE

Wood

PRATT

Iron

QUEENPOST

KINGPOST

Source: New Hampshire Department of Transportation, Bureau of Transportation Planning

have been washed downstream during floods only to be retrieved and returned to service.

The oldest, simplest type of truss construction went by the name of the kingpost bridge, a design widely utilized in Europe. Used mainly for small bridges, it had a vertical beam in the middle and two diagonal beams going to the ends of the bridge, where the horizontal beams rested on the bridge's footings (see page 19).

Technically, the vertical timber in the middle is "in tension," being pulled downward by the weight of the horizontal timber beneath. The two diagonal timbers are "in compression," being pressed together between the force of the bridge's weight and the resistance of the joints resting on the abutments.

This is, of course, an oversimplified account of a very complex situation. According to Jan Lewandoski, one of Vermont's foremost wooden-bridge experts, when a number of existing covered bridges were analyzed using engineering school computers, the conclusion was that some of these time-proven structures should logically have fallen right into the river. Early covered-bridge builders sometimes built small models to test their designs; in one case, a builder won a contract by setting his model between two chairs and standing on it, then daring his competitor to do likewise.

The queenpost bridge (see page 19), an obvious extension of the kingpost idea, was capable of spanning a somewhat larger stream. Local builders were familiar with both designs, which were widely used in barn construction. But for still wider spans and heavier loads, new and much more ingenious arrang-

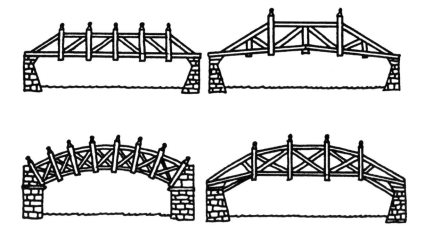

The four basic bridge truss designs described by Palladio in Treatise on Architecture.
Source: Covered Bridges of the Northeast, *Richard Sanders Allen*

ments of timbers had to be invented. These were America's distinctive contribution, during the great covered-bridge race that took place during the first half of the 19th century.

THE GREAT TRUSS RACE

COVERED BRIDGES HAD been built in other forested countries, such as Switzerland and Germany. But in early-19th-century America, the need for bridging large coastal rivers and the presence of a plentiful supply of primeval timber coincided with one of history's most extraordinary bursts of inventive genius. The result was a unique flowering of covered-bridge expertise.

This was the classic period of "Yankee ingenuity," immortalized by Mark Twain in his 1889 novel, *A Connecticut Yankee in King Arthur's Court.* Since freedom-loving and land-seeking settlers from Connecticut and elsewhere in the Northeast came to Vermont, it shared in this surge of inventiveness. In fact the first US patent went in 1790 to Samuel Hopkins of Pittsford, for an improved way of turning wood ashes into potash, a type of lye much in demand for soap production. The patented devices created in the Connecticut River Valley between Vermont and New Hampshire made the so-called Precision Valley the birthplace of the machine-tool industry and a production center of worldwide significance—a history that visitors can relive at the American Precision Museum in Windsor, Vermont.

Within this hustling, bustling marketplace of East Coast innovation and entrepreneurship, bridge builders raced to see who could devise the best truss. The winner could expect patent royalties whenever local builders employed his design, so competition was fierce.

The acknowledged grandfather of covered-bridge design was an Italian named Andrea Palladio, who in 1570 wrote *A Treatise of Architecture,* whose four volumes included four truss designs for wooden bridges. One was a multiple kingpost, another was a queenpost, and two designs combined arches with interlocking triangles (see page 20).

Neglected for two centuries, Palladio's architectural ideas began to take hold in Britain after his opus was translated into English in 1742. But aside from an 87-foot garden bridge on Lord Burlington's estate, the bridge designs found little use, for lack of suitable timbers.

But in North America, Palladio's concepts arrived at a time when all sorts of people were sketching all sorts of designs for bridges, most of which fortunately never got past the drawing board stage. Palladio may have influenced John Bliss's 1764 bridge across the Shetucket River in Norwich, Connecticut, a 124-foot, uncovered structure considered this country's first true truss bridge.

It was Timothy Palmer of Newburyport, Massachusetts, who, by applying Palladio's principle of the wooden arch, became the first of the great covered-bridge builders. A self-taught architect, house builder, and inventor, he

patented his high-arched truss (travelers had to go up and then down) in 1797. His bridges included an earlier span of the Connecticut River at Windsor, Vermont, and a 1362-foot bridge to two New Hampshire coastal islands that included one 244-foot arch.

Palmer was skeptical when, in 1805, Judge Richard Peters, a member of the company financing the 550-foot, three-span Permanent Bridge in Philadelphia, suggested it would last longer if roofed. Local carpenters Adam Traquair and Owen Biddle designed and built a covering so successful that Palmer adopted the idea for his next bridge in 1806. By 1810, the practice of putting "woodsheds on bridges" (as one Scottish visitor mistakenly described what he saw) had become standard.

Theodore Burr of Torrington, Connecticut, a millwright and builder who created his first bridge in 1800, also drew on Palladio's designs to develop a truss that allowed the roadway to run level between the supporting arches. The Burr truss, or kingpost arch, as it was also called, patented in 1817, combined parallel arches with a framework of multiple kingpost timbers and counterbraces, a concept so successful that it became the basis for thousands of American bridges, including several in Vermont.

If any builder could be said to have "won" the bridge patent race, it was Ithiel Town, a New Haven, Connecticut, architect. After using Burr's design for several bridges, he decided there had to be a way that didn't require such huge timbers. His "Town's lattice mode" truss, as he called it, patented in 1820, was the first major departure from past bridge designs.

Like many great ideas, it simplified. Instead of arranging timbers of different lengths at different angles, the Town lattice was made of identical, parallel, diagonal members crisscrossed over one another (see page 19). At every point where these thick planks crossed, and where they met larger top and bottom timbers, they were secured with wooden pegs. In effect, the truss formed a series of triangles—the most stable geometric form, as we have seen—which distributed stresses throughout the bridge. Eric Gilbertson, who headed Vermont's Division for Historic Preservation, knows of only one instance in which a Town lattice truss failed, when an overloaded truck crashed through the floor. "It literally exploded" because the stresses were so evenly distributed, he said. "There were pieces scattered from hell to break-fast." He added that the bridge would have survived if the driver had kept going, rather than stopping and fleeing the truck when he heard cracking sounds.

An early competitor derided Town's truss as a "garden trellis fence," which it indeed resembled, but it was phenomenally strong for its weight, and proved so easy to build that it was still being employed long after Town's 1835 patent on an improved version ran out. The lighter sidewall timbers were cheaper and easier to find, a relatively unskilled builder could follow a plan to create one, and multispan bridges—those built across one or more midstream piers—didn't have to be individually designed. If the bridge needed to be

strengthened, this could be done simply by having two lattices in each truss. The common saying was that the Town lattice design "could be built by the mile and cut off by the yard." The overwhelming majority of Vermont bridges are of this variety, including one built in Woodstock in 1969 by Milton S. Graton and his associates of Ashland, New Hampshire, proving the design is still viable for modern use.

Town's toughest competitor was Stephen H. Long, originally from Hopkinton, New Hampshire, and later a brevet-colonel with the US Army Topographical Engineers. In 1830 he developed the first truss based on mathematical calculations. His patented design had some features resembling Town's, but overall it was a series of boxed X's (see page 19). Agents for the two inventors vied for contracts, arguing their cases in the newspapers as well as at meetings.

But after 1840, both designs were largely superseded by the Howe truss, invented by William Howe of Spencer, Massachusetts. If the name Howe seems vaguely familiar, perhaps it's because his nephew Elias is immortal for his part in inventing the sewing machine. (Inventing ran in the family. William's brother Tyler invented a spring bed.) William Howe's genius was to identify the weak point in wooden-bridge construction. Wooden-bridge members that were being pushed together—"in compression"—stayed strong; in fact, they gained in strength, technically speaking. But wherever two members were being pulled apart—"in tension"—the pressure affected the weak link in the system, the pegged joints. That was one reason the early covered-bridge builders preferred spruce, which combined lightness with greater strength than pine or hemlock.

If you remember from the discussion of the kingpost truss, the vertical post is the part in tension, because the weight of the load going across the bridge pulls it down. Howe started with a design similar to Long's (there were patent fights, which Long lost) and substituted iron rods for the vertical timbers. This not only solved the tension problem, but it also meant bridges could be tightened up, the vertical member being in effect a long bolt with a big nut on the end. Howe also devised iron angle blocks into which the ends of the wooden timbers were fitted, further strengthening the joints.

Like Town's design, Howe's lent itself to mass production. Factories could ship precut timbers, iron rods, and angle blocks to a site for quick assembly. Almost any sound tree trunk could be used to make timbers, a boon to bridge builders in areas of the country where spruce was unavailable. Railroads became heavy users of the Howe truss.

Palmer, Burr, Town, Long, and Howe were the foremost bridge designers, but there were regional inventors as well, some of whom never tried to patent their designs. A few northern Vermont bridges use an elaboration of Long's plan devised by Peter Paddleford of Littleton, New Hampshire. Arnold Tasker of Cornish, New Hampshire, developed a variant of the multiple king-post that found many applications in southern Vermont. There's a wonderful

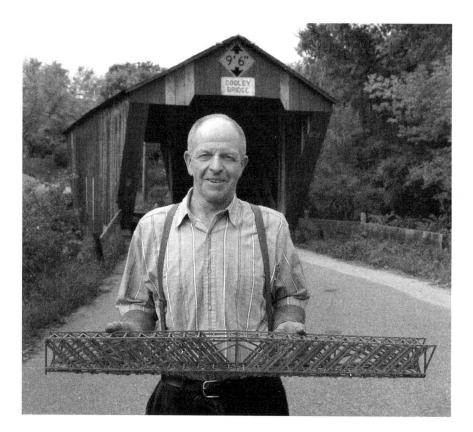

story of Tasker coming into Claremont, New Hampshire, one Saturday after-
noon with an 8-foot, 13-inch square model bridge and being laughed at by the
local loafers. Laughter changed to cheers, however, when he went to a hard-
ware store, set up his bridge, loaded 10 kegs of nails onto it, and then climbed
on top himself.

But the man who epitomized the heroic spirit of the early covered-bridge
builders—the one widely considered the greatest of them all—was Nicholas
Montgomery Powers, born in Pittsford, Vermont, in 1817 and later a resident
of nearby Clarendon.

Apprenticed to Pittsford's Abraham Owen, with whom he built two Pitts-
ford bridges, Powers got his first contract at the age of 20. When the first
bridge he built—which spanned Furnace Brook at Pittsford Mills, where
Route 7 meets Route 3 today—was replaced 96 years later, it was still strong
enough to hold the demolition-construction crew's 20-ton steamroller.

Powers went from local projects to railroad work, notably helping to
bridge the Connecticut River at Bellows Falls, Vermont. Inspired by his col-
laboration with college-educated engineers, he began experimenting with
models (see photograph above for new designs).

In 1854 he was brought to North Blenheim, New York, to build what is

now the world's longest single-span covered bridge. The three-truss, two-lane bridge was based partly on Long's ideas, but it was experimental enough and ambitious enough to earn the name Powers' Folly while being assembled.

The three concentric arches, secured with 5100 pounds of wrought-iron bolts and washers, were 228 feet long and spanned 210 feet. When the day came to remove the falsework, Powers climbed on top and went to the center of the bridge. "If she goes, I'll go with her!" he proclaimed. (Various sources give different versions of his immortal words; this is from Richard Sanders Allen.) The bridge settled to a fraction of an inch of where he'd predicted, and remains in place to this day, although it no longer carries traffic.

In 1866 George A. Parker, an engineer Powers had worked with in Bellows Falls, called him to Perryville, Maryland, where a tornado had destroyed most of an immense bridge across the mouth of the Susquehanna River. College-educated draftsmen had tried for weeks to devise a better plan, without success.

Parker asked Powers how long it would take him to come up with a design. "I'll give it to you after I've had my lunch," he replied. It was a quarter to ten.

By the appointed hour, Powers had covered a timber block with drawings and calculations. Awarded the job, he finished in time to win a $500 bonus. As a final triumph of homespun practicality over theory, he had his 16-year-old son, Charles, design the drawbridge section.

Powers, who thereafter kept his promise to his wife to stay nearer to home, became a legend. Richard Sanders Allen found accounts claiming that Powers had built "all the lattice bridges in Vermont" (the Town lattice being one of his favorites) and "most of the covered bridges in New England and New York." His last, at the age of 63, was the humble but sturdy Brown Bridge, built in 1880 on a back road near his hometown of Clarendon.

Howe's combined use of wood and iron pointed to a future in which bridges would be made entirely of iron. After the Civil War, covered bridges were made less and less often of wood. But history has a way of closing its circles. In Vermont today, the iron bridges are even more endangered than the wooden covered bridges they succeeded, primarily because of road salt–induced rust. Sentiment is growing in favor of building new wooden bridges where their statutory 8-ton load limit is not a problem, although safety concerns usually result in two-lane, concrete-and-steel bridges instead.

Today, engineering-school contests and creativity competitions like Odyssey of the Mind often specify that contestants build balsa wood structures very much resembling covered bridges, the object being to support the heaviest load. The importance of design can be gauged by the fact that these creations, made of less than a pound of the flimsiest wood available, frequently hold 400 pounds or more before collapsing. The old-time covered-bridge builders' hearts would have warmed to see how often the winning entries in design competitions resemble their craftsmanship.

THE BATTLE OF THE BRIDGE

COVERED BRIDGES MAY seem serene and tranquil in their pastoral settings, but many are survivors of embattled histories. Their construction, their maintenance, their restoration, and their future have often been controversial. They still need support, from travelers as well as residents, so this introduction will close with information on how you, too, can help covered bridges remain part of our landscape.

Today, covered bridges are generally owned by a state or a town, and traffic moves through them for free. This is a comparatively recent development. Private ownership and subsequent bridge tolls were common in the early years, along with municipal lotteries authorized by the legislature. Such bridges were often good investments, as was the case with Colonel Enoch Hale's 1785 bridge at Bellows Falls, which showed the nation that wooden bridges were practical. While not a covered bridge, it used only one central pier for its 365-foot length, and its success opened the way to the era of covered-bridge innovation—as well as opening the commercial route between Vermont and Boston.

Over the Connecticut River, which was once spanned by 35 covered bridges between Vermont and New Hampshire, the first toll-free structure was the 1859 Ledyard Bridge (taken down in 1934), paid for by surrounding towns and Dartmouth College. The Cornish-Windsor covered bridge, still in existence, took tolls until 1943.

Towns often wound up owning bridges after toll companies folded. Such was the case with Vermont's oldest covered bridge, the Pulp Mill Bridge connecting Middlebury and Weybridge, apparently built some time between 1808 and 1820 (the records have been lost). It went public in 1828 when the Waltham Turnpike Company dissolved.

The early tolls seem trifling today: 4¢ for a horse and rider, 10¢ for a one-horse carriage, 1¢ for a pedestrian, half a cent a head for sheep or swine. The construction costs seem slight as well: As late as 1912, it cost only $5000 to put a covered bridge across the Connecticut River connecting Lancaster, New Hampshire, and Lunenberg, Vermont. And in 1941, it was reported that one Vermont town decided to spend $4000 to repair a covered bridge rather than pay $40,000 for a new one made of concrete and steel.

But Vermont has been chronically poor and its taxpayers often extremely conservative or downright stingy. The late Walter Hard, whose free-verse chronicles ran in early-20th-century Vermont newspapers, recorded one instance. A Town Meeting in Rutland had taken up the proposal to build a covered bridge to the Kelly farm. A member of the rival Billings clan rose and said, "Mr. Moderator, we already have built covered bridges at Goodkin's Falls, Ripley's, Dorr's and Billings'—five bridges within two miles." He paused, then delivered the line that doomed the suggestion: "I move we bridge the whole damned creek lengthwise!"

The concerns about "wasting money" on covered bridges have been real enough: the lack of adequate sight distances in approaching one-lane crossings; the weight of modern-day milk trucks, log trucks, and the town's own maintenance dump trucks, when loaded with gravel for repair of back roads; the possibility of arson. Sentiment in favor of replacing old bridges with something more modern sometimes has led to neglect. Today, anyone traveling to visit bridges will see wide variations in the quality of abutments, roofing, side walls, and floor planking, reflecting differences in local attitudes.

Even when repairs have been voted, they have frequently been of questionable authenticity. Concrete footings, metal roofs, skylights to illuminate interiors, steel beams or modern laminates for reinforcement—such are the signs of selectmen doing their duty to present-day taxpayers rather than to posterity. The state tranportation agency has tended to favor reinforced concrete over wood for new bridges and glue-laminated wood for strengthening antique bridges, and it dangles the carrot of substantial state and federal funding if towns do as its engineers suggest. David Wright of Westminster, Vermont, a president of the National Society for Preservation of Covered Bridges, once remarked, "I won't say that the Vermont Agency of Transportation has done more damage than the 1927 flood, but I'm tempted. I've read more foolishness in engineering reports on historic structures than almost anywhere else." Meanwhile, state transportation officials warn that truckers routinely take overloaded vehicles across covered bridges and that towns need to foresee potential liability problems if bridges fail. Said one, "People don't use any common sense. They've got to go with any size load they've got. They beat the bridges to death and then say, 'Why don't you fix it again?' It's frustrating."

While those who know the financial struggles of Vermont small towns will find it hard to condemn money-saving strategems of local and state officials (the children come first, and schools are expensive), the question remains whether careful historic restoration of irreplaceable resources might not be the best long-term investment.

Part of the answer to that question depends on whether visitors who come to see covered bridges appreciate the nuances of historical preservation and will spend much-needed dollars while in town. By all means, while making purchases or staying the night, let proprietors know the bridges brought you. If you find a bridge in particularly fine condition, write a letter to the local selectboard or to the editor of the local newspaper and express your appreciation.

In fact, there are ways of keeping bridges both authentic and functional, especially in Vermont. The National Society for Preservation of Covered Bridges reaches a community of bridge lovers through its newsletters and regular meetings (write to PO Box 910, Westminster, VT 05158-0910). Jan Lewandoski and his company in Stannard, Vermont, and Graton Associates in Ashland, New Hampshire, have both been active in restoration in Vermont, as notes on specific bridges will show. Both these sources of expertise are rallying points for those who care about restoration and believe that many new bridges

could be wooden as well. The idea that all-wooden bridges can't carry modern traffic loads is easily refuted: The Boston & Maine's steam locomotives crossed covered bridges of the doubled Town lattice design in the 20th century. Even the arson bugaboo has found a solution in modern protective coatings that can be applied to the interior sidewalls of bridges. According to Wright, one of the newest is nontoxic, soaks in without changing the appearance of the wood, does not weaken timbers, and lasts indefinitely on interior surfaces.

Will building new covered bridges weaken our links with the old ones and the past they evoke? Not if we value them as evidence of ingenuity, craftsmanship, and practicality rather than as something quaint and old-fashioned. In the long run, there is no clear dividing line between new and old covered bridges. Indeed, one of the great advantages of wooden bridges is that they reveal their problems one by one, and parts can be replaced one by one. In the end, what matters most is a series of relationships—between one truss timber and another, between the land and its people, between generations. Long before the term "renewable resource" was invented, these structures were a living part of a forested landscape—and with care and attention, they always will be.

HOW THIS GUIDE IS ORGANIZED

EACH SECTION OF this guide combines a group of bridges that can comfortably be visited in part or all of a day, or perhaps a weekend, depending on how much time you spend at museums, swimming holes, and other attractions we point out along the way.

If you are staying in an area of Vermont and have a limited amount of time, or if you just want know more about the bridges in and around your hometown, you can use this guide to design your own tour. In the index, Vermont's covered bridges can be referenced by common name and by town, and the maps show where the bridges, and towns, are found in relation to one another.

Within the tours, the title of each entry gives the bridge's name or names that local residents and town clerks are likely to know. Following the bridge's common name is a list of headings that give all the available information about the bridge. An explanation of those headings follows:

Other and historical names: Includes names found through historical research and in guide publications.

Municipality: Vermont is divided into 251 legal units, the towns and cities that elect officials and own most local roads and bridges. Municipalities often encompass more than one town or village—thus, the next section:

Locality: The city, town, or village where the bridge is commonly said to be found. Sometimes a town has a legally independent village within it, sometimes there are several villages in one town, and often there are unofficial districts, settlements, hamlets, and so on where residents may say a bridge is located should you stop to ask your way.

Ownership: Local, state, or private.

Traffic allowed: Pedestrian only, cars only, weight or height limits, et cetera.

Crossing: The stream or body of water spanned and the road crossing it.

Built: Gives date of construction when known and sometimes date of major reconstruction.

Builder: Usually denotes a local contractor. Covered bridges were so common and so little noted at the time that often no builder's name survives.

Type: The kind of trusses—the sidewalls, which in most cases actually hold up the structure (see Introduction). Nonauthentic additions, such as steel beams below the floor or the presence of glue-laminated timbers, will be indicated under **Notes.**

Dimensions: Official figures as available; occasionally personal measurements.

Photography tips: Approximate compass orientation, to 16 points of the compass, to help determine the best times of day for taking pictures. The portal most likely to be encountered initially as you drive up to the bridge is listed first, and often it is the most attractive side. Obstacles such as trees and hills, ways of gaining streambed access, and special angles are noted in some cases.

Getting there: Gives approximate distances—tenths of miles, by odometer readings—from major landmarks that are unlikely to change (post offices, town offices, other bridges rather than store names). Street names are given in most cases—for talking with residents—but should not be used as guides because signs often have not been installed, get stolen, wear out, or are placed so as to be easily missed. The instructions for following roads ("Go north on," "Head east from," and so on) are not based on compass measurements; rather, they're intended to give a general sense of direction.

Parking: Points out potential conflicts with traffic or private-property owners. If there is no clearly defined parking space or roadside turnoff, Vermont landowners are almost always sympathetic to visitors asking to use their driveways (if they don't park for hours). Make no mistake, property rights are fiercely defended; but neighborly sharing is another strong value. The local custom for hunters, anglers, and bridge lovers is to go to the house to ask for permission so they know who you are. If no one is home, *please* don't park in the driveway, on the lawn, or snoop around the grounds.

Notes: Historical information and interesting anecdotes, along with observations on the character of the site, such as the presence of local swimming holes underneath the bridge.

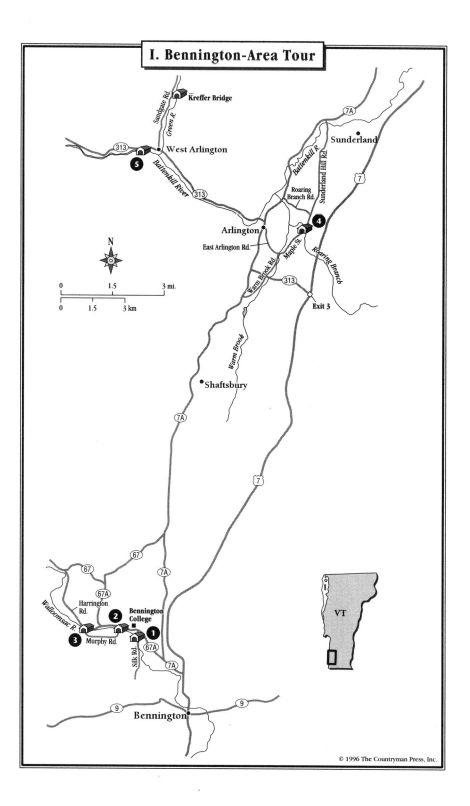

I. Bennington-Area Tour

Kreffer Bridge

Sandgate Rd.

Green R.

West Arlington

313

5

Battenkill River

313

7A

Sunderland

Battenkill R.

Sunderland Hill Rd.

7

Roaring Branch Rd.

Arlington

East Arlington Rd.

4

Maple St.

313

Roaring Branch

Warm Brook Rd.

Exit 3

N

0 1.5 3 mi.

0 1.5 3 km

Warm Brook

•Shaftsbury

7A

7

67

7A

67

67A

Harrington Rd.

Walloomsac R.

2

Bennington College

3

Murphy Rd.

1

Silk Rd.

67A

7A

VT

9

9

Bennington

© 1996 The Countryman Press, Inc.

I. Bennington-Area Tour

IF VERMONT HAS the most covered bridges per square mile in the country, that is partly because many were built later than in other states. That, in turn, is because Vermont was long a frontier, where Indian raids and legal battles over land ownership limited settlement before the Revolutionary War.

Bennington County, being closer to the existing colonies, was settled earlier and thus has a rich history, as does each of its five covered bridges. The name Bennington came from that of New Hampshire governor Benning Wentworth, who made the first of 135 future Vermont grants to that town in 1749.

Meanwhile, the colony of New York was making similar grants for the same territory (no one thought of the area as Vermont), and sometimes rival claimants showed up for the same property. The future Vermonters, who tended to be independent-minded and contentious types dissatisfied with the settled ways of life farther south, found New York's Dutch-inherited system of large grants to single landlords extremely distasteful.

The Walloomsac River in Bennington, where it is now spanned by the Henry Bridge (No. 3), was the site for a key confrontation. Albany Sheriff Ten Eyck and a posse came to arrest James Breckenridge, owner of the farm that included the bridge, only to find armed Green Mountain Boys at the bridge, in the Breckenridge house, and in the woods. He urged his men forward, but instead they turned and went back to New York—to stay. The pattern had been set for individual rights, local control, and contentiousness, all of which we will meet again in the sometimes tumultuous histories of individual Vermont covered bridges.

"The Hampshire Grants, a country unpeopled and almost unknown in the last war, now abounds in the most active and rebellious race on the continent

and hangs like a gathering storm at my left," wrote British general John Burgoyne of the militias that routed his attempt to seize Continental ammunition stores at Bennington in 1777. The battle actually took place across what would become the Vermont–New York state line, but it is in Bennington that a 306-foot dolomite obelisk, built in 1891, commemorates the Battle of Bennington. (It is located where the rebels had their armory.) The state historic site there is a good place to pick up a free brochure telling more about that conflict. The **Bennington Museum** on West Main Street (802-447-1571) has information, artifacts, and a variety of exhibits on local arts and crafts traditions and early New England life.

Today's Monument Avenue was Bennington's main street in its early years; another brochure describes a self-guided 1-hour walking tour that includes the monument and 41 other sites. Notably, a bronze statue of a mountain lion commemorates the former Catamount Tavern, where Ethan Allen and other Green Mountain Boys met to form the Republic of Vermont. A somewhat longer downtown Bennington self-guided walking tour covers the town's industrial and commercial history, in which waterpower from the Walloomsac River (which all three Bennington covered bridges cross) played an important part. Get these brochures at the chamber of commerce booth on Route 7.

The northern part of Bennington County, which retains two covered bridges in or near Arlington, has a long history of catering to visitors. In recent years this region, Manchester especially, has capitalized on charm to become a recreational shopping mecca. At first sight, the profusion of boutiques and outlet stores may seem to have overwhelmed the historical element, but it's still there. Arlington has 190 buildings in its historic district, along the old Bennington-to-Rutland stagecoach road. A **Norman Rockwell Museum** (802-375-6423) housed in a church on VT 7A will bring to life the quieter, gentler, more family- and community-minded era many people associate with covered bridges. Some of the museum guides were Rockwell's models in the years he lived in Arlington. Also on Route 7A, in Manchester, is **Historic Hildene** (802-362-1788), a restored Lincoln-family mansion whose carriage barn has become a visitors center and museum. Manchester Center is dominated by the restored **Equinox Hotel and Resort** (802-362-4700), a classic example of the 19th-century rural resort hotels to which affluent city folk fled in the summer during the covered-bridge era. It's also one of the state's foremost exemplars of timber-frame construction—or rather, three of them, having been built in 1801, 1832, and 1834. For an example of a stagecoach stopover from that time, visit Shaftsbury's **Peter Matteson Tavern and Topping Tavern Museum** on East Road (802-442-2180).

Dorset's picturesque village green and surrounding 19th-century buildings—a kind of antidote to Manchester and its traffic—benefit from a combination of affluence and concern for historic values. Money matters. For instance, along with upper Bennington County's many fashion shops and galleries, history lovers will find an unusually high number of shops selling

antiques (to pursue further, contact the **Manchester and the Mountains Chamber of Commerce,** 802-362-2100).

Bennington County's bridges are in the valleys, so if the mountains tempt you, consider a jaunt east from Bennington along Route 9 to Wilmington's aptly named High Mowing Farm Bridge (No. 48). There are good stopping points for some of the best vistas. A final grace note: After seeing Bennington's three bridges, a renowned picnic site and Vermont tradition is the town's deer park, less than a mile south of the bridges on the east side of Route 7, where visitors can feed as well as watch the herd of pet deer.

1. SILK BRIDGE

Other and historical names: Locust Grove; Robinson.
Municipality: Bennington.
Locality: Bennington.
Ownership: Town.
Traffic allowed: Up to 8 tons.
Crossing: Walloomsac River and Silk Road.
Built: About 1840.
Builder: Probably Benjamin Sears.
Type: Town lattice.
Dimensions: 88 feet long, 14.25 feet wide, 10 feet high at truss, 11.9 feet high at center.
Photography tips: NNE–SSW; afternoons are best for side views, which work well due to the partly open, red-painted sides.

Silk Bridge

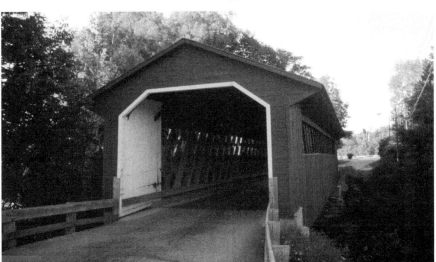

Getting there: This can be tricky. Starting at the deer park on Route 7, go north 0.6 mile to the junction of Routes 7 and 7A. Take 7A 0.9 mile north to its junction with Route 67A, and take 67A. Go about a mile to where Bennington College is on your right (north), after 67A makes a big, sweeping turn to the left. The road intersecting 67A almost opposite the entrance to the college (this road is easy to miss while going west, so use the sweeping turn as a key) is the Silk Road. Turn left: The bridge is 0.2 mile south of 67A. The good news is that all three of Bennington's covered bridges are now within 2 miles.

Parking: You'll see a good turnoff on the westerly roadside.

Notes: Robinson Bridge is the original name, according to John Spargo, former Bennington Museum director. The names Silk Road and Silk Bridge come from nearby residents, not silk manufacturing.

2. PAPER MILL VILLAGE BRIDGE

Other and historical names: Paper Mill.
Municipality: Bennington.
Locality: Paper Mill Village, formerly Bennington Falls.
Ownership: Town.
Traffic allowed: Closed to all traffic since 1986; adjacent temporary bridge limit 8 tons.
Crossing: Walloomsac River and Murphy Road.
Built: 1889.

Paper Mill Village Bridge

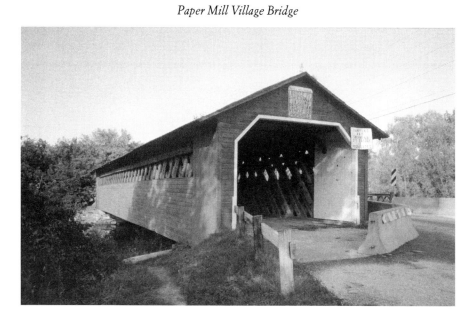

Builder: Charles F. Sears.

Type: Town lattice.

Dimensions: 125.5 feet long, 14.25 feet wide, 8.67 feet high at truss, 11.17 feet high at center.

Photography tips: NNE–SSW; site is complicated by the temporary bridge next to the closed bridge.

Getting there: Not that hard, but it is possible to miss it the first time. Starting at the junction of Routes 7A and 67A, go 1.4 miles on 67A to Murphy Road. The bridge will be visible on the south—left—side of 67A.

Parking: Not a problem after crossing temporary bridge.

Notes: This one is a heartbreaker for some covered-bridge lovers, although local kids enjoy it as part of a swimming hole. It was named for a 1790s paper mill that was one of the state's first; tissue paper is still manufactured nearby. The nearby dam used to be Bennington Falls. The 1889 bridge was built by the son of the builder of the Silk Bridge (see No. 1), and was repaired extensively in 1952, like the other two Bennington bridges. But a 1994 state study found those repairs to the bottom load-bearing timbers inappropriate, and since then a leaking roof has left the bridge "critically deteriorated" and "on the verge of collapse." The engineers estimated it would cost $250,000 just to avoid having a heavy snow load or the bridge's own weight send it into the river, and $50,000 to $100,000 more for a proper reconstruction (which they recommended as the cheapest solution). As of 1995, the town was waiting for state funds to become available, possibly with Murphy Road's anticipated reconstruction in 1996.

3. HENRY BRIDGE

Other and historical names: None known.

Municipality: Bennington.

Locality: Bennington.

Ownership: Town.

Traffic allowed: Up to 8 tons.

Crossing: Walloomsac River and Murphy Road.

Built: Original structure about 1840; completely replicated in 1989.

Builder: Original builder unknown; 1989 bridge by Blow and Cote, Inc., of Morrisville, Vermont.

Type: Town lattice.

Dimensions: 120.8 feet long, 14.3 feet wide, 9 feet high at truss, 11.1 feet high at center.

Photography tips: NE–SW.

Getting there: It's easy from the Paper Mill Village Bridge: Just keep going 1.3 miles on Murphy Road. Or starting at the junction of Routes 7A and 67A, go 2.1 miles on 67A to where it turns north at a four-way intersection. Take the

southerly road, Harrington Road, 0.5 mile to Murphy Road and the bridge.

Parking: Use the turnoffs away from the bridge itself.

Notes: The name Henry came about after original owner James Breckenridge sold 50 acres to Elnathan Henry, who built the Henry House, where later Irish immigrant William Henry operated a store and tavern. The Walloomsac River narrows made the area attractive because of its waterpower, and also made a good bridge site. Irish Corners, as it was known for its numerous Irish immigrants, had water-powered mills into the 1920s, notably a cotton mill from the 1830s to the 1880s, and a gristmill operated by the Henry family east of the bridge on the south side of the river. The Irish Corner Historic District is on the National Register of Historic Places as preserving "the feeling of a 19th century riverside community."

The present Henry Bridge is not only storied, but it also played a critical role in current covered-bridge planning in Vermont.

The original covered bridge, the third bridge at the site, was famed at one point for presumably being Vermont's strongest. The discovery of iron ore beds in the 1860s led to the tripling of the lattices, supposedly increasing the truss strength so ore-laden wagons could cross. (This was a method used to good effect by railroad companies.) But during 1952 repairs, it was determined that the way the work was done did not add to the bridge's strength—that is to say, the original Town lattice not only carried the ore wagons, but it also held up a huge added load of dead weight. The repairs included removing the extra side timbers and most of the overly thick flooring.

By 1989, needed repairs for the bridge, costing $223,617, were contracted. "The bridge is being disassembled and tested, with Cote Brothers replacing parts as needed," the *Bennington Banner* reported that July. But when the contractors found many of the timbers were bent, they asked to go a step further. The plan for total reconstruction should have gone to the Division for Historic Preservation for review but somehow never got there.

Ironically, it was the New York State Covered Bridge Society that tried hardest to save the bridge at the same site where Albany Sheriff Ten Eyck's attempt to arrest James Breckenridge was frustrated by the Green Mountain Boys (see tour introduction). Society president Richard Wilson of Rome, New York, a frequent visitor to the work site, learned from a carpenter that the old trusses were going to his property and were for sale if someone wanted them. Wilson informed the *Bennington Banner,* which blew the whistle on the real nature of the "repair" work, but by then it was too late. HENRY BRIDGE DISMANTLED AS STATE AGENCIES LAY BLAME UPON EACH OTHER, ran an August headline.

The upshot was that not a stick of the old Henry Bridge remains, although the old and new bridges share the same form. The new wood is southern pine, with ash treenails, not the usual Vermont spruce and oak. The old timbers were saved, but at last report they were sitting uncovered in a town pile, still awaiting creative reuse.

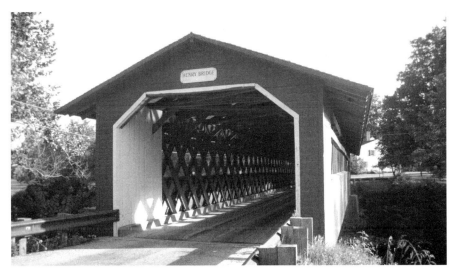

Henry Bridge

"That was kind of a bad deal," said Vermont Agency of Transportation engineering section supervisor David Lathrop, adding that it was a learning experience. It was partly that fiasco that led the agency to hire a knowledgeable consultant to do its latest study of 75 highway covered bridges; and when that study finds a bridge can't be repaired to carry traffic, it recommends the bridge be bypassed or moved, not demolished or indiscriminately modified.

4. CHISELVILLE BRIDGE

Other and historical names: High; Roaring Branch.
Municipality: Sunderland.
Locality: Chiselville, associated more with Arlington.
Ownership: Town.
Traffic allowed: No weight limit (reinforced).
Crossing: Roaring Branch Brook and Sunderland Hill Road.
Built: 1870.
Builder: Daniel Oatman.
Type: Town lattice.
Dimensions: 117 feet long, 11.8 feet wide, 8.7 feet high at truss, 10.9 feet high in center.
Photography tips: SW–NE; morning pictures are best due to obstacles; steep banks make riverbed access difficult except via private property (and concrete pillars make side shots less than scenic).
Getting there: From Route 7, go west 1.3 miles from Exit 3 on Route 313; then at a four-way intersection turn right on Warm Brook Road. Continue 0.6

mile until that road ends at a T-intersection with East Arlington Road. Go right (east) on that road; it changes its name to Maple Street, which is Arlington's name for the road the bridge is on—which in true Vermont fashion changes its name in Sunderland to the Sunderland Hill Road. The bridge is 1 mile from the T-intersection.

Perhaps easier: Coming south on Route 7A from Manchester, turn left on Roaring Branch Road just before a concrete-and-steel bridge (the stream the Chiselville Bridge crosses parallels this gravel road). Go 0.9 mile to reach a T-intersection with Sunderland Hill Road. Turn right (south), and you are only 0.4 mile from the Chiselville Bridge.

Parking: A sign on the south side warns against any parking. Never fear; there's a decent turnoff on the north side.

Notes: Chiselville got its name from a former chisel factory. To see some of the old factory housing, take the Chiselville Road, a gravel road off the road in Arlington leading to the bridge. According to Ruth M. Rasey-Simpson's book *Hand-Hewn in Old Vermont,* the town's log stringer bridge over the Roaring Branch (a branch of the Battenkill River, incidentally) almost cost a local doctor his life in 1779 during a spring torrent as he went to help Revolutionary War soldiers, and was also a great incovenience (diary: "Had 2 feet of water in the sleigh box and lost 12 lbs. tallow, entire batch for doctor's candles. Came home pretty considerable wet"). The local atheist almost died in the quicksand-like river-bottom mud when he fell in, but he was tossed a log by a local woman—only, however, after he had repeated the Apostle's Creed for her. Finally, the town sent a delegation to look at the Permanent Bridge in Philadelphia (see Introduction) and other covered bridges, and returned to recommend a Town lattice, which was built in 1841. The old doctor was the first to cross. Escaped slaves on the Underground Railroad crossed, too; in 1820, the town's voters unanimously supported a hostel for them near the bridge.

The builders painted it red. Why, visitors often ask, are so many barns and bridges painted red? Because iron ochre was a cheap pigment. Here is the recipe for that early bridge's paint: 2 qts. skim milk, buttermilk or whey; 8 oz. newly slaked lime; 6 oz. oil from ground flaxseed; 2 oz. turpentine; 1.5 lbs. pulverized ochre.

Then on October 4, 1869, a gale and downpour sent the aptly named Roaring Branch and its flood-borne wreckage crashing against the covered bridge, destroying it. Shortly afterward, local builder Daniel Oatman and the selectmen met at the ford, and he promised them, "I'll build you a bridge *there* that will *never* wash out," indicating the 40-foot cliffs near the local mill dam.

How much did covered bridges cost? In 1869, 710 pieces of cut timber, 1800 wooden pegs, 22 bunches of shingles, 140 wooden "keys" for braces, 250 pounds of nails, oil, Brandon red ochre, white lead, 60 loads of stone, blasting gunpowder, blasting damages, and Oatman's fee cost a total of $2307.31.

The new bridge's high placement let it outlast the Flood of 1927, which destroyed hundreds of Vermont covered bridges, fulfilling Oatman's promise. But in 1971 it was severely damaged when two loaded gravel trucks tried to cross at the same time. Supporting steel girders were added in 1973. The flood of trucks continues: The most recent state study says $140,000 in repairs is needed to keep snow and the bridge's own weight from collapsing it, and it urges posting the road against the heavy truck use.

5. WEST ARLINGTON BRIDGE

Other and historical names: Bridge at the Green; Arlington Green.
Municipality: Arlington.
Locality: West Arlington.
Ownership: Town.
Traffic allowed: Up to 8 tons.
Crossing: Battenkill River and unnamed road leading to River Road.
Built: 1852.
Builder: Unknown.
Type: Town lattice.
Dimensions: 80.3 feet long, 14 feet wide, 9.8 feet high at truss, 12.4 feet high at center.
Photography tips: N–S; postcard photographers climb the rocks across Route 313 and use a telephoto lens to group the bridge with the green's classic

West Arlington Bridge

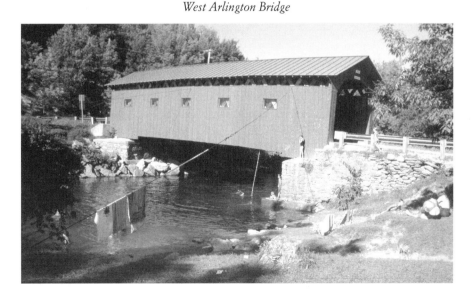

buildings; idyllic swimming hole shots are often possible in the afternoon.

Getting there: Easy. From the intersection of Routes 7A and 313, take Route 313 (Battenkill Drive) 4.2 miles. The bridge is directly by Route 313, in plain sight on the south side.

Parking: Go through the bridge to the parking lot by the Grange building on the green.

Notes: Preserved by having been bypassed, still authentic in construction, and located in a picturesque village setting, this red-painted structure is one of Vermont's best-loved and most-photographed covered bridges. The swimming hole there has been much publicized and is a regional favorite.

Winds have been a problem in this valley, as the guy wires attached to the bridge attest. Soon after the bridge was built, it was blown off its abutments into the river. (It's said that the structure was so strong that a farmer from Sandgate seeking to do business at the green rode across the river and back on the side boards.) Too heavy to be lifted back, the bridge was taken apart and rebuilt, this time with iron rods securing it to the banks.

Most of the streams crossed by Vermont's covered bridges hold trout, but the Battenkill is world famous for its large and wily denizens. Some visitors may want to wet a line just to say they once "fished the Battenkill."

Also in Bennington County

BY GOING 3.7 miles west on Route 313 from its intersection with Route 7A, or by going half a mile east on Route 313 from the West Arlington Bridge (No. 5), a traveler reaches Sandgate Road, which heads north off Route 313. Up that road 2.5 miles in Sandgate is the **Kreffer Bridge,** a privately owned plank-decked steel stringer bridge with a wooden cover spanning the Green River, built in 1977 by William and Harry Skimore to a design by Susan DePeyster. It was a gift to long-time town clerk Anne Kreffer upon her retirement, because she always wished to live on a road with a covered bridge. While not exactly authentic, it is photogenic: 33 feet long, running WNW–ESE.

II. Rutland-Area Tour

RUTLAND COUNTY'S COVERED bridges are all on Otter Creek or tributaries of it. A substantial and canoe-friendly body of water for most of its 100-mile length, and still home to otters, it was for centuries a superhighway through the forest for Native Americans—as will become clear in the discussion of the Sanderson Bridge in Brandon (No. 13). Its modern-day equivalent is Route 7. Never far from "the Creek," Route 7 is the key to reaching Rutland County's bridges: the Kingsley Bridge in Clarendon and the Brown Bridge in Shrewsbury; then the Twin Bridge in Rutland Town just to the east; then Pittsford's Gorham, Cooley, Depot, and Hammond Bridges and Brandon's Sanderson Bridge, all just to the west.

Rutland County's eight covered bridges can be seen in a day, with enough time left over for browsing in one or more nearby museums that give a rich sense of the wooden-bridge era. Take this tour on a Tuesday if possible, because that's the day the **Pittsford Historical Society Museum** (802-483-2040) is open; it's on Route 7 in the village, two buildings east of the Lothrop Elementary School. This unusually vigorous local group has materials on the town's four bridges and on Pittsford-born Nicholas Powers (see Introduction), pictures and old film footage of the Flood of 1927 that played a large role in Vermont's covered-bridge history, an interpretive display on the early-19th-century iron industry that helped finance the bridges, and more.

Other worthwhile historical sidelights include the **New England Maple Museum** (802-483-9414), also in Pittsford, on Route 7 just north of the village; and the **Vermont Marble Exhibit** (802-459-2300), 4 miles away in the center of Proctor. The **Norman Rockwell Museum** (802-773-6095) on Route 4 in Rutland, east of the city center, also gives the flavor of bygone days. Two self-guided historical tours, one for walking in Rutland and one for driving south

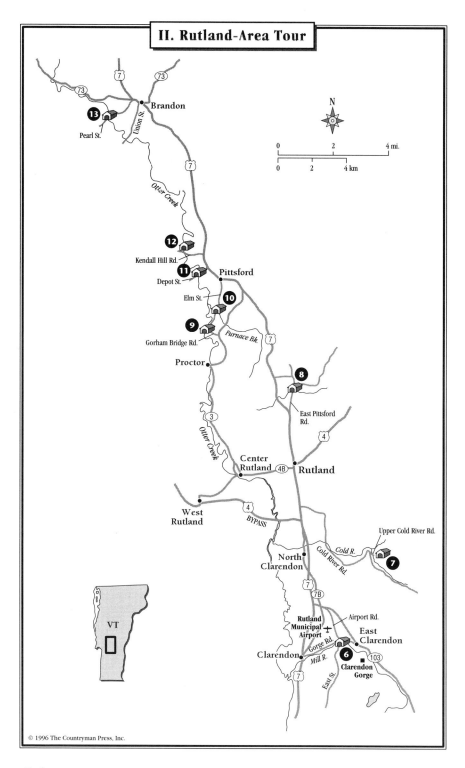

II. Rutland-Area Tour

N

| 0 | | 2 | | 4 mi. |
| 0 | 2 | | 4 km | |

73
7
73

13 Pearl St.

Brandon

Union St.

Otter Creek

7

12 Kendall Hill Rd.

11 Depot St.

Pittsford

Elm St. **10**

9 Gorham Bridge Rd.

Furnace Bk.

7

Proctor

8

East Pittsford Rd.

3

4

Otter Creek

Center Rutland 4B Rutland

West Rutland

4

BYPASS

Upper Cold River Rd.

Cold R.

Cold River Rd.

North Clarendon

7

7

7B

Rutland Municipal Airport

Airport Rd.

East Clarendon

Gorge Rd.

Clarendon **6**

Mill R.

East St.

103

Clarendon Gorge

VT

© 1996 The Countryman Press, Inc.

and west of that city, have been developed with help from the University of Vermont's historic preservation program. The area along Route 7 just south of Wallingford has been designated as an Agricultural Historical District and is particularly picturesque.

For information on these and other area attractions and facilities, the **Rutland Region Chamber of Commerce** (802-773-2747) has an information booth in Main Street Park, at the southerly junction of Routes 4 and 7. The **Brandon Chamber of Commerce** has a good booth as well, located at the easterly junction of Routes 7 and 73, by the Civil War monument. Those trying to follow the New York–Vermont Lake Champlain historic corridor while seeing bridges should not overlook the **Hubbardton Battlefield** (802-273-2282), whose displays brilliantly illuminate a successful rearguard action that, like the Battle of Bennington, ultimately helped turn the tide toward American independence.

6. KINGSLEY BRIDGE

Other and historical names: Mill River.
Municipality: Clarendon.
Locality: East Clarendon.
Ownership: Town.
Traffic allowed: Up to 3 tons; cars and light trucks only.
Crossing: Mill River and East Street.
Built: 1870.
Builder: Timothy Horton.
Type: Town lattice.
Dimensions: 120.6 feet long, 14.1 feet wide, 9.3 feet high at trusses, 12.9 high feet at center.
Photography tips: N–S; dedicated photographers may want to ask the business that owns the restored mill about streambed access, which is otherwise difficult. The mill itself is a great shot.
Getting there: Not too bad. From the junction of Routes 7 and 103 south of Rutland, go east on Route 7 for 0.3 mile to Airport Road and turn right (south). Travel 1.4 miles, past the airport, to where a closed church marks the intersection with Gorge Road. Take Gorge Road to the right (west), and the bridge is only 0.1 mile away, where East Street goes south off Gorge.
Parking: Troublesome. Don't use the nearby parking lot; the business reserves it for customers. There's a one-car turnoff where Gorge Road and East Street meet and another across the bridge on the southwest corner. The speed limit is 35 miles an hour, so be careful (a sign prohibits children playing in the bridge).
Notes: The Kingsleys, a family of millers, gave their name to the bridge and the mill. Nathaniel Crary built the first mill in East Clarendon in 1788,

Kingsley Bridge

after a town vote authorized it, but he sold out to Chester Kingsley, who also built carding and clothing-dressing mills of his own. The bridge's site, which has a waterfall nearby, saw a carding mill, a gristmill, and a sawmill rise. The existing mill was built by noted covered-bridge builder Nicholas Powers, a Clarendon resident in later life. It proved Powers's genius for sturdy construction by surviving the Flood of 1927. It operated into the 1930s, when Midwestern competition sounded the death knell. More recently, the restored structure has been a center for portable hot tub sales.

7. BROWN BRIDGE

Other and historical names: None known.
Municipality: Shrewsbury.
Locality: Between Upper Cold River and Lower Cold River.
Ownership: Town.
Traffic allowed: Up to 8 tons.
Crossing: Cold River and Upper Cold River Road.
Built: 1880.
Builder: Nicholas Powers.
Type: Town lattice.
Dimensions: 112.4 feet long, 13.3 feet wide, 8.8 feet high at truss, 11.6 feet high at center.
Photography tips: SE–NW; noon is the best time to photograph the bridge

because it's in a steep ravine; side shots with river in foreground are easy and especially good in winter.

Getting there: Tricky. The easiest way is probably to find where Cold River Road meets Route 7 on the "strip" between Route 7's intersections with Route 4 and the Route 4 bypass. A U-Haul dealership's orange rental trucks mark the corner, which is 0.8 mile north of the intersection of Route 7 and the Route 4 bypass terminus. From there, go east on Cold River Road 0.9 mile; then go right at the T-intersection. Continue 3 miles, to where Cold River Road, after shifting to the left several times, makes a wide swing to the right. Upper Cold River Road is easy to miss because it dives downward off Cold River Road, and the sign with that name is not readily visible. Look for a sign saying 8'11"—a warning that the covered bridge has less than normal clearance. Below that is a sign cautioning that the road is not maintained during the winter (it's narrow and steep once past the bridge; explore it only if you're adventurous). The bridge is only 0.2 mile down Upper Cold River Road.

Parking: There's plenty after you drive through the bridge. This is a local swimming hole in hot weather.

Notes: A secluded bridge with an "unimproved" but unimprovable river-side picnic area. This sturdy Town lattice was Nicholas Powers's last bridge, built when he was 63. Jan Lewandoski considers it Powers's finest Town lattice, due to numerous subtle details in its construction. According to longtime resident Marjorie Pierce, it was more than an access point for a few hill farms. The "settlement" of Upper Cold River was north of the bridge, and Lower Cold River was to the south, with the Brown Bridge (named for a nearby resident) as the link. North Ham (hamlet), East Ham, Shrewsbury Center, and Cuttingsville are other divisions in this long-memoried town.

8. TWIN BRIDGE

Other and historical names: None known.
Municipality: Rutland Town.
Locality: Rutland Town.
Ownership: Town.
Traffic allowed: None; off road and boarded at both ends.
Crossing: Formerly East Creek, now on dry land.
Built: 1850.
Builder: Nicholas Powers.
Type: Town lattice.
Dimensions: 60 feet long, 15 feet wide.
Photography tips: NW–SE; afternoon is best.
Getting there: The bridge is 3.6 miles from the northerly junction of Routes 7 and 4. Going north out of Rutland on Route 7, look for a rocket-ship-like black water tower on the right (east); to the left, there may be people sunbathing at the swimming hole on East Creek, near a brick hydroelectric station

Twin Bridge

building. Ahead, Route 7 swings to the left, and East Pittsford Road goes straight. Take East Pittsford Road over a hill, and as it starts to swing to the right at 0.8 mile from the junction with Route 7, look on the right (east) side for a shed only about 8 feet from the pavement. That's the Twin Bridge. If you cross the concrete-and-steel bridge, you've gone just a few yards too far (and have seen where the Twin Bridges used to be).

Parking: It's ample at the town sand and salt storage area by the shed/bridge.

Notes: Yes, you read it right: not "the twin bridges" because the other one is gone. And thereby hangs one of the great covered-bridge tales.

Nicholas Powers put up the original bridge over East Creek in 1849. The next year, he had to build another one a few feet away on the same road: The river changed course during the spring high water. If it changed back, the local selectmen were ready. "The accident proved a boon," Herbert Wheaton Congdon wrote in 1941. "The two channels have taken care of all later floods."

Would that it were so. Up in the mountains, there was a body of water called Chittenden Reservoir, used then as now to generate hydroelectric power. In 1947, the utility company, seeking to prolong the generating season, added wooden "flashboards" above the spillway gate to trap more of the spring rains. They got their wish: After 21 days of rain in May, 3.7 inches fell in the area on June 3. The water in the reservoir surged, overpowering the boards and sending a flash flood into East Pittsford Pond, a body of water a

mile or so downstream. It no longer exists: The sudden influx washed out its dam, after which the combined waters went crashing down East Creek into the valley, where they became a 15-foot wall of onrushing destructive force.

"Bridges over East Creek toppled one after another as the wave came forward," the *Rutland Herald* reported on June 5, 1947. Hundreds of homes and businesses were damaged in what the *Herald* called the worst disaster in the city's history, although no one was killed. (One tourist offered comic relief when he asked a local resident, "Is this city wet or dry?") The Twin Bridges were among the structures torn loose and sent downstream.

It's a tribute to Powers's craftsmanship that the 60-foot, 1850 Town lattice bridge was later rounded up and brought back, although not to serve as a bridge again. Today it's a storage shed for Rutland's town highway department. In a way, though, it is still a place for public notices to be posted: There's a town bulletin board at one corner.

9. GORHAM BRIDGE

Other and historical names: Goodnough.
Municipality: On Pittsford-Proctor town line.
Locality: In Pittsford, Fredetteville.
Ownership: Town.
Traffic allowed: Up to 3 tons; 11-foot, 9-inch posted clearance.
Crossing: Otter Creek and Gorham Bridge Road (in both towns).
Built: 1842 (local and Congdon; some sources say 1841).
Builder: Abraham Owen and Nicholas Powers.
Type: Town lattice.
Dimensions: 114.8 feet long, 16.7 feet wide, 9.5 feet high at trusses, 12.3 feet high at center.
Photography tips: SE–NW; great access for side shot; the afternoon gives good light for pictures with farm silo through bridge.
Getting there: Gorham Bridge Road (not necessarily marked as such) runs westerly from Route 3; it is 1.6 miles from where Route 3 intersects with Main Street in Proctor (note the marble arch bridge that carries Main Street over Otter Creek) or 1.9 miles from the intersection of Routes 3 and 7 in Pittsford (where Nicholas Powers built his first covered bridge). The bridge is 0.5 mile down Gorham Bridge Road.
Parking: There's a big space east of the bridge, where Elm Street comes into Gorham Bridge Road. Park there (pull up enough so the car won't be in pictures) because Elm Street is the route to the next bridge.
Notes: Nicholas Powers learned bridge building as Abraham Owen's apprentice, but by the 1840s they were equal partners. In 1840 they compromised on the nearby Mead Bridge (now gone) by using both a Burr arch (Powers's preference) and a Town lattice (Owen's choice). Using only the

lattice in this bridge worked well: It washed off its foundations in the Flood of 1927 but was in good enough shape to be hauled out of the water later and placed on higher abutments.

Jean Davies, the author of Pittsford's revised town history, said that according to the diary of Douglas Bates, the bridge stayed in Otter Creek until the fall of 1928, when it was partly disassembled and pulled up the west bank into a meadow. Extensive rot made it necessary to bolt new pieces onto many of the lattice planks. The bridge's side trusses were moved back over the river on a steel rope suspension bridge between trees on each bank, around January 1, 1929. The temporary bridge was removed; then the floor and roof were put on, with steel braces strengthening the roof frame and a metal roof replacing the former slate roof. Also, pilings were driven into the river so the bottom framework could be strengthened with larger timbers and so the entire bridge could be jacked up in the middle and then positioned on its abutments to give it proper camber (a slight arching bend).

The names Gorham and Goodnough came from nearby residents; the Pittsford Historical Society Museum has a portrait of Deming Gorham (1789–1861) along with a photo of the bridge after the Flood of 1927 and old films of that flood. The settlement in Pittsford near the bridge now known locally as Fredetteville was once the Goodnough District.

Gorham Bridge

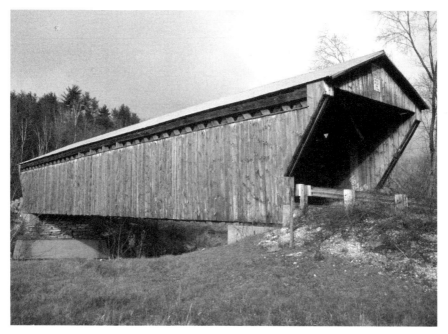

Don't miss the scythe in the tree, in front of the last house before the bridge on Gorham Bridge Road. Its owner left it in the fork of a tree too long, the tree grew around it—and there it remains.

10. COOLEY BRIDGE

Other and historical names: None known.
Municipality: Pittsford.
Locality: Pittsford.
Ownership: Town.
Traffic allowed: Up to 8 tons.
Crossing: Furnace Brook and Elm Street.
Built: 1849.
Builder: Nicholas Powers.
Type: Town lattice.
Dimensions: 50.5 feet long, 15.2 feet wide, 9.8 feet high at trusses, 12 feet high at center.
Photography tips: ENE–WSW; morning best.
Getting there: From the Gorham Bridge (see No. 9), go 0.9 mile north on Elm Street. In Pittsford, from the junction of Routes 7 and 3 go north 1 mile

Cooley Bridge

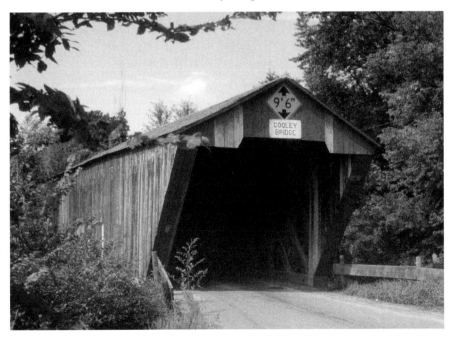

on Route 7 to where it angles right (the yellow-brick Walker Memorial Library is nearby), and make a sharp left onto Elm Street. If you were coming south on Route 7 and continued straight ahead, that would be Elm Street. The bridge is 1.2 miles south on Elm. (Elm Street is also known locally as Bridge Street.)

Parking: An ample turnoff is on the Pittsford village side of the bridge (drive through coming from the Gorham Bridge).

Notes: This red-painted shortie with its distinctive overhanging gables is one of Vermont's most photographed bridges. It's been described as a misplaced Conestoga wagon, which it indeed resembles.

The former Cooley house is nearby, on the north side of Elm Street. Benjamin Cooley, a town founder, was among the soldiers of the Revolutionary War who came along the Crown Point Road to reach Mount Independence and Fort Ticonderoga on Lake Champlain via a military road cut through the wilderness in 1759–60 during the French and Indian War. Looking from a hill at the land to the north, he vowed to return and did, like many downstate ex-soldiers hungry for land. A marker for the Crown Point Road (of which few traces remain) can be found 0.1 mile southwest of the Gorham Bridge.

This bridge preserves the full text of an old stenciled advertisement whose address is often obliterated on other bridges, presumably to stop the flood of mail after the offer expired: "Free illustrated booklet *Covered Bridges,* Box 12, Jennington, Pa. 19046."

11. DEPOT BRIDGE

Other and historical names: None known.
Municipality: Pittsford.
Locality: Otter Creek divides Pittsford from Florence.
Ownership: Town.
Traffic allowed: Up to 8 tons.
Crossing: Otter Creek and Depot Road.
Built: 1840.
Builder: Unknown.
Type: Town lattice.
Dimensions: 121 feet long, 15.2 feet wide, 11.1 feet high at trusses, 12.1 feet high at center.
Photography tips: ENE–WSW; trees complicate the side shot unless done on a cloudy day from the north.
Getting there: Heading north on Route 7 out of Pittsford, from the yellow-brick Walker Memorial Library go 0.2 mile to Depot Road on the left, which goes west between a convenience store and a branch bank. The bridge is 0.7 mile along Depot Road.
Parking: There are two adequate car turnoffs west of the bridge, one close

(on the eastbound shoulder) and one within easy walking distance (the entrance to the farm road on the westbound shoulder).

Notes: The railroad came after the bridge, but the latter soon took its name from the railroad station once located near the present town transfer station (the latter being for waste and recyclables, not people).

The original bridge is now supported by steel I beams, part of the third major repair job in its history. It is braced against winds by—appropriately enough—a railroad rail, added by Samuel Carrara during the second set of repairs in 1974. The Town lattice's main weakness was always its susceptibility to lateral wind pressure, especially if local builders didn't use adequate bracing or if vehicles knocked out upper diagonals. Carrara had to put a concrete post in a nearby meadow and pull the bridge into a more upright position.

The Depot Bridge's somewhat out of the way location has allowed several old advertisements to remain at least partly legible.

12. HAMMOND BRIDGE

Other and historical names: None known.
Municipality: Pittsford.
Locality: Otter Creek divides Pittsford from Florence.
Ownership: Vermont Division for Historic Preservation.
Traffic allowed: None; bypassed and closed off.
Crossing: Otter Creek, next to Kendall Hill Road.
Built: 1842 (some sources say 1843).
Builder: Asa Nourse.
Type: Town lattice.
Dimensions: 139 feet long.
Photography tips: E–W; the shot from the truck route bypass bridge is sensational—but not so getting bypassed by trucks going to and from the OMYA marble grinding plant in Florence (whose steam plumes can be seen from Route 7). Be very, very careful.
Getting there: From the Walker Memorial Library on Route 7 in Pittsford (see No. 11), go 1.1 miles north to Kendall Hill Road, more commonly known as "the truck route" (and marked by highway signs as such), and turn left. Take that road 0.3 mile to the Hammond Bridge.
Parking: You'll find a large parking lot dedicated to bridge use.
Notes: This is a lovely site, with good streamside access. Fiddlehead ferns—wild edibles that are a Vermont tradition—grow nearby and are at the fiddlehead-shaped edible stage early in May. Walk through the bridge to take a path north to where early farmers built Fort Mott, a stockade partly protected by a U-shaped bend in Otter Creek, or a path south to the ford that preceded the bridges. The town took its name from that ford and from the fact that

General Jeffery Amherst, who ordered the building of the 1759–60 Crown Point Road that went through Pittsford, was an admirer of British statesman William Pitt (1708–1778). The Hammond Bridge got its name from a family living nearby.

Like the Gorham Bridge (see No. 9), this bridge was rescued from the Flood of 1927. Unlike its fellow traveler, the Hammond Bridge fetched up more than a mile away, onto land owned by Edward Pomainville Sr. Local engineer James Tennien thought of a way to retrieve it and got a contract to do so. While the waters were still high, he put metal drums underneath it, pumped in air, and got it afloat. It was pulled back upstream by horses, including some owned by Pomainville. In local historian Jean Davies's new town history, Pomainville is quoted as recalling, "They got it up and all ready to put into place, and the river came up again and floated it off, so they had to do it all over again, and get it back. Jim was noted for having a very short temper. There was a 'sidewalk superintendent' who was giving him a lot of suggestions, whereupon he told him that if he heard another word out of his mouth, he was going to knock him in the river. The guy said something like, 'Well, I was only trying to help'—and found himself in the river." Finally, the bridge was lowered into place by letting water back into the barrels.

For a written re-creation of the Revolutionary War events that took place in the vicinity of the Hammond Bridge, stop at the **Pittsford Historical Society**

Hammond Bridge

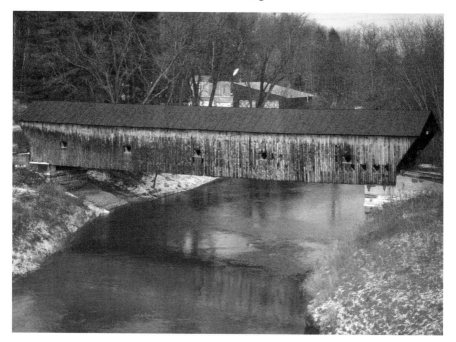

Museum (on Route 7 in the village, two houses east of the Lothrop Elementary School), which is highly recommended in any case. Among the historical publications they sell is local author Grace Anderson's novel, *In the Shadow of Cox Mountain,* that being the domed-shaped elevation visible to the northeast.

13. SANDERSON BRIDGE

Other and historical names: Upper.
Municipality: Brandon.
Locality: Brandon.
Ownership: Town.
Traffic allowed: Closed to all but pedestrians, possibly permanently.
Crossing: Otter Creek and Pearl Street Extension.
Built: About 1840.
Builder: Unknown.
Type: Town lattice.
Dimensions: 132 feet long, 16 feet wide, 9.7 feet high at trusses, 12.6 feet high at center.
Photography tips: E–W; morning is best because of trees to the west.
Getting there: Brandon has two junctions of Routes 7 and 73. The eastern junction has a Civil War monument, a park nearby, and a useful chamber of commerce information booth. Near the western junction, 0.3 mile away, is a small shopping plaza with the local post office. From this junction, go left (south) on Pearl Street, continuing to the right when the road forks after crossing over the railroad. The bridge is 1.3 miles from Route 7.
Parking: There's plenty of room on the east side. Avoid parking on the west side and disturbing residents there.
Notes: Named for the Sanderson family, who had a farm there from the early years of the town, this bridge won temporary fame when it appeared in *National Geographic* magazine for July 1974 in an Ethel Starbird article, "Vermont: A State of Mind and Mountains." They should have sent Robert Kincaid. The picture comes with the misinformed statement: "Practical as the Model A chugging across it, this covered bridge at Brandon was put up to keep snow off, not to bring skiers and sightseers in." Actually, old town histories often have budget entries for "snowing" the covered bridges—dumping and shoveling snow *inside* so sleighs could cross.

More recently, the Sanderson Bridge made headlines when its environs turned out to be a major archaeological site. After the covered bridge was closed in 1987 (a temporary steel stringer bridge was placed beside it), the town voted for a concrete-and-steel bridge at a new crossing point, leaving the old bridge to be restored for pedestrian use. Vermont requires an archaeological study before work is done in a potentially sensitive area, and Otter Creek was the old "Indian road," so in 1993 the University of Vermont dug sample pits where the roadway to the new bridge would go.

Sanderson Bridge

In archaeological terms, they struck it rich. To the east of the bridge, they found Woodland Indian remains from around 400 A.D.; to the west, beneath the Sandersons' lawn, remains dating back 5000 years were discovered. On the east side, they found Mistassini quartzite from Canada and Kineo felsite from Maine, evidence of early trading. They found remains of old posts, perhaps indicating a building from a more permanent Woodland settlement— an unprecedented find for Vermont. Otter Creek's annual flooding had left several zones intact; as one state archaeologist put it, "You could find footprints."

The discoveries led to a debate over whether to pay up to $250,000 to study the remains, to "preserve" them by burying them and building the road—or to use the old, already approved road by restoring the Sanderson Bridge to carry traffic again. A cost analysis found the covered-bridge option to be the cheapest on an annualized basis, but the board of selectmen voted 4–1 to put only a concrete-and-steel bridge up for a public vote. However, a special Town Meeting voted down that proposal, leaving open the possibility that the covered bridge will again carry traffic—perhaps as early as 1997.

III. Lake Champlain Valley Tour

ORTH OF BRANDON, the Taconic Mountains end and the
Champlain Valley begins. While Route 7 remains the central artery
for bridge trekkers, the bridges are more widely dispersed. The
reward is that they are more varied in structure than those in Rutland County,
which are all Town lattices.

The Champlain Valley, as it is commonly known, is occasionally dubbed
"the Great Plains of Vermont." It is geologically and climatically different
from the rest of the state. Endowed with rich clay and loam soils, and warmed
somewhat by Lake Champlain (sometimes called "the sixth Great Lake"), the
valley, in the heyday of covered bridges, was one of New England's main
sources of grain and produce. There was not the same concentration of
bridges as in mountain country, with its many streams and ravines, but there
was a strong need for good bridges so producers could reach markets or ship-
ping points, a need that continued into the dairying era, which by the late 19th
century had replaced sheep farming.

Lovers of timber-frame buildings will find many fine barns to admire while
driving through the region. The finest—not yet open to the public—is a 107-
by-418-foot behemoth on Shelburne Farms that includes a 375-by-85-foot
show ring and room for 100 horses and 300 tons of hay. (Like the Howe truss,
it made use of metal members to overcome weaknesses in the wooden frame.)
The county's other phenomenal example of timber framing is the 1809 steeple
of Middlebury's **Congregational church,** which has survived hurricanes
because five independent sections, nesting one within the other, form the
spire.

The five bridges of Addison County (in the towns of Shoreham, Cornwall-
Salisbury, Middlebury, and Ferrisburgh) and the four in Chittenden County

III. Lake Champlain Valley Tour

N

Lake Champlain

22 • Shelburne

7

21

Lake Rd.

Charlotte •

Hollow Rd.

20

Spear St.

Thompson's Point Rd.

Roscoe Rd.

Lewis Creek Rd.

19

18 • North Ferrisburgh

• Ferrisburgh

Vergennes •

7

Otter Creek

New Haven River

River Rd.

17

Halpin Rd.

Muddy Branch

Happy Valley Rd.

Washington St.

16 • Middlebury

Cornwall •

30

Otter Creek

• Salisbury

Swamp Rd.

15

Lemon Fair River

Whiting Rd.

Shoreham Center •

14 • Whiting

Richville Pond

73

• Brandon

7

• Sudbury

30

73

| 0 | 3 | 6 mi. |
| 0 | 3 | 6 km |

VT

(in the towns of Shelburne and Charlotte) described in this tour are close to interpretive resources that could occupy a week's time to explore fully. The **Shelburne Museum** (802-965-3346), in Shelburne, funded with part of a railroad baron's fortune, is world class, with stunning collections of old tools and housewares that most people don't even know exist, transplanted historic buildings, the former Lake Champlain steamboat *Ticonderoga,* and numerous special exhibitions each summer—the list could go on and on.

In Middlebury, the **Sheldon Museum** (802-388-2117) preserves a 19th-century household, has a research collection, and acts as a focal point for the downtown Middlebury historic walking tour. Nearby, the **Vermont State Craft Center** at Frog Hollow (802-388-3177) will give an eye-opening view of what has happened to the tradition of craftsmanship that helped the covered bridges last so long. The **Vermont Folklife Center** (802-388-4964), on Middlebury's Court Square in the basement of the Painter House, features folk art, has materials on such Vermontiana as country stores and storytelling, and houses a huge collection of taped and sometimes transcribed interviews with older Vermonters—this last a great way to get the flavor of bygone times. In Ferrisburgh, the **Rokeby Museum** (802-877-3406) displays a highly creative 19th-century Quaker family's way of life, which was preserved intact (the family started the nonprofit foundation) in a setting with unique charm and resonance. Five generations of the noted Strong family are evoked at the **John Strong D.A.R. Mansion** in West Addison (802-759-2309). Downtown Vergennes, centered on its historic waterfall area, is also worth a visit.

That would be plenty, but remember, this is the historic Lake Champlain corridor. Those following the trail of battle sites along Lake Champlain can stop and avail themselves of the **Mount Independence Revolutionary War Historic Site** in Orwell; Fort Ticonderoga, across the lake (there's a ferry at nearby Larrabee's Point; call 802-897-7999); the **Chimney Point Historic Site** (802-759-2412) in Addison; the Crown Point fort remains and museum across the bridge in New York; and the **Lake Champlain Maritime Museum** (802-475-2022) at Basin Harbor in Ferrisburgh.

It is common for Vermont towns to have historical societies and increasingly common for them to have museums. But nowhere else in the state is there such an emphasis on what has been called "heritage tourism."

14. SHOREHAM COVERED RAILROAD BRIDGE

Other and historical names: East Shoreham Covered Railroad; Rutland Railroad.

Municipality: Shoreham.

Locality: East Shoreham.

Ownership: State Division for Historic Preservation.

Traffic allowed: None possible; located on an abandoned railroad bed, now a hiking trail.

Crossing: Richville Pond (an impoundment of the Lemon Fair River) and the former Addison Branch of the Rutland Railroad.

Built: 1897.

Builder: Rutland Railroad Company; comprehensive restoration for historic preservation by Vermont Structures, Inc., of Middlebury in 1983.

Type: Howe.

Dimensions: 109 feet long, 20 feet wide, 13.5-foot opening for track.

Photography tips: E–W; fairly easy access beneath the bridge unless high water.

Getting there: From the northern intersection of Routes 30 and 73 in Sudbury, go 2.7 miles north on Route 30 to the crossroads in Whiting village (the post office is on the southwest corner). Go left (west) on Shoreham Road, which soon becomes Whiting Road in Shoreham (welcome to Vermont). Observe that at 0.3 mile, a farm road to the right uses part of the old Addison Branch railroad bed. At 2.8 miles, at the top of the hill past a large farm, a sign indicates "E. Shoram" Road on the left (south). Take it 0.7 mile to the Vermont Department of Fish and Wildlife Richville Access Area.

Parking: Ample unless it's early spring and the bullhead are running.

Notes: This rural, secluded, and scenic site is one of Vermont's gems. The Lemon Fair (the name apparently adapted from the French phrase for "makes mud") is too murky for swimming but attracts many with its good fishing, hunting, and wildlife viewing. For those visitors, the presence of one of Vermont's two surviving railroad bridges (not counting one moved to a tourist attraction in New Hampshire) is only a side benefit. But this rare bridge, little altered in form, is a major monument both for bridge lovers and railroad buffs.

Not in use since 1951, it was meticulously restored—new roof, new siding, new eastern abutment—in 1983, with a plank walkway replacing the rails. Its history illustrates the relationship between covered bridges and railroads, which not only made good use of the Howe truss into the 20th century but also concentrated heavy freight traffic in a way that supported the use of wooden bridges generally.

In the days of rapid railroad growth following the Civil War, the 15.6-mile Addison Branch was a pawn in a chess game between ambitious railroad magnates. John B. Page of the Rutland Railroad leased tracks and put a steam-

Shoreham Covered Railroad Bridge

boat on Lake Champlain with the obvious intention of circumventing J. Gregory Smith and the Vermont Central Railroad, which had hitherto blocked any competitor's access to the lucrative traffic with the Great Lakes region. In 1871, Smith caved in, offering to lease the incipient rail spur for an exorbitant $376,000 per year. He completed the east–west link with the Delaware & Hudson at Ticonderoga, New York, by adding a floating bridge on Lake Champlain. This masterpiece of wooden construction included a 300-foot section that could be swung open to allow steamboat lines—competitors of the railroads—to send goods down the lake and, ultimately, to the Hudson River, Erie Canal, and Great Lakes.

Smith's complicated and accident-prone construction off Larrabee's Point in Shoreham stayed more or less operational until 1923. But even before that, the Addison Branch had for the most part given up pretensions of being a main route and had settled into routines typical of life around covered bridges in many parts of Vermont. Cans of milk went to small creameries at Whiting, North Orwell, the Hough's Crossing section of Orwell, and Larrabee's Point, and their cheese, butter, and other products were shipped out. Sheep farmers sent wool to mills. Hay, livestock, and farm equipment were transported about. Goods special-ordered from the city arrived, along with the daily mail, whose delivery was a significant event in places like Leicester Junction and East Shoreham. In the rail spur's final years, the run was so boring that the old steam engine consigned to the rural route once slowed down and stopped because the engineer, who had been put out to pasture himself on the undemanding line, had fallen asleep. The end of World War II gas rationing, highway improvements, and the consequent arrival of the trucking era spelled the end for the Addison Branch, its small milk plants, and, ultimately, for many of Vermont's one-lane wooden bridges.

Vermont's iron bridges are considered important historic resources as well, and are also endangered. As of 1995, the metal bridge formerly within sight of the wooden railroad bridge was in rusted pieces by the fishing access, having been replaced by a new metal bridge several years previously.

15. CORNWALL-SALISBURY BRIDGE
(in Cornwall)
Salisbury-Cornwall Bridge (in Salisbury)

Other and historical names: Creek Road; Cedar Swamp; Salisbury Station; Station.

Municipality: Cornwall-Salisbury border.

Locality: Near Salisbury Station.

Ownership: Towns.

Traffic allowed: Up to 3 tons, 10-foot height.

Crossing: Otter Creek and Swamp Road (Cornwall) and Creek Road (Salisbury).

Built: 1865; center pier added in 1970.

Builder: Unknown.

Type: Town lattice.

Dimensions: Two 76.8-foot spans, 14.2 feet wide, 10.2 feet high at trusses, 13.2 feet high at center.

Photography tips: E–W; farm fields allow side shots, but there are lots of trees.

Getting there: From Cornwall, go south on Route 30 to Swamp Road, 3.9 miles south of the Cornwall fire station—where the Williams Farm has a maple sugar house at the northeast corner of the crossroads. Go left (east) 1.8 miles to the bridge.

Parking: An ample lot is off the road by the river, apparently also a fishing access.

Notes: See No. 14 for a description of how covered bridges often worked in tandem with railroads. This, too, was a bridge giving farmers access to markets, as the earlier name Station Bridge implies. Truck traffic now has the town looking at $140,000 in repairs, according to a 1993 state study, to beef up the bridge's flooring (the lattices could still do the job). Few traces remain of its original paint; the portals are said to have been bright yellow trimmed with red.

Within walking distance is the place where pioneer widow Ann Story brought her family through the Indian raids of the Revolutionary War by digging a hideout in the banks of Otter Creek and living there.

16. PULP MILL BRIDGE

Other and historical names: Paper Mill.

Municipality: Otter Creek is Middlebury-Weybridge boundary.

Locality: Middlebury and Weybridge.

Ownership: Towns.

Traffic allowed: Up to 4 tons, 8-foot height; turn on lights; two lanes.

Crossing: Otter Creek and Seymour Street Extension.

Built: 1808–1820; laminated arch added to beam arch about 1860.

Builder: Unknown, for Waltham Turnpike Company; laminated arch added by Deacon David E. Boyce.

Type: Burr arch.

Dimensions: Three spans; 199 feet long, 9.1 feet wide eastbound, 8.5 feet westbound, 8.1 feet high at truss, 10.1 feet high at center.

Photography tips: Nearly E–W; the classic shot is from the west in the mid- to late afternoon, including traffic island flowers in the view; side views are problematic.

Getting there: From the junction of Routes 7 and 125 in Middlebury just north of the Court Square rotary (by the Congregational church), go 0.3 mile north on Route 7 to a crossroads where Elm Street goes left (look for the HISTORIC MARBLE WORKS sign). Take Elm Street 0.2 mile under the railroad, to a T-intersection. Marble works are to the left. Go right on Seymour Street 0.6 mile to the bridge.

Parking: Turnoffs to the east of the bridge are for private use. Go through the bridge, turn right, and almost immediately turn off the road and stop in front of a locked gate. Behind the gate is a Central Vermont Public Service recreation site within easy walking distance of the bridge. A CVPS spokesperson said the gate is only there to prevent vehicles from tearing up the grass; the facility is intended for public picnicking and access to Otter Creek (a hydroelectric dam is just downstream from the bridge).

Pulp Mill Bridge

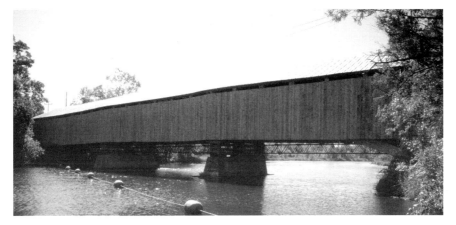

Notes: This is generally agreed to be Vermont's oldest covered bridge, although the evidence is indirect: An 1808 state legislature measure related to the Waltham Turnpike Company makes mention of "their bridge by the paper mill on the Otter Creek, which bridge has been lately erected and may stand a number of years . . ." The company was authorized to collect tolls when they "shall have covered and put a railing on said bridge." The act further states that "a bridge shall be erected . . . within twelve years from the passing of this act." This suggests that a simpler bridge was replaced with a covered bridge by 1820, using the Burr truss popular before the Town lattice was patented in 1820. Generally speaking, any Vermont bridge dating before 1839 is quite old, since major floods in 1830, 1832, and 1839 destroyed many earlier efforts.

According to present-day covered-bridge builder Jan Lewandoski, the original design was deficient from the start for such a long, wide bridge. This was commonly recognized by midcentury, when Deacon David E. Boyce, whose family built several now lost bridges in the area, thought of bending 10 layers of planks and bolting them together over the first arch and attaching them to the multiple kingpost frame. He used the same technique to save the town's other Burr arch bridge, the 1836 Three Mile Bridge, later the victim of arson.

Today, the Pulp Mill Bridge is one of only seven two-lane covered bridges in the country, according to the recent state covered-bridge study. The Shelburne Museum Bridge (see No. 22) is Vermont's other example. The Pulp Mill Bridge underwent extensive repairs in 1980, and lately the town has been seeking federal highway corridor enhancement funds to add an adjacent pedestrian walkway.

Those seeking insight into the horse-and-buggy era, which made the greatest use of covered bridges, can do no better than to go through the Pulp Mill Bridge, turn right, and go 1.2 miles to the **University of Vermont's Morgan Horse Farm**—dedicated to Vermont's famous Morgan horse breed—a popular visitors' attraction.

17. HALPIN BRIDGE

Other and historical names: High.
Municipality: Middlebury.
Locality: Middlebury.
Ownership: Town.
Traffic allowed: Up to 2 tons, as of 1995; a state study says this is an illegal posting, 3 tons being the minimum according to the Federal Highway Administration; a 1994 reconstruction made an 8-ton limit feasible.
Crossing: Muddy Branch (of New Haven River) and Halpin Road.
Built: 1824.
Builder: Unknown.
Type: Town lattice.

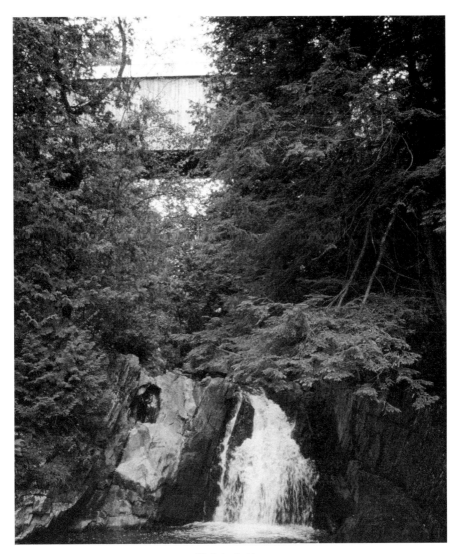

Halpin Bridge

Dimensions: 66.2 feet long, 12.1 feet wide, 10.1 feet high at truss, 11.4 feet high at center.

Photography tips: W–E; afternoon is the best time to take pictures because of the layout and the east side being Halpin family property. Ask at the farmhouse about access to the spot where postcard photographers have shot the bridge from below (serious photographers only, please).

Getting there: Tricky. The central reference point is a back-road street junction not far from the bridge, where Washington Street Extension is running roughly east–west and two roads go north from it: Happy Valley Road and Halpin Road. These two roads are separated by only one house on Washington

Street; Happy Valley Road starts to the west of the house, and Halpin Road to the east. Each of these three roads offers a way to the bridge. From downtown Middlebury, Washington Street goes roughly northeast off the Court Square traffic rotary. Go 0.3 mile to a five-way meeting of streets, and continue straight across (ignoring one road to the right and two to the left) to Washington Street Extension. After 1.1 miles, turn left onto Halpin Road. Go 1.5 miles north and then turn right (east) and go another quarter mile, also on Halpin Road.

Happy Valley Road's northern terminus is just north of the village area of Middlebury, at the foot of a hill, opposite Exchange Street (which goes west and ends at Elm Street, the road to the Pulp Mill Bridge—see No. 16).

Parking: The area dedicated to bridge visitors is on the west side. Don't go through the bridge unless you need to talk to the Halpin family about streambed access.

Notes: At 41 feet over the stream, this is Vermont's highest covered bridge, beating out the Chiselville Bridge (see No. 4) by a foot. Now serving only the Halpin family farm, it was originally built to help one of the state's earliest marble excavations—the Halpin quarry at Marble Ledge—bring wagonloads of marble to downtown Middlebury, where the waterfall drove marble-cutting saws. In midcentury, there was a rail spur to Halpin Road, traces of which can still be seen.

The bridge's authentic form has been preserved, with minor repairs in the 1960s and a complete overhaul by Jan Lewandoski in 1994. For the latter, the bridge was taken off its abutments (which needed reconstruction) with a crane; the chance of workmen falling to their deaths had apparently been a deterrent to local maintenance in the past, Lewandoski said. When the time came to swing the rebuilt bridge back into place, there was a near fiasco: The engineers who built the new concrete abutments had not measured them properly. The bridge barely fit, with a gap on the east end so large that a neighbor said he put a sheet of plywood over it that night to keep some child from falling through. Now an iron plate covers that gap, but it's easy to see how close one corner of the bridge came to not fitting on its side of the east abutment. The new design prevents water flowing from the road onto the bridge—a fault all too common as towns keep adding gravel to back roads, Lewandoski said.

18. SPADE FARM BRIDGE

Other and historical names: Old Hollow.
Municipality: Ferrisburgh.
Locality: North Ferrisburgh.
Ownership: Private.
Traffic allowed: None possible; bridge is off road.
Crossing: Was moved to span small farm pond.

Built: Sign on bridge says 1824; Richard Sanders Allen says 1850s more probable.

Builder: Justin Miller.

Type: Town lattice.

Dimensions: 85 feet long.

Photography tips: NNE–SSW; morning best because of trees.

Getting there: Not hard, since it's about 100 feet from Route 7, on the west side. From the north, it's 1.5 miles south of the Hollow Road intersection in North Ferrisburgh (see No. 19). From the south, it's 1.1 miles past the Rokeby historical site, which is on the east (left) side of Route 7 with a sign and a historical marker.

Parking: Driveway; ask at the house for permission to visit.

Notes: To visit the bridge's original location, go east on Hollow Road, which meets Route 7 next to the North Ferrisburgh Post Office, and drive a short distance to the concrete-and-steel bridge. A former owner of the bridge said old-timers who used to live nearby and stopped to see it again recalled the way its placement at the base of a hill made it a death-defying thrill to come down the slope on their bicycles and zoom through. She also said the big kids loved to use it as an ambush point to jump down and scare the little kids.

When the old bridge was replaced and slated for dismantling in 1958, local dairyman Sam Spade had it moved to his farm to save it. Although in poor repair for lack of state aid, which only applies to highway bridges, this structure is still a veritable museum of the old advertising posters, metal signs, stenciling, and so on that were common in days of slower travel. No other covered bridge in the state comes close to comparing with it in this respect.

The former owner described another death-defying incident that occurred in 1988. When her family came to the Spade Farm, something started killing their ducks, but they couldn't figure out what it was. Then one day she came out of the house, looked into the bridge, and in the roof bracing saw the culprit: a big cat "as big as a golden retriever, with a lot of hair on it. The first thing I could grab was a two-by-four, and I went after it. It never came back." This might have been a catamount sighted several times in a neighboring town at the same period. "I was told by local inhabitants of the area not to do that again," the woman said.

While she owned the bridge, she kept a bench in the middle of the span, and urged visitors to sit there. "It's a very peaceful bridge," she said. "It always talks to you. You always feel the presence of people, feel them speak to you. It's a good feeling, a nice feeling." Those words could apply to many of Vermont's historic covered bridges.

19. QUINLAN BRIDGE

Other and historical names: Lower.

Municipality: Charlotte.

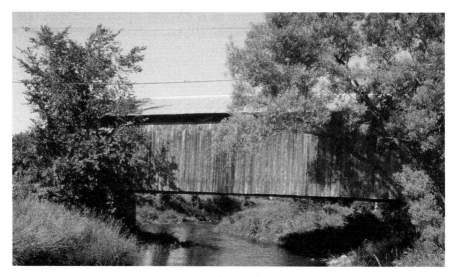

Quinlan Bridge

Locality: East Charlotte.
Ownership: Town.
Traffic allowed: Up to 5 tons.
Crossing: Lewis Creek and Lewis Creek Road.
Built: 1849.
Builder: Unknown.
Type: Multiple kingpost with Burr arch.
Dimensions: 86 feet long, 13 feet wide, 9.4 feet high at trusses, 11 feet high at center.
Photography tips: NNW–SSE; farm fields allow good side shots in the afternoon.
Getting there: From Route 7 in North Ferrisburgh, go right (east) onto Hollow Road at the crossroads where the North Ferrisburgh Post Office is on the southwest corner. (From the north, it's 1.3 miles south of the road to Mount Philo State Park, which goes east off Route 7.) After 0.3 mile, turn left onto Mount Philo Road. Go 0.5 mile, then bear right onto Spear Street Extension. The Quinlan Bridge is 2.1 miles farther on, less than 100 feet from Spear Street Extension, at the beginning of Lewis Creek Road.
Parking: The large, triangular connection between the two roads north of the bridge is suitable for shoulder parking. Less than 0.1 mile farther along Spear Street Extension is a much used riverside turnoff.
Notes: The unknown builder of this bridge probably built the Upper (upstream, that is) Bridge as well, to guess by the similarity of the truss design. Repaired in recent years, it is now supported by two steel beams.

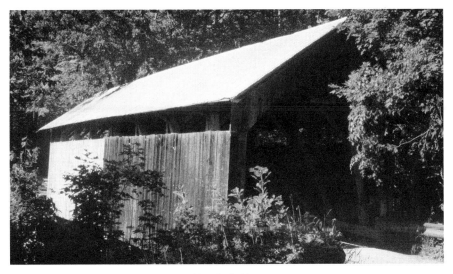

Sequin Bridge

20. SEQUIN BRIDGE

Other and historical names: Seguin (from which current common name was derived by usage); Upper; Brown's.

Municipality: Charlotte.

Locality: East Charlotte.

Ownership: Town.

Traffic allowed: Up to 5 tons.

Crossing: Lewis Creek and Roscoe Road.

Built: 1850; considerable authentic-style repair work done in 1994.

Builder: Unknown.

Type: Multiple kingpost with Burr arch.

Dimensions: 70.6 feet long, 13 feet wide, 9 feet high at trusses, 12 feet high at center.

Photography tips: S–N; early to midafternoon best because of trees.

Getting there: From Route 7 in North Ferrisburgh, go to and through the Quinlan Bridge (see No. 19). At the intersection immediately after the bridge, go left (east) on Lewis Creek Road (not marked as such). Go 1.6 miles to a T-intersection with Roscoe Road. Turn left (north) and go 1.1 miles to the bridge.

Parking: A decent turnoff is on the south side of the bridge. Cars travel this road fairly fast, so be careful inside the bridge.

Notes: A fairly secluded location for a well-maintained and well-preserved bridge. In the mid- to late afternoon, sunlight coming through cracks in the siding makes truly spectacular patterns that will be an enduring memory.

21. HOLMES OR HOLMES CREEK BRIDGE

Other and historical names: Lakeshore.
Municipality: Charlotte.
Locality: West Charlotte.
Ownership: Town.
Traffic allowed: Up to 5 tons, no trucks.
Crossing: Holmes Creek and Lake Road.
Built: 1870.
Builder: Unknown.
Type: Kingpost with tied arch.
Dimensions: 40.5 feet long, 11.6 feet wide, 8.5 feet high at trusses, 11.5 feet high at center.

Photography tips: SW–NE; midafternoon and later are best for side shots (trees, private property); late morning and later are good for shots to include Lake Champlain.

Getting there: From Route 7 in Charlotte, find the crossroads with Route F–5, known locally as Ferry Road; this is the road to the Essex Ferry to New York, as signs will indicate. Go left (west) on Ferry Road over a ridge 1.3 miles to the intersection with Lake Road. (You might want to stop at the general store there if you like vistas, because the view of Lake Champlain and the

Holmes Bridge

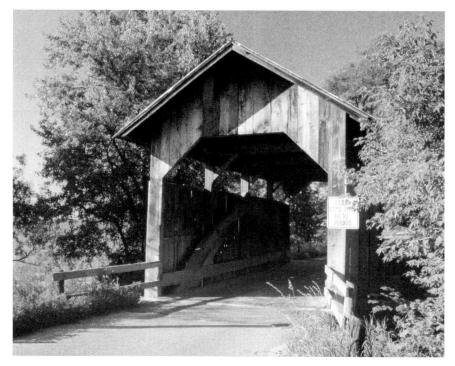

Adirondacks from the ridge is surprisingly comprehensive.) Take Lake Road right (north), 1.8 miles to the bridge.

Parking: The unique lakeside setting of this bridge makes it very attractive—and a pain to park near. The town pays taxes to maintain a municipal swimming and recreation area just beyond the bridge and doesn't want people parking by the lake and dodging the fee, so the usual turnoff spaces are blocked. It costs $2 to park at the recreation area ($4 to swim), although in the off-season parking is free. There's a ball field north of the bridge where parking is free, but that means walking nearly a quarter mile downhill, then uphill. A nearby business owner said many people just park illegally by the roadside, snap a picture, and go, although this isn't recommended. It's a nice place to go swimming.

Notes: Graton Associates redid this bridge in 1994, which now has one new 7–layer laminated arch. The Lake Road was the first road in Charlotte, and the existing bridge replaced an earlier bridge, according to local historian Frank Thornton. It has the distinction not only of being one of Vermont's shortest covered bridges, but also of being at the lowest elevation; Lake Champlain's water level hovers around 100 feet above sea level.

22. SHELBURNE MUSEUM BRIDGE

Other and historical names: Cambridge.
Municipality: Shelburne.
Locality: Shelburne.
Ownership: The Shelburne Museum.
Traffic allowed: Museum and emergency vehicles only.
Crossing: Originally the Lamoille River in Waterville, now a pond excavated by the museum.
Built: 1845.
Builder: Some sources say Farewell Weatherby, but Shelburne Museum researchers believe Weatherby was only someone closely associated with the project. An annotated picture points to George William Holmes, a Waterville-area contractor and barn builder, as the designer and crew boss.
Type: Burr arch.
Dimensions: 168 feet long; one of only two double-lane bridges in Vermont (see No. 16).
Photography tips: E–W; morning best due to surrounding trees and placement as former museum entrance. Bring flash for shots of antique carriages stored inside.
Getting there: Easy, since the bridge is perhaps 50 feet to the west of Route 7 in the village area of Shelburne. Look for signs for the Shelburne Museum, then for the bridge, which is highly visible.
Parking: Museum visitors enter the grounds at the top of the Route 7 hill just south of the bridge. Short-term visitors can pull off on the wide Route 7

shoulders here or can stop as customers of nearby businesses. If you have time, visit this incomparable museum.

Notes: Called the Cambridge Bridge because it was built on a road leading to that town (and, in an unusual gesture, with Cambridge's financial help), it gave Waterville better access to the newly built railroad station at Cambridge Junction. In the late 1940s, the Shelburne Museum asked the state highway department to help find a bridge worth preserving. A project using dynamite to change the course of the Lamoille River and create a new crossing gave the museum a choice of two bypassed covered bridges to preserve. One was deemed too small and ordinary to represent the state's bridges, but the "double-barrelled" bridge with its walkway was too much to resist, although no one could find a precedent for moving a bridge of its size. After a search, they hired Brackett and Warren Hill of Tilton, New Hampshire, to dismantle and reassemble the bridge in Shelburne under the supervision of University of Vermont engineering professor Reginald V. Millbank. Moving the 165-ton structure 36 miles and installing it took from September 1950 to March 1951 and involved putting "falsework" supports under the bridge when both taking it apart and putting it back together. (The numbers painted on the timbers to guide reassembly are still visible.) Rotted sections were replaced in the timbers, some of which are 14 square inches and 54 feet long. When the falsework was removed at the museum, this classic of old-time construction settled only about a quarter inch. It served as the museum entrance until the early 1970s, when the threat from traffic stresses prompted construction of a new entrance on the hill to the south.

Shelburne Museum Bridge

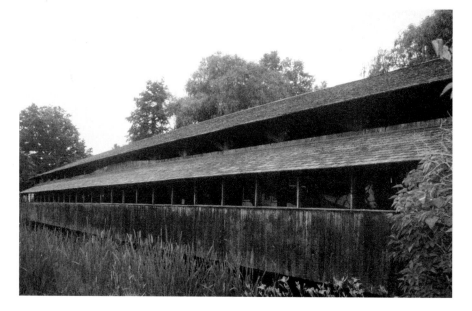

IV. Northwestern Vermont Tour

CHITTENDEN COUNTY IS in US Census terms Vermont's only urban area, a booming region with an increasingly wide-ranging influence. Lakeside Franklin County is, like Addison County, one of Vermont's great farming regions. Lamoille County to the east sees the transition into true Green Mountain territory.

The covered bridges are concentrated in the middle of this corner of the state. While it is possible to reach them via Routes 15 and 128, a drive that picks up a nice local historical museum in a restored mill in Jericho, Route 15's connection with the Burlington urban area is an unresolved mess. Faster, if a bit less scenic at the start, is to go up I-89, get off at Exit 18, and take Routes 104A and 104 east to the bridge in Fairfax. Then go south on Route 128 to the bridge in Westford, take the same road that that bridge is on as a shortcut back to Route 104, and continue east into the Cambridge area, where there are three bridges. Head north on Route 108 and west on Route 36 to find the last bridge in East Fairfield. Alternatively, those interested in seeing more bridges in less time rather than seeking to visit every bridge might want to skip East Fairfield and go instead to the three bridges in Waterville and the two in Belvidere, not far north of Cambridge on Route 109 (see Tour VI). The Jericho sites, which include an interesting imitation covered bridge and the aforementioned mill, could then be picked up by returning to the Burlington area via Route 15.

The progression from west to east in this chapter, from I-89 to Cambridge Junction, shows off a typical feature of northwestern Vermont's landscape: a valley carved by a powerful, west-running river. Although not as long as north-running Otter Creek (see Tours II and III), the Winooski, Lamoille, and Missisquoi Rivers are all titans in Vermont terms. Each has been vital to

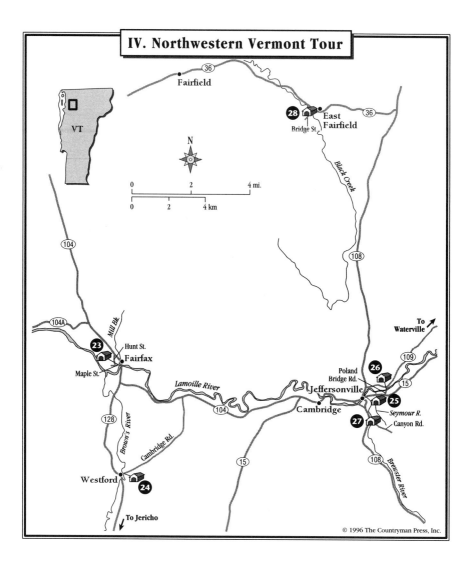

IV. Northwestern Vermont Tour

VT

Fairfield

36

East
Fairfield

36

28
Bridge St.

Black Creek

N

0 2 4 mi.
0 2 4 km

108

104

To
Waterville

104A

Mill Bk.

109

23
Hunt St.
Fairfax

Maple St.

Poland
Bridge Rd.

26

15

Jeffersonville

Lamoille River

104

Cambridge

25
Seymour R.
Canyon Rd.

128

Brown's River

Cambridge Rd.

15

27

108

Brewster River

Westford

24

© 1996 The Countryman Press, Inc.

To Jericho

industry, first through water-powered mills, then through hydroelectric development, and always through their rich bottomland farming areas. We will be encountering Lamoille River basin covered bridges as we travel on into the Montpelier region (Tour XI). The only Missisquoi River bridges to have survived the region's floods are along tributaries in the Enosburg-Montgomery area (Tour VI), and even farther east in Troy.

Since Routes 104A, 104, and 15 take turns going up the heart of the basin, crossing and recrossing the Lamoille River, it will come as no surprise that there are some very nice public riverside areas. One of the best is only 2.5 miles east of where Route 104A leaves Route 7. Another good one is located along the brief stretch of Route 19 that parallels the Lamoille River, the same route that accesses the north end of the Poland Bridge (see No. 26).

One riverside site is so remarkable as to be a destination: **Fairfax Falls.** The dam, power station, and waterfall are on the part of Route 104 that a bridge traveler would bypass by taking the back-road shortcut from Westford toward Cambridge. From the junction of Routes 128 and 104, the site is 0.9 mile to the east. Another 0.1 mile upstream, to the left off Route 104, is a historic metal bridge across the dammed and seemingly placid Lamoille. Take Goose Pond Road over that bridge, then go left 0.1 mile on River Road to a far better view of the falls than from Route 104. In fact, it's possible to clamber out on rocks to within a few feet of where the thunderous cataract shatters and sends up a towering spray. In flood season especially, it's a dizzying, heart-pounding spectacle.

Partly because of the floods, the state's northwest corner is not as rich in covered bridges as other areas, but has points of historic interest that a covered-bridge lover could find rewarding. Early Vermont leader Ethan Allen's rambunctious ways and daring exploits are celebrated at the **Ethan Allen Homestead** in Burlington (802-865-4556), where there is a restored 1787 farmhouse and a re-created tavern, among other exhibits. Winooski was a center for the kinds of mills that employed hundreds, chiefly in the clothing trade (contemporaneous with the covered-bridge building boom and its associated local mills); the **Winooski Falls Mill Historic District** preserves several of those structures and has **Winooski Falls Park.** The **St. Albans Historical Museum** (802-527-7933) emphasizes local history and takes note of the Civil War Confederate raid on a St. Albans bank. Nearby Grand Isle County, whose land areas were too small to have any streams justifying covered bridges, can boast of Vermont's earliest settlement, commemorated at **St. Anne's Shrine** on Isle La Motte (802-928-3362). On Grand Isle, the state-owned **Hyde Log Cabin** (802-828-3226) has exhibits centered on one of the country's oldest (1783) log cabins. Jericho's historical society maintains a restored streamside mill as a museum. In Fairfield, there is a replica of the **birthplace of Chester Alan Arthur,** the 21st president, which interprets his life (802-828-3226).

Some guides still list the Swanton covered railroad bridge, sadly destroyed by arson several years ago. The state owns the roadside site looking out on the

three-span bridge's midstream pillars, for those who want to picnic and mourn. Fire seems to have been another theme in the history of the northwest corner's bridges. Visitors might want to know that the 22 Confederate soldiers in the bold St. Albans Raid of October 19, 1864, who dashed down from Canada and took $208,000 from a St. Albans bank, tried to seal off their exit by throwing burning phosphorus on the covered, two-lane Black Creek Bridge at Sheldon. (There was a Civil War demolition charge specifically for covered bridges, shaped like a treenail, and a repeating "covered bridge gun" that could hold off a large enemy force when placed so it could fire into a bridge.) Townspeople doused the flames in the 1860s, but the bridge did burn in the 1920s. The *Burlington Free Press* for July 22, 1929, reported a memorable western Lamoille County fire: "Driven to frenzy by pain, two valuable work horses late this afternoon raced from the Curtis meadow to the highway, the hayrack blazing. On the bridge to the Bakersfield road the animals collapsed and died of their burns . . . The structure caught fire and was totally destroyed. What remained of it collapsed and fell into the Lamoille River."

Let's hope that times have changed from when the death of a covered bridge came almost as a footnote.

23. MAPLE STREET BRIDGE

Other and historical names: Lower.
Municipality: Fairfax.
Locality: Fairfax village.
Ownership: Town.
Traffic allowed: State study recommended no more than 3 tons.
Crossing: Mill Brook and Maple Street.
Built: 1865.
Builder: Kingsbury and Stone.
Type: Town lattice.
Dimensions: 56.8 feet long, 17.3 feet wide, 7 feet high at trusses, 10.5 feet high at center.
Photography tips: NE–SW.
Getting there: From Exit 18 on I-89, go 0.1 mile south on Route 7, then 4.5 miles east on Route 104A, then 1.6 miles south on Route 104 into the center of Fairfax. Just beyond a large, square, wood-frame building (on the right side), Maple Street goes downhill to the right, while River Road's triangular intersection with Route 104 goes uphill to the left. Take Maple Street 0.2 mile to the bridge. To leave the bridge, go through it and turn right onto Hunt Street, which returns to Route 104 (and has a nice hilltop view of the village and bridge). Exiting Maple Street onto Route 104—uphill and with a nearly blind corner—can be dangerous.
Parking: Drive through the bridge and use the entrance to a little-

frequented side road; or, better still, use the parking lot just uphill on Hunt Street.

Notes: The Fairfax Bridge saw a major rehabilitation in 1990–1991 by Jan Lewandoski. At 17.3 feet, it is one of the widest covered bridges in the state. Very popular among the local youth, it had more graffiti on one recent visit than any other covered bridge in the state. "Every year they clean it up; every year they do it again," remarked one resident.

Visitors can decide for themselves on one local controversy: Some say that when the bridge was replaced on its foundations after being washed onto the bank of Mill Brook in the Flood of 1927, the eastern end was placed facing west, and vice versa. Others disagree.

24. BROWN'S RIVER BRIDGE

Other and historical names: Brown's; Westford.
Municipality: Westford.
Locality: Westford.
Ownership: Town.
Traffic allowed: None at present; off road, though will be moved back to new abutments.
Crossing: Was and will be Brown's River and Cambridge Road.
Built: 1837–1838.
Builder: Unknown.
Type: Burr arch.
Dimensions: 97 feet long.
Photography tips: WSW–ENE; now in open field by town garage; unobstructed, afternoon somewhat better.
Getting there: From the intersection of Route 104 and Maple Street in Fairfax (see No. 23), go south 0.7 mile on Route 104 to its junction with Route 128. Take Route 128 south 3.3 miles to where it swings sharply to the right, in the center of Westford, by the green with the gazebo. Pass the library and town office, then turn left off Route 128 onto Cambridge Road (which—as its name suggests—will be the fastest route to the next set of bridges). The Brown's River Bridge is less than 0.2 mile from Route 128 on the right side, just past the entrance to the town highway garage. It's clearly visible from Cambridge Road.
Parking: Ample at town garage.
Notes: This bridge is noted for its very large, hand-hewn timbers. It was repaired in 1976 by the Vermont Naval Reserve (Seabees) and townspeople. Due largely to the local historical society's efforts, with money from the town selectmen and federal highway aid, the structure received a comprehensive restoration in 1987 from Graton Associates, after being moved off its original abutments. It has been closed to traffic since the late 1960s. The process of

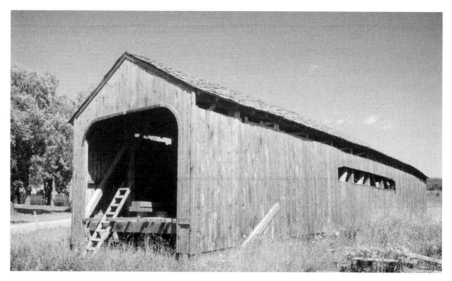

Brown's River Bridge

moving and repairing the bridge was featured on the television programs *National Geographic Explorer* and *America, How Are You?*

25. GATES FARM BRIDGE

Other and historical names: Little.
Municipality: Cambridge.
Locality: Cambridge village.
Ownership: Town.
Traffic allowed: Connects farm fields and serves farm vehicles.
Crossing: Seymour River and a farm road.
Built: 1897.
Builder: George W. Holmes.
Type: Burr arch.
Dimensions: 60 feet long.
Photography tips: WNW–ESE.
Getting there: This bridge is just to the east of the village area of Cambridge, about 0.2 mile from the intersection of Lower Valley Road (the street with the post office) and Route 15. From the Cambridge United Church on Route 15, go east 0.2 mile to where the road starts to swing left. Just before the road crosses the river, stop. The bridge should be visible to the right, in a field, a few hundred feet away.
Parking: Alongside Route 15.
Notes: This the bridge that the Shelburne Museum didn't want when the Cambridge Bridge was discontinued and went to the museum instead (see No.

22). After the new bridge was built, the state highway engineers decided to change the course of the Seymour River so it emptied into the Lamoille River upstream of the new bridge, not downstream. The Little Bridge, as it was then called, was moved in 1950, to restore the Earle Gate family's access to their farmland. The bridge had taken one other journey in its history: The Flood of 1927 slid it 20 feet off its foundations, but trees kept it from traveling farther, and it was successfully put back.

The bridge recently underwent a comprehensive restoration. When the Lamoille flooded in the summer of 1995, the waters left marks 3 feet up on the new sideboards, but the bridge remained in place.

26. POLAND BRIDGE

Other and historical names: Junction; Kissing.
Municipality: Cambridge.
Locality: Cambridge Junction.
Ownership: Town.
Traffic allowed: Had been up to 3 tons, but recently closed after a major timber suffered damage from a vehicle.
Crossing: Lamoille River and Poland Bridge Road.
Built: 1887.
Builder: George W. Holmes; abutments by Luther A. Wheelock.
Type: Multiple kingpost with Burr arch.
Dimensions: 152.9 feet long, 15.7 feet wide, 8.2 feet high at trusses, 11.5 feet high at center.
Photography tips: S–N.
Getting there: The Poland Bridge Road connects Route 109 (to the north of the bridge) with Route 15 (to the south). To reach the bridge's south side (better light for photos), start at the western junction of Routes 108 and 15 in Jeffersonville and take Route 15 east for 1.2 miles. From the eastern intersection of Routes 15 and 108 (the one that leads to Route 109 and the north side of the bridge), go 0.6 mile. At a fuel dealership (on the right), turn left (north) onto what a sign calls JCT. RD TH 23. The bridge is just beyond the railroad tracks. To reach the north side, return to the previously mentioned junction of Routes 15 and 108 and go 0.4 mile north on Route 108 (over a metal bridge), then 0.8 mile on Route 109 to the spot where a side road angles sharply back. The Poland Bridge is 0.2 mile along that road.
Parking: There's no problem using the roadsides, especially with the bridge closed.
Notes: Residents say this magnificent structure, the longest clear span covered bridge in highway use in Vermont aside from the Cornish-Windsor Bridge (see No. 64), had been perceptibly leaning to one side—and then a vehicle struck an east side kingpost diagonal timber in the summer of 1995. That

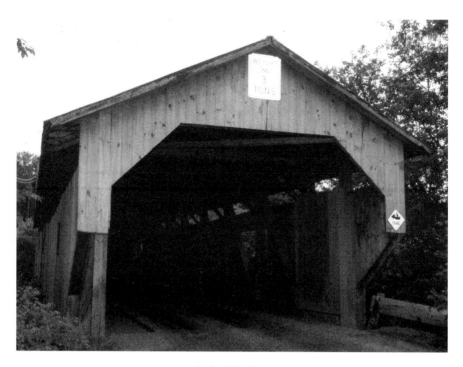

Poland Bridge

straightened the sideways tilt but increased a more serious problem: The bridge was sagging. Alerted by the state study to the fact that the bridge's own weight was slowly overcoming its strength, the selectmen closed it. The state consultants recommended against reopening it even for light traffic, suggesting instead that it be bypassed. Stabilizing the structure to keep its weight and snow load from breaking it would cost about $225,000, and opening it to light traffic would cost about $288,000, they estimated.

This big bridge started with a big fight. In the 1880s, Cambridge Junction was a significant railroad junction, where the Vermont division of the Portland and Oggensburg met the Burlington and Lamoille. But people living to the north had to take a roundabout route to get there and wanted a bridge. Cambridge voters dismissed the idea; as a news correspondent wrote at one point (quoted by Robert L. Hagerman in *The Covered Bridges of Lamoille County*), "Such a bridge hardly seems necessary, and it does not seem right for the town to have to build a bridge, when it has no particular use for it, unless it be to accommodate a few, while upon the many it will come very hard to have this addition of taxes put upon them in hard times." This statement could serve as a text for the stories of many Vermont bridge repairs down the years.

But Luke P. Poland of Waterville, a lawyer who had been chief justice of the Vermont Supreme Court and a representative and senator in Washington, D.C., made such a bridge a project for his retirement years. He led a lawsuit

that resulted in an 1885 Lamoille County Court judgment ordering a bridge and a connecting road to be built.

Cambridge dragged its feet, but in 1887 it finally voted, according to Town Meeting minutes, "to instruct the Selectmen to build a wood, Howe Truss, or Arch bridge. Single track of sufficient width to stand the wind. And the matter of stone (for the abutments) to be left discretionary with the Selectmen."

Poland died while mowing hay on his farm before the bridge was done. The local *News and Citizen* reported in January 1888, "It is a good job, and we hope it may long remain as a monument of skill and a memorial of the late Judge Poland, as the whole bridge question was the pet scheme of the honored gentleman . . . A large line of travel has already commenced over the new road and bridge from Belvidere and Waterville, which bids fair to make this a thriving point."

When the Flood of 1927 came, "Water filled the bridge on the Waterville road to a deep depth, but Mr. Bridge failed to leave its berth," the *News and Citizen* reported.

Times changed, the railroads faded, and so did Cambridge Junction's hopes. But the bridge continued to find uses. Hagerman notes one of the more creative: On August 3, 1968, a "psychedelic" band called the Galvanized Toadstool performed there for the Cambridge Teen Club, whose president, Chris Page, reported that the acoustics were "terrific."

27. SCOTT BRIDGE

Other and historical names: Grist Mill; Bryant; Grand Canyon; Brewster River.

Municipality: Cambridge.

Locality: Jeffersonville.

Ownership: Town.

Traffic allowed: State study recommends no more than 5 tons.

Crossing: Brewster River and Canyon Road.

Built: Unknown.

Builder: Unknown.

Type: Multiple kingpost with Burr arch.

Dimensions: 84.5 feet long, 13.7 feet wide, 8.4 feet high at trusses, 11 feet high at center.

Photography tips: WNW–ESE; midday to late afternoon best.

Getting there: From Route 15 in Jeffersonville, take Route 108 south. (Route 15 meets Route 108 at two points in Jeffersonville. Turn at either intersection; the two Route 108 spurs meet to the south of Route 15.) Look for a mill building (including a waterwheel) 0.5 mile along Route 108. Canyon Road goes left (east) from near that building. The bridge is only 0.1 mile down Canyon Road.

Scott Bridge

Parking: A large municipal lot serves both the bridge and a regionally famous swimming hole.

Notes: A gristmill formerly located near the bridge gave it one name. A 1952 freshet nearly spelled disaster for the structure: Selectman Clark Dodge Sr. was about to drive onto it when he noticed that the end had settled considerably. Stopping his car, he found a 4-foot washout between the road and the bridge abutment. The town built a cribbing (crisscross stack) of railroad ties and jacked up the bridge, only to have another rainfall wash the cribbing out. Finally, a new concrete abutment was poured, with area resident Alden Bryan making a substantial donation to make up the gap between the $4800 cost and partial state aid.

28. EAST FAIRFIELD BRIDGE

Other and historical names: None known.
Municipality: Fairfield.
Locality: East Fairfield.
Ownership: Town.
Traffic allowed: Closed; previously up to 2 tons.
Crossing: Black Creek and Bridge Street.
Built: 1865.

Builder: Unknown.

Type: Queenpost.

Dimensions: 67.3 feet long, 13.6 feet wide, 7.7 feet high at trusses, 10.4 feet high at center.

Photography tips: SW–NE.

Getting there: Only 0.1 mile from Route 36. From the Bakersfield junction of Routes 108 and 36, go west on Route 36 for 3.2 miles, then turn left (south) onto Bridge Street.

Parking: Not difficult with the bridge closed.

Notes: The bridge crosses the impoundment for a former mill, the last evidence of a former early industrial complex beside the falls of Black Creek. A path leads to the falls area.

Also on this tour

IN JERICHO, THE **Mills Bridge,** a 25-foot-long covered stringer bridge built in 1967 by Merton Mills across the Brown River east of Route 15, serves as an entrance for a campground. Go to the silver recreational vehicle (camp headquarters) to ask permission to explore the bridge. While in Jericho, do not fail to visit the **Jericho Historical Society Museum** in a restored mill (802-899-3225). These mills were once common, but proved even more endangered than the covered bridges, since they had to be closer to the waterpower and were more at risk from floods. (The great bridge equation: Better truss allows for longer bridge, which allows placement higher up on the banks, which results in greater safety from floods.)

On the west side of Route 108, in the Jeffersonville section of Cambridge, the 40-foot **Morse Mill Bridge** serves a horseback-riding business. It was built in memory of a covered bridge once near the site, using a design Suzanne and Wayne Terpstra came up with after looking at pictures of covered bridges.

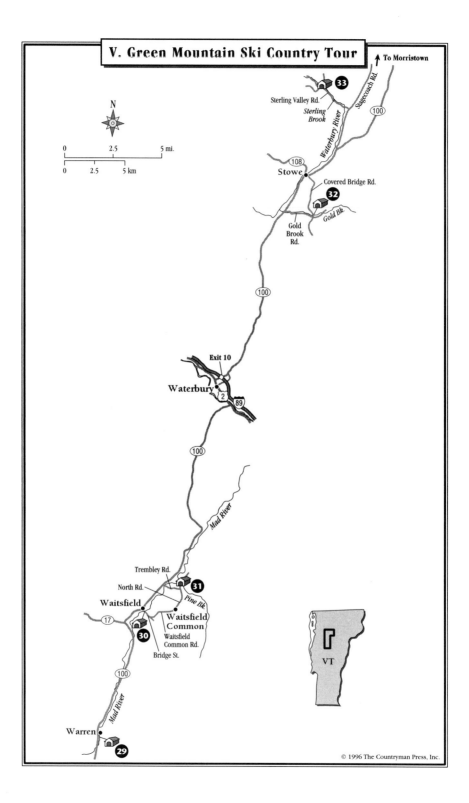

V. Green Mountain Ski Country Tour

To Morristown

Sterling Valley Rd.

33

Sterling Brook

Waterbury River

Stagecoach Rd.

100

108

Stowe

Covered Bridge Rd.

32

Gold Bk.

Gold Brook Rd.

100

N

0 2.5 5 mi.

0 2.5 5 km

Exit 10

Waterbury

2

89

100

Mad River

Trembley Rd.

North Rd.

31

Pine Bk.

Waitsfield

17

Waitsfield Common

30

Waitsfield Common Rd.

Bridge St.

VT

100

Mad River

Warren

29

© 1996 The Countryman Press, Inc.

V. Green Mountain Ski Country Tour

THE ATTRACTION OF Route 100—which like the nearby Green Mountains runs through most of the state—comes more from from its scenery than its history. It traverses one of Vermont's most strikingly beautiful valleys, with some of the state's best trout waters running alongside. Route 100 goes through many skiing towns, whose clientele supports intriguing shops and galleries, including many antiques emporiums.

The US Forest Service, which manages the **Green Mountain National Forest** just west of Route 100, has a headquarters in a restored barn north of Rochester (802-767-4261). They have detailed information for hikers, campers, canoeists, anglers, hunters, even berrypickers. One of their recent projects was establishing the White River Travelway, a series of public access points along Route 100. A particularly scenic stop is the roadside waterfall in **Granville Gulf.** (Narrow hollows or ravines are often called gulfs in Vermont.)

The official state map gives Route 100 an honorary designation as the 43rd Infantry Division Memorial Highway. Thus, a pastoral road accessing alpine ski areas commemorates a Vermont-led unit that fought in the Pacific in World War II.

From Stowe, this tour veers northeasterly along another scenic highway, Route 108. Negotiating the winding mountain pass through **Smuggler's Notch**—historically a rum-running route, but now famous for its huge glacial boulders and caves—gives a sense of how 2-mile-high glaciers sculpted Vermont during the last ice age, reducing jagged mountains to the landscape whose human scale is now so much admired.

Those seeking unforgettable sights should be aware of several side spurs:

• **Up Route 73,** in the hamlet of Robinson, take the National Forest road north several miles into the hills of bygone Bingo (not marked as such on

maps), where the small stream there has an almost dreamlike loveliness.

• **Up Route 125,** Texas Falls may not really be Texas-sized, but it is likewise remarkable.

• **Up Routes 73 and 17,** Brandon Gap and—farther north—Appalachian Gap offer stirring views. The Lincoln Gap, on a rougher road closed in winter, is the highest pass.

29. WARREN BRIDGE

Other and historical names: None known.
Municipality: Warren.
Locality: Warren village.
Ownership: Town.
Traffic allowed: Up to 8 tons.
Crossing: Mad River and Covered Bridge Road.
Built: 1879–1880.
Builder: Walter Bagley.
Type: Queenpost.
Dimensions: 54.9 feet long, 13.3 feet wide, 10.2 feet high at trusses, 12.7 feet high at center.
Photography tips: W–E; good side views. A postcard picture has alerted many visitors to the presence of a natural stone bridge in the streambed, through which it is possible to photograph part of the dam waterfall down-

Warren Bridge

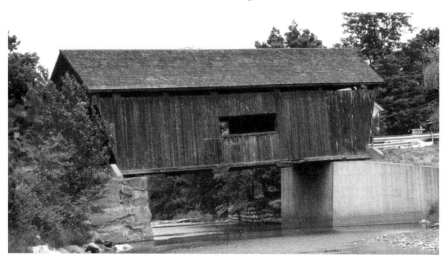

stream as well as part of the bridge itself. Geraldine Cota, whose property includes the path to the stone bridge, said that those who attempt the "treacherous" slope do so at their own risk. She'd much rather be there when people go down, so that she can lead the way and show how to get over the stone bridge to the vantage point. Hers is the second house on the left to the north of the bridge.

Getting there: In Warren, three roads going east from Route 100 all lead to the bridge. The first and third form a loop road, Main Street, which goes past the east end of the bridge. Covered Bridge Road between them goes through the bridge. Coming from the south, look on the right for the sign with an arrow that says WARREN VILLAGE just before a concrete-and-steel bridge on Route 100. Turn onto Main Street here, and drive 0.4 mile to the bridge. Just north of that turn on the left is the road to Lincoln Gap—the area's highest mountain pass, and a summit for the adventurous—then Covered Bridge Road to the right, all within 0.2 mile. Another 0.4 mile north on Route 100 brings you to the northern terminus of Main Street. From the north, that end of Main Street is 4.8 miles south of the junction of Routes 100 and 17.

Parking: There's an okay turnoff at the southeast corner of the bridge, and there's plenty of space on the river side of Covered Bridge Road, about 100 feet from the bridge. The town hall lot east of Main Street is within walking distance.

Notes: Signs on the bridge give names of nearby roads that were common destinations, not of the bridge. Still authentic in design, the Warren Bridge has a unique asymmetrical design: a vertical east portal, but upper side walls that project differently at the west portal. A town ordinance states that the bridge will remain unaltered unless two-thirds of the voters approve a change. The constructions near the dam downstream from the bridge represent an attempt at independent hydroelectric power generation.

30. VILLAGE BRIDGE

Other and historical names: Big Eddy; Great Eddy.
Municipality: Waitsfield.
Locality: Waitsfield village.
Ownership: Town.
Traffic allowed: Up to 3 tons.
Crossing: Mad River and Bridge Street.
Built: 1833; walkway added about 1940.
Builder: Unknown.
Type: Multiple kingpost with Burr arch.
Dimensions: 105 feet long, 15.5 feet wide, 9.5 feet high at trusses, 10.3 feet high at center; side walkway.
Photography tips: N–S; morning best (village background); owner of

nearby photo shop allows visitors to use store for close-up side shots; excellent river shots (see parking instructions).

Getting there: The bridge is 0.1 mile east of Route 100 on Bridge Street (there is a sign), which forms the town of Waitsfield's main intersection with Route 100. Bridge Street is 1 mile north of the junction of Routes 100 and 17, soon after Route 100 comes close to the river and swings left; from the north, it's 0.5 mile south of the elementary school (which is on both sides of Route 100 and has two distinctive lines of evergreens on the west side).

Parking: As the name "Village Bridge" implies, this is a much used area. Don't park at the seemingly obvious places just beyond the bridge—these are for commercial or residential use. On-street parking may be at a premium. The ample Bridge Street Marketplace lot, however, is within easy walking distance of the bridge. One entrance is on Route 100 just south of its intersection with Bridge Street, marked by a freestanding oval sign. Coming from the north, a sign for the marketplace is visible on a building on the Bridge Street corner. This parking area provides good riverside access and, in summer, the chance to wade out to a midstream island—a great photo site. In the warmer months, there are portable toilets.

Notes: This is probably Vermont's second oldest bridge, and one of the few with an attached walkway. The town had lost bridges repeatedly to floods until the townspeople finally agreed in 1830 it was time to build a more substantial structure in the village. The associated tax was payable in "good common labor" at the rate of 8¢ an hour.

Heavily used through the years, the bridge needed a major restoration by 1973, which was carried out by Graton Associates. Milton Graton compared

Village Bridge

the struggle over whether or not to continue using the wooden bridge to the feud between the Hatfields and the McCoys. Graton's dedication to all–wooden construction can be seen in the use of "ship knees"—right-angle timbers cut from places where tree branches meet tree trunks—for roof bracing, rather than the steel braces the state specified in the bid request. (Sailing vessels used these natural joints as well, hence the name.) The Eddy area was a mill site; before the first gristmill in Waitsfield was built in 1793, a large hollowed-out birch stump and a pestle hung on a spring pole near where the bridge is now, so people who could not go to the gristmill in Hancock could grind their grain. A sign warning that it is illegal to go on the roof reflects the continuing use of the so-called Great Eddy (the impoundment from a dam) as a local swimming hole.

31. PINE BROOK BRIDGE

Other and historical names: Wilder.
Municipality: Waitsfield.
Locality: Waitsfield.
Ownership: Town.
Traffic allowed: Up to 5 tons.
Crossing: Pine Brook and North Road.
Built: 1872.
Builder: Unknown.
Type: Kingpost.
Dimensions: 48.3 feet long, 14.2 feet wide, 9.4 feet high at truss, 12 feet high at center.
Photography tips: SW–NE.
Getting there: This bridge is east of Route 100 and north of Waitsfield village. From the Village Bridge (see No. 30), continue east on Bridge Street to a fork, and take the left-hand road to Waitsfield Common. Go left on North Road; the Pine Brook Bridge is 1.2 miles north. Or from the intersection of Route 100 and Bridge Street, go north 0.8 mile on Route 100, and then go right (east) on Trembley Road. A state rest area, locally called the Pines for its large pine trees, is at that turn. When Trembley Road ends in a T-intersection, turn left and go 0.3 mile north to the bridge on North Road.
Parking: Tricky. The best place is the shoulder on the north side.
Notes: When Milton Graton and his sons restored this bridge in 1977, they were directed to add steel beams beneath for support. Not wanting to alter the bridge's authenticity, and in danger of losing $7000 from the Historic Sites Commission, who would only pay for "historic preservation," Graton hit on an ingenious compromise: He put the beams a half inch below the wooden trusses, far enough so only an overload would make them bend enough to touch and be supported. One problem with this bridge—a problem restora-

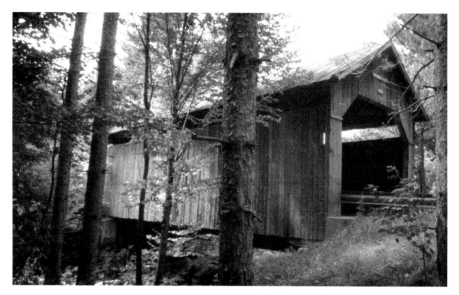

Pine Brook Bridge

tion-expert Jan Lewandoski said would have been difficult for the builder to foresee—is a kingpost with spiral grain. Visibly cracking apart, it is now secured by a metal clamp.

32. EMILY'S BRIDGE

Other and historical names: Gold Brook; Stowe Hollow.
Municipality: Stowe.
Locality: Stowe Hollow.
Ownership: Town.
Traffic allowed: Up to 2 tons.
Crossing: Gold Brook and Gold Brook Road.
Built: 1844.
Builder: John W. Smith.
Type: Howe.
Dimensions: 48.5 feet long, 12.4 feet wide, 8.3 feet high at trusses, 11.4 feet high at center.
Photography tips: NE–SW.
Getting there: From the junction of Routes 108 and 100 in the village area of Stowe, go 1.8 miles south on Route 100. Just north of where Route 100 crosses a stream (Gold Brook), go left (east) on Gold Brook Road. At the 0.3-mile point, Gold Brook Road comes to a four-way intersection. Gold Brook Road goes to the left; disregard any sign suggesting it does otherwise. About a

mile after this turn, you'll come to another four-way intersection. The bridge should be immediately to the left on Covered Bridge Road.

Parking: A turnoff area is south of the bridge. There is a path to a swimming hole.

Notes: The previous names of this bridge have been supplanted by the fame of Emily, its supposed ghost. Joseph Citro, perhaps the state's foremost collector of ghost stories, states in *Green Mountain Ghosts, Ghouls and Unsolved Mysteries* that the bridge in Stowe Hollow is Vermont's only haunted covered bridge, although the previous owner of the Old Hollow Bridge (see No. 18) might differ.

The ghost, which Citro has never encountered, has a reputation for malicious acts, such as injuring animals crossing the bridge at night, or ruining paint jobs. Flashing white lights, warm spots in winter, chills in summer, hats blown away on still days, pictures with inexplicable blurs, a woman's voice crying for help, a white figure shaking a car—all have been reported.

Robert Hagerman (*Covered Bridges of Lamoille County*) found several versions of the Emily story, most of them unearthed by Morrisville High School student Susan Twombly's interviews with residents. Take your pick:

• Emily was a girl of the late 1800s who planned to rendezvous with her intended at midnight in the bridge, so they could elope, and hanged herself when he failed to appear.

• In 1925, Emily Smith, 36 and fat and unattractive, fell in love with Donald, who got her pregnant. When Emily's father said he would force them to marry, Donald killed himself instead by jumping off the High Bridge (now gone). Emily had twins, who died soon after they were born, after which she jumped off the High Bridge herself in her bright red wedding dress.

• Emily was riding her horse to her wedding in the village when it bolted at the High Bridge and threw her to her death on the rocks below.

Twombly came to believe a more prosaic basis for the tales, a story recounted by longtime resident Ernest Wright. He said young Emily and her husband were riding together on Gold Brook Road, some distance from the bridge, when their horse-drawn conveyance struck a culvert. Emily was thrown out and injured. Far from being fatal, the accident led to a lawsuit that the town settled out of court.

The name Gold Brook would not surprise savvy Vermont geologists, rockhounds, and amateur prospectors. So-called placer gold, the kind found in tiny nuggets, can be panned or sluiced in many of the state's streams, although no mother lode has been found. For the average visitor, the real "gold" may be in the spectacular stripings, mottlings, and layerings of the ordinary rocks of north-central Vermont. Caution: Do not bring a child who loves pretty rocks

on a covered-bridge expedition to this territory without expecting to lose gas mileage due to the height of collected specimens on the way back.

33. RED BRIDGE

Other and historical names: Sterling.
Municipality: Morristown.
Locality: Sterling.
Ownership: Town.
Traffic allowed: Up to 6 tons.
Crossing: Sterling Brook and Bedell Hill Road (Town Highway 50).
Built: 1896; iron rods added in 1897 after wind damage.
Builder: Unknown.
Type: Unique to Vermont, using both a kingpost and a queenpost.
Dimensions: 64.3 feet long, 13.7 feet wide, 9.6 feet high at trusses, 11.8 feet high at center.
Photography tips: N–S; afternoon best because of trees; deep gorge gives chance for shots from below, but access is physically challenging; southwest corner has the best route down the bank to the river.
Getting there: This is tricky, but it's worth it. From the junction of Routes 100 and 108 in Stowe, go 1.8 miles north on Route 100 to where Stagecoach Road splits off to the left. This is a paved road, with spectacular views of

Red Bridge

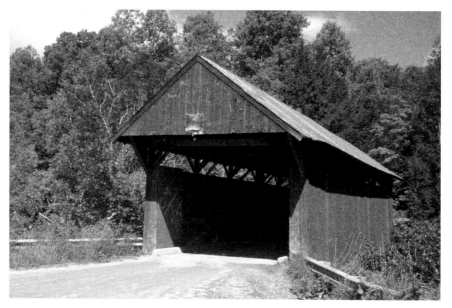

Mount Mansfield, Vermont's highest mountain. Go 0.7 mile to where Sterling Valley Road comes in from the west. Go left on that road 1.6 miles to the bridge and a complicated intersection (Sterling Bridge Road, Sterling Bridge Loop Road, and Bedell Hill Road all come together) at the bridge. On the way, at the 1.2-mile mark, look to the right (north) for a turnoff near an impressive cataract. From the north, Sterling Bridge Road's eastern terminus at Stagecoach Road is 3.9 miles down Stagecoach Road from Morristown Four Corners.

Parking: There's plenty of room on the sides of the little-used gravel intersection.

Notes: Named for its paint job, and a treasure because of its unique truss, the Red Bridge is safe from truck overloading because it has two steel beams and a reinforced concrete roadway underneath.

Sterling was once a chartered town, like Stowe and Morristown. But it proved unworkable as a municipality. Defeated by its ridges and ravines, it was dissolved and its territory absorbed into that of four other townships. The story illustrates the degree to which covered bridges not only facilitated personal travel in Vermont's earlier years but also helped maintain the ties that created functional communities.

Also along Route 100

PARTLY BECAUSE THIS route is a tourist draw and popular with second-home owners, there are several covered-bridge-motif structures that the National Society for the Preservation of Covered Bridges has dubbed "romantic shelters." These include:

• **In Pittsfield,** just east of Route 100 and easily visible, the **Giorgetti Bridge,** a 55-foot cement stringer bridge across the Tweed River, built in 1976 by John Giorgetti.

• **In Warren,** 3.4 miles west of the intersection of Routes 100 and 17, on a private road to the north of Route 17, the **Battleground Bridge,** a 65-foot stringer bridge over Mill Brook, serving as the entrance to the Battleground Resort and condominiums.

• **In Stowe,** the **Whitecaps Bridge,** built for the Whitecaps Corporation's housing development, is visible from Route 108. Whitecaps proprietor Clinton H. Thompson used the Gold Brook Bridge as a model to design the stringer bridge's cover; the bridge was built by Construction, Inc., of Stowe. Crossing the West Branch of the Waterbury River, it's 56 feet long.

• **Also worthy of note:** In the village of Stowe, you might want to visit the covered walkway next to a Route 108 concrete-and-steel bridge over the Waterbury River. Built in 1973 by the highway department, it's 150 feet long.

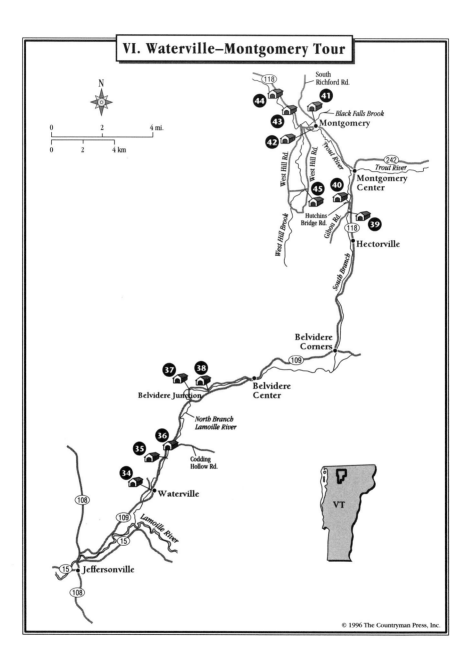

VI. Waterville–Montgomery Tour

VI. Waterville-Montgomery Tour

THIS TOUR VIVIDLY illustrates one of the most common patterns of covered-bridge building in Vermont. Before the ravages of floods and modern traffic, many more communities that retain only one or two bridges resembled Waterville, Belvidere, and Montgomery.

It was not enough for a town's board of selectmen to know that covered bridges were theoretically sound. There had to be a local builder capable of creating something both durable and economical. Once someone came forward with a design that proved itself—the Jewett Brothers of Montgomery, for instance—he or his company (and perhaps later his apprentice) would get more and more contracts, and in so doing refine the techniques of acquiring, drying, and framing timbers, leading to more jobs. Thus the bridges in a town or valley would come to resemble each other.

In the case of the three towns here (and elsewhere in Vermont, notably around Tunbridge), this situation was accentuated by geography. Narrow valleys with meandering rivers required numerous crossings for settlements to function as communities. Montgomery, with its six bridges and one just over the town line with Enosburg, might be said to be the covered-bridge capital of Vermont. As may be seen by some of the area's weathering buildings, this preservation has come at the price of comparative poverty. The general rule in Vermont is that the farther north one goes, the more the state looks the way it once did, and the harder it is to make a living.

This is territory in which towns have sometimes never gotten around to naming all their roads, much less paving them. The abandoned Creamery Bridge site evokes the north country's often tragic beauty in an especially memorable way, and deserves to be one of the pilgrimage points for dedicated covered-bridge trekkers.

The area can be accessed from Burlington starting with Route 15, and from I-89 via Route 100 from Waterbury. The itinerary takes you from Route 15 north on Route 109 through Waterville and Belvidere, then north on Route 118 through Montgomery to the northernmost bridge just over Montgomery's boundary with Enosburg. Farther north, Quebec has its own covered bridges—but that's beyond the scope of this book.

34. CHURCH STREET BRIDGE

Other and historical names: Village.
Municipality: Waterville.
Locality: Waterville.
Ownership: Town.
Traffic allowed: Up to 8 tons.
Crossing: North Branch (of the Lamoille River), sometimes called the Kelly River, and Church Street.
Built: One source says possibly 1877, another 1895.
Builder: Unknown.
Type: Queenpost.
Dimensions: 61.1 feet long, 12.2 feet wide, 7.8 feet high at truss, 10.9 feet high at center.
Photography tips: E–W; path to river at northwest corner of bridge.
Getting there: From the junction of Routes 108 and 109 north of Jeffersonville, go northeast on Route 109 for 4.3 miles to two churchlike buildings (one is the Waterville Town Hall) on the right. Take the street to the left for 0.1 mile.
Parking: There's a turnoff at the northwest corner.
Notes: This bridge has several old advertisements inside, including stenciling. Four steel beams were added underneath in 1968, after a truck driven by local resident Roger W. Mann Jr. was stranded halfway across the bridge when its back wheels fell through the floor. Robert L. Hagerman quotes Mann as later remarking, "We had a nice road across the ice during the winter," the accident having taken place just before Christmas of 1967. The bridge also survived a fire in 1970 that started at a nearby house, with firefighters hosing the bridge down.

35. MONTGOMERY BRIDGE

Other and historical names: Lower; Potter.
Municipality: Waterville.
Locality: Waterville.

Ownership: Town.

Traffic allowed: Up to 8 tons.

Crossing: North Branch (of the Lamoille River), sometimes called the Kelly River, and Montgomery Bridge Road.

Built: 1887.

Builder: Unknown.

Type: Queenpost.

Dimensions: 70.2 feet long, 11.9 feet wide, 8.5 feet high at trusses, 10.7 feet high at center.

Photography tips: NE–SW.

Getting there: Take Route 109 to Waterville. The bridge is just to the east of the highway, 1.2 miles north of the Waterville Town Hall or 0.5 mile north of the Waterville Post Office.

Parking: There's an okay turnoff on the Route 109 side, a better turnoff through the bridge.

Notes: Originally named for nearby resident Luke Potter, this bridge later took its name from the nearby Dallas Montgomery Farm, not because it was on the route to Montgomery. It underwent a major reconstruction in 1971, following two major incidents. In early January 1969, snow drifted 5 feet deep on one side of the roof, and the bridge started to groan and shift sideways. Dallas Montgomery, who climbed up to clear the snow, told Robert L. Hagerman, "It teetered back and forth, and that had me kind of worried." Local resident Wilmer Locke winched it back into shape, added braces, and put iron rods across the top of the bridge. Then on August 11, 1971, a truck

Montgomery Bridge

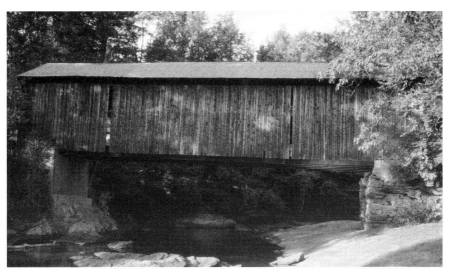

carrying hot asphalt to pave the road to the Montgomery Farm crashed through the floor, doing a complete flip-flop and ending up on its back in the river. (The driver escaped through a door window with only minor cuts and bruises.) The previous afternoon, other loaded trucks had used the bridge while about a dozen kids used the swimming hole directly underneath—but luckily the accident took place in the early morning. That was enough for the town: Four steel beams underneath now give it a capacity of 43,000 pounds, although state law says all wooden deck bridges have a top limit of 16,000 pounds. The bridge area still serves as a swimming hole, which has remarkably colored rocks, possibly from local iron.

36. CODDING OR KISSIN' BRIDGE

Other and historical names: Codding Hollow; Jaynes; Upper.
Municipality: Waterville.
Locality: Waterville, near Codding Hollow.
Ownership: Town.
Traffic allowed: Up to 8 tons.
Crossing: North Branch (of the Lamoille River), sometimes called the Kelly River, and Codding Hollow Road.
Built: Around 1877.
Builder: Unknown.
Type: Queenpost.
Dimensions: 62.1 feet long, 11.7 feet wide, 9.8 feet high at trusses, 12.3 feet high at center.
Photography tips: N–S; river access at southeast and northwest corners of bridge.
Getting there: From the Montgomery Bridge in Waterville (visible to the right of Route 109; see No. 35), go 0.5 mile north on Route 109. Then turn right and drive another 0.1 mile to the bridge.
Parking: An adequate turnoff is northwest of the bridge.
Notes: This Waterville bridge, too, was given extra support after an unfortunate incident. In the fall of 1960, a local contractor's gravel-filled dump truck got dumped in the river on its rear end, with the driver escaping uninjured but a passenger suffering a broken arm. Later that year, four steel beams were added beneath. Like the Montgomery Bridge, this secluded bridge has a section of the river suitable for swimming. The sign on the bridge saying KISSIN' was tacked on by a visitor in the 1950s, according to longtime Codding Hollow resident Lloyd Locke, cited by Hagerman. The out-of-towner's prank has since become a local tradition, perhaps because almost all covered bridges were at one time thought of as "kissing bridges" (see Introduction).

37. MILL BRIDGE

Other and historical names: Lumber Mill.
Municipality: Belvidere.
Locality: Between Belvidere Junction and Belvidere Center.
Ownership: Town.
Traffic allowed: Up to 8 tons.
Crossing: North Branch (of the Lamoille River) and Town Highway 3.
Built: 1895.
Builder: Lewis Robinson.
Type: Queenpost.
Dimensions: 70.5 feet long, 12.1 feet wide, 9.9 feet high at trusses, 12.3 feet high at center.
Photography tips: SW–NE; good path to riverbed on southern side.
Getting there: On Route 109 heading north from Waterville, go 1.5 miles from the Waterville Elementary School to just past a concrete-and-steel bridge over the North Branch. Turn left and proceed 0.5 mile to the bridge. This road is also 6.5 miles south of the junction of Routes 109 and 118.
Parking: Good turnoffs are on both sides of the road on either side of the bridge.
Notes: The name Mill Bridge came from a tub factory upstream and a lumber mill downstream. Like many of the five bridges within 5 miles of each

Mill Bridge

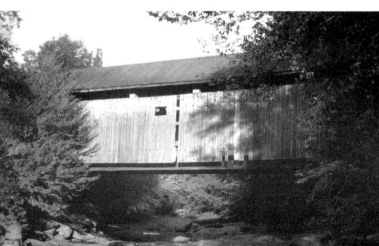

other in this valley, the Mill Bridge was altered (steel beams put underneath in 1971–72) following an accident. On November 30, 1971, a local contractor's snowplow broke through the floor, fortunately catching on a beam by its tailgate. The steel beams went in six weeks later, with new concrete abutments put in place afterward. Note the rounded portal at one end and the squared portal at the other. Also worth noting is the huge erratic (a boulder dropped by a retreating glacier) in a nearby field. In an old Vermont story the tourist asks the farmer, "Where did all these rocks come from?" The farmer replies, "Glacier brought 'em." Tourist: "Where did the glacier go?" Farmer: "Guess it went back to get more rocks."

38. MORGAN BRIDGE

Other and historical names: Upper.
Municipality: Belvidere.
Locality: Between Belvidere Junction and Belvidere Center.
Ownership: Town.
Traffic allowed: Up to 5 tons.
Crossing: North Branch (of the Lamoille River) and Town Highway 2.
Built: 1887; major and possibly total reconstruction in 1898.
Builder: Lewis Robinson; 1898 work by Lewis Robinson, Charles Leonard, Fred Tracy.
Type: Modified queenpost.

Morgan Bridge

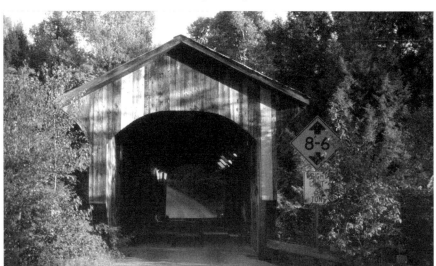

Dimensions: 62 feet long, 12.2 feet wide, 9.2 feet high at trusses, 11.5 feet high at center.

Photography tips: N–S; good streambed access.

Getting there: From the intersection of the road to the Mill Bridge (No. 37) with Route 109, continue north 0.9 mile on Route 109, and then take a road to the left. This bridge is very near Route 109. From the north, this road is 5.6 miles from the junction of Routes 109 and 118.

Parking: Turnoffs are on both sides of the bridge on the north side of the road.

Notes: This bridge was posted against trucks in 1971; for the reason why, see No. 37. So far, steel beams have not been needed. A recent inspection by a state consultant found its floor could probably carry 9 tons, more than the 8-ton statutory limit for wooden-deck bridges. The river pools below are shallow, but a rope hanging from the bridge suggested the area sees use as a swimming hole. Small, square holes in the rocks indicate rusted-out iron pyrites, one sign of the abundant Vermont iron that once supported a thriving early-19th-century iron industry.

39. GIBOU ROAD BRIDGE

Other and historical names: Hectorville; Gibou.

Municipality: Montgomery.

Locality: Hectorville.

Ownership: Town.

Traffic allowed: Closed; nearby concrete-and-steel bridge carries traffic.

Crossing: South Branch (of the Trout River) and (formerly) Gibou Road.

Built: 1883; moved from Montgomery village to Hectorville in 1899.

Builder: Sheldon and Savannah Jewett.

Type: Town lattice.

Dimensions: 54 feet long.

Photography tips: E–W; good river access.

Getting there: From its junction with Route 109, take Route 118 north 6.4 miles. Or go 1.6 miles south of the junction of Routes 118 and 242. Gibou Road goes to the west, and the bridge is only about 0.1 mile from Route 118 along this road. Abandoned buildings, one of which was formerly a church (and is reputed to be haunted), may be a landmark at the intersection with Route 108.

Parking: A secluded site with plenty of turnoffs.

Notes: Notable features include old advertisements still preserved inside and a nearby swimming hole with unusual water-sculpted rocks. With this bridge, we meet Sheldon and Savannah Jewett, who between 1862 and 1890 constructed all the surviving covered bridges in Montgomery and nearby

Gibou Road Bridge

Enosburg, and two more no longer in existence. They had their own sawmill on West Hill, where they prepared hemlock timbers, for the most part. The building method, according to Montgomery's town history, was to move the main timbers over the stream, then the side trusses, after which the top beams were added, the roof put on, and the floor installed. The pair may have been aided from time to time by Jewett brothers Braman, Giles, Oscar, Samuel, Alfred, and William.

40. HUTCHINS BRIDGE

Other and historical names: None known.
Municipality: Montgomery.
Locality: Montgomery Center.
Ownership: Town.
Traffic allowed: Up to 3 tons.
Crossing: South Branch (of the Trout River) and Hutchins Bridge Road.
Built: 1883.
Builder: Sheldon and Savannah Jewett.
Type: Town lattice.
Dimensions: 77.1 feet long, 16.1 feet wide, 8.6 feet high at trusses, 11.1 feet high at center.
Photography tips: E–W.

Getting there: From the intersection of Gibou Road (see No. 39) and Route 118, go north 0.4 mile on Route 118. Or from the intersection of Routes 118 and 242, go south 1.2 miles on Route 118. Hutchins Bridge Road goes west from Route 118, and the bridge is 0.2 mile along that road.

Parking: Go through the bridge to the entrance of a logging road near the southwest corner of the bridge.

Notes: Some of the old fieldstone abutment work remains. There are falls in the river near the bridge, but river access is by a steep path. A state consultant recommended strengthening this bridge to carry truck traffic, since it serves a dead-end road with no alternative route. (See the history of covered-bridge accidents and reinforcements for the Waterville and Belvidere bridges, Nos. 34–38).

41. FULLER BRIDGE

Other and historical names: Blackfalls.
Municipality: Montgomery.
Locality: Montgomery village.
Ownership: Town.
Traffic allowed: Up to 8 tons.
Crossing: Black Falls Brook (sometimes called Mill Brook) and South Richford Road.
Built: 1890.
Builder: Sheldon and Savannah Jewett.
Type: Town lattice.
Dimensions: 49.7 feet long, 16.8 feet wide, 8.9 feet high at trusses, 11.3 feet high at center.
Photography tips: N–S; morning best; side shots may be easiest from NW corner of the bridge, from a street that runs parallel to the stream.
Getting there: From the junction of Routes 118 and 242, take Route 118 north 2.3 miles to where the main highway swings left and the road to South Richford goes straight ahead. The bridge is a little more than 0.1 mile along South Richford Road.
Parking: This is tricky because of the in-town location. The best plan is to go right (east) just south of the bridge, to a parking spot about 100 feet from the bridge.
Notes: This bridge shares in the troubled history of the valley's covered bridges. It was built to replace an uncovered wooden bridge that collapsed under the weight of a four-horse load of bobbins from the Black Falls Bobbin Mill. Renovated in 1981, it was struck by a log truck's loading boom in 1983, which destroyed the roof. As of 1995, it exhibited to an unusual degree a common problem in the area's covered bridges: The treenails—the wooden pins holding the lattices together—were mostly made of beech, and powder

post beetles, which prefer hardwood to softwood, had damaged many of them. Many others had been knocked back into the lattice by traffic, so they were not fully engaged. Still others appeared never to have been long enough to go all the way through the layers of wood, coming up as much as an inch short of doing their job. One pin was missing completely. Consultants recommended $135,000 in repairs or relocating the bridge to a preservation site and constructing a new one, which would cost about $290,000.

Montgomery's town history includes a poem titled "The Covered Bridge" by Elizabeth Fuller, a member of the family that gave its name to the Fuller Bridge:

> *The covered bridge is standing yet*
> *A relic of the past,*
> *'Twas built in 'horse and buggy days,'*
> *When life was not so fast.*
>
> *It's seldom now that wagon wheels—*
> *The trotting of a horse—*

Fuller Bridge

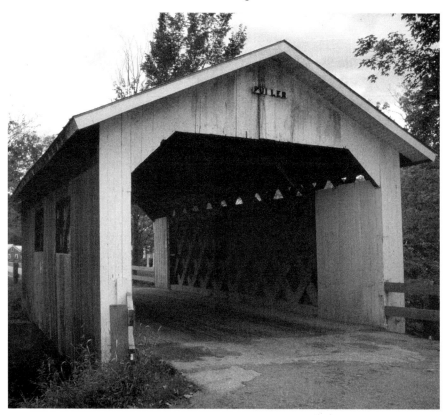

Are heard within the covered bridge,
The changing times, of course.

I once could boast that I could tell
What farmer came to town
By just the way his buggy squeaked,
His horses' hoofs went down.

But now I see a streak of blue,
Sometimes a streak of gray,
An auto has passed through the bridge,
Is speeding on its way.

The bridge was once a haven
On a rainy summer day.
The children in the neighborhood
Would gather there to play.

Sometimes 'twas 'kitty corner,'
Sometimes 'twas 'keeping school,'
A noisy bunch of youngsters
Bent on breaking every rule.

They went climbing up the lattice work
And hiding on the beams,
Calling out to folks who passed,
And scaring all the teams.

The boys would carve initials
Unite what names they pleased,
And then look down in laughter
Because the girls were teased.

But what excitement always reigned
When circus bills were posted
Roaring lions! Acrobats!
All things the circus boasted.

We studied on those circus bills
Where daring stunts were shown
And after painful practice
Had a circus of our own.
But now when children cross the bridge
They're told to hurry through,

And frightened into knowing
What a speeding car might do.

The covered bridge is standing yet
And through its open portals
The cars go dashing day and night
What chance have we poor mortals.

42. COMSTOCK BRIDGE

Other and historical names: None known.
Municipality: Montgomery.
Locality: Montgomery village.
Ownership: Town.
Traffic allowed: Up to 3 tons.
Crossing: Trout River and Comstock Road.
Built: 1883.
Builder: Sheldon and Savannah Jewett.
Type: Town lattice.
Dimensions: 68.9 feet long, 16.3 feet wide, 8.5 feet high at trusses, 11.3 feet high at center.
Photography tips: E–W.

Comstock Bridge

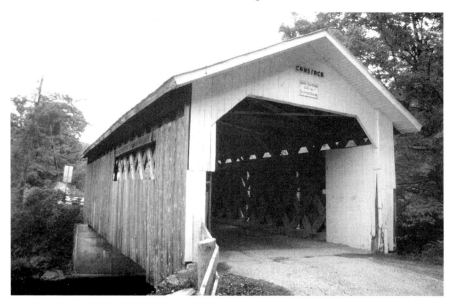

Getting there: The bridge is about halfway down Comstock Road, which forms a loop, connecting twice with Route 118, on the south side of that highway. One end connects with Route 118 near the town green. The other end is 0.4 mile farther along Route 118, a left turn just to the west of a concrete-and-steel bridge (which is within sight of the covered bridge). In both cases, the bridge is about 0.2 mile from Route 118.

Parking: The entrance to a little-used, nonhighway road on the west side is a better place to park than the wide shoulders on the east side.

Notes: The deep, slow river looks as if it might be good for swimming, but streambed access is steep and difficult.

43. LONGLEY BRIDGE

Other and historical names: Harnois; Head.
Municipality: Montgomery.
Locality: Montgomery village.
Ownership: Town.
Traffic allowed: Up to 6 tons.
Crossing: Trout River and Town Highway 4.
Built: 1863.
Builder: Sheldon and Savannah Jewett.
Type: Town lattice.

Longley Bridge

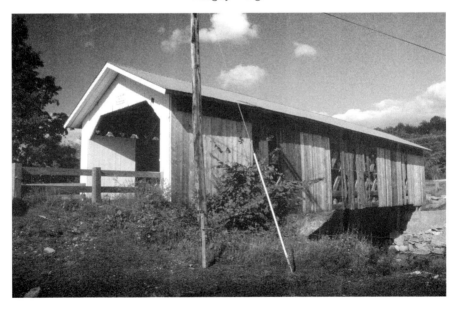

Dimensions: 84.6 feet long, 15.9 feet wide, 8.6 feet high at trusses, 11.3 feet high at center.

Photography tips: E–W; good access for side shots.

Getting there: From the Montgomery town green (intersection with South Richford Road), go 1.1 miles west on Route 118. The bridge is perhaps 100 feet from Route 118, on the left (south).

Parking: There's a good turnoff on Route 118, on the left (east) side.

Notes: A nice picnic and swimming site.

44. HOPKINS BRIDGE

Other and historical names: None known.
Municipality: Enosburg.
Locality: Enosburg.
Ownership: Town.
Traffic allowed: Up to 8 tons.
Crossing: Trout River and Hopkins Road.
Built: 1875.
Builder: Sheldon and Savannah Jewett.
Type: Town lattice.
Dimensions: 90.8 feet long, 16.2 feet wide, 8.7 feet high at trusses, 11.3 feet high at center.

Photography tips: E–W.

Getting there: From the Longley Bridge (No. 43), go 1.4 miles west on Route 118; the Hopkins Bridge will be in plain view close to Route 118, on the left. Or, from its junction with Route 105, take Route 118 for 2.3 miles, and the bridge is on the right.

Parking: Adequate turnoffs.

Notes: A sign preserved into the 1990s reads SLOW AUTO TO 10 MILES AN HOUR HORSES TO A WALK PER ORDER SELECTMEN. A story from Montgomery's town history: A man who owned a fine team of horses, and who freely disregarded such posted admonitions, was brought into court to pay the $5 fine. He handed the judge a $10 bill and told him to keep the change, as he was going back through the bridge again in about 15 minutes.

The Vermont Agency of Transportation's consultant recommended strengthening this bridge, since it serves a dead-end road, at a cost of about $190,000.

45. CREAMERY BRIDGE

Other and historical names: West Hill; Crystal Springs.
Municipality: Montgomery.
Locality: West Hill.

Ownership: Town.

Traffic allowed: Closed.

Crossing: West Hill Brook and abandoned section of Creamery Bridge Road.

Built: 1883.

Builder: Sheldon and Savannah Jewett.

Type: Town lattice.

Dimensions: 58.9 feet long, 15.3 feet wide, 7.5 feet high at trusses, 11.3 feet high at center.

Photography tips: SW–NE.

Getting there: Tricky. On Route 118, about a half mile west of the main intersection in Montgomery, there are three concrete-and-steel bridges in a row, very close to each other. Two roads go south from Route 118, one between the first and second modern bridges, the other between the second and third bridges. Take the second road, Town Highway 11—though it may not be marked as such. Even though this covered bridge has been called the West Hill Bridge, do not be misled by a sign for West Hill Road. Take TH 11 and go 2.6 miles to an intersection and turn left (Creamery Bridge Road). This abandoned road gets worse and worse, so don't go too far. About 0.7 mile in, there's a good parking area before the road goes downhill (beyond which point the road is deeply rutted). The bridge is a short walk away, along the road.

Parking: Stop anywhere beside the road.

Notes: Haunted or not, this bridge can be haunting. Gradually the road falls into ruin, but get out and walk farther. The loudest sounds are birds and

Creamery Bridge

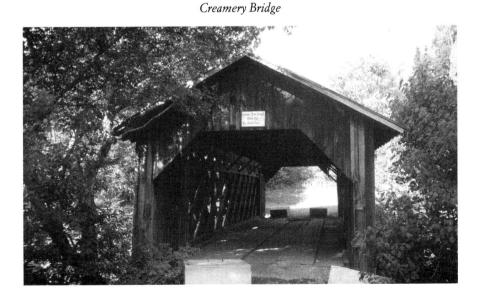

the brook rushing over a waterfall downstream from the bridge. Trees are taking back the land, as if people never really owned it. There is a feeling not just of rural seclusion, but of having come to one of the ends of the earth.

And there is the bridge, falling into ruin itself—holes in the floor, evidence of fires about. (Bring a flashlight if it's getting dark.) Ironically, this was the settlement where the Jewett Brothers got their start, cutting lumber with the waterpower of West Hill Brook. Get out Robert Frost and read "Directive" or "The Need of Being Versed in Country Things."

VII. Brattleboro-Area Tour

WITH THIS BRIDGE tour, we begin an exploration of Vermont east of the Green Mountains. This spine of peaks used to be more of a Great Divide than it is now. Most have forgotten the "mountain rule," which in the days of Republican hegemony a half century ago specified that the governor and lieutenant governor should be from opposite sides of the north–south range. One leg of the tour goes west into the mountain region, ending with an upland bridge in Wilmington, along Route 9. (That highway is called the Molly Stark Trail on maps because General John Stark, marching to the Battle of Bennington from New Hampshire—see introduction to Tour 1—declared that the rebels would defeat the British or Molly Stark would be a widow.) Route 9 offers inspiring vistas, with good turnoffs and even a skyline restaurant dedicated to the views.

These days, the Connecticut River Valley is something of an invasion route for what some native Vermonters see as a takeover by "flatlanders." Southeastern Vermont generally is a sophisticated place, with many summer music festivals, art galleries, and second-home developments that help support them. But since the newcomers are usually bent on keeping Vermont from going the way of northern New Jersey or the areas north of Boston, this trend has benefited historic preservation—as will be seen in this and the next two tours.

Possible attractions along the way include the **Brattleboro Museum and Art Center** (802-257-0124), in the former Union Railroad Station. Visitors to Wilmington should be aware of the **Luman Nelson Museum of New England Wildlife** (802-464-5535), which may help newcomers to Vermont gain a sense of what live around the covered bridges and appear along roadsides. Bellows Falls, an area of Rockingham just a bit to the north of this bridge tour, is rich in historic sites; for more details, see the introduction to the next tour.

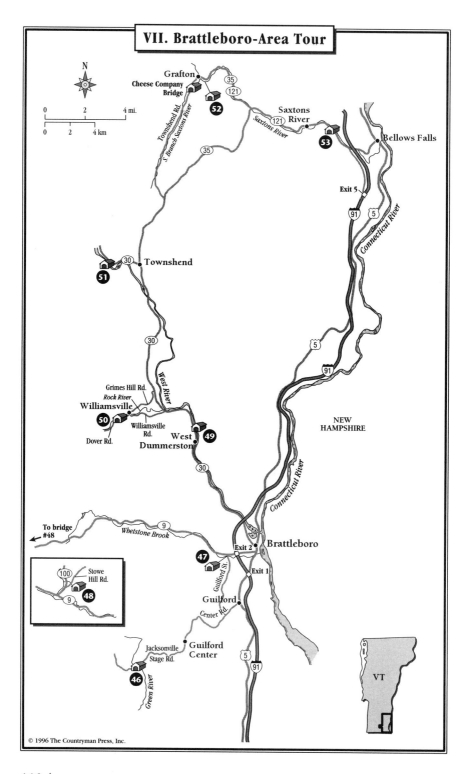

But on this route, the grand example of historic preservation lending itself to heritage tourism is Grafton, a village of about 600 with a regional reputation. Its ambience, if not its character, has been reshaped by the presence of philanthropist Dean Mathey's **Windham Foundation,** a major supporter of preservation efforts in the state. Since 1963, that organization has helped restore many of the village buildings, and interprets its surroundings through exhibits at its headquarters on Townshend Road. (An information center on that road, which goes south off Main Street, has maps and brochures.) The foundation gets part of its money from operating a restored 18th-century tavern that has accommodated the likes of Daniel Webster, Henry David Thoreau, Ulysses S. Grant, and Rudyard Kipling, who created a significant chapter of his life near Brattleboro. Not only is there the unusually professional **Grafton Historical Society Museum,** but there is a local **Museum of Natural History** as well. And of course numerous shops have sprung up to serve visitors' needs for antiques, crafts, and gourmet food. The effect is perhaps a bit too cute to reproduce the decades when Grafton quarried soapstone and tended more than 10,000 sheep, but there's a true love of the past that shines through. And as one brochure puts it, "Grafton's uniqueness, however, comes from being a real town—not a museumlike town—with its citizens being its most valuable resource." That's generally true in Vermont, even in places like Manchester and Woodstock that, by comparison with poorer towns, have developed reputations for artificiality and overcommercialization.

In looking through the histories of individual covered bridges, a reader will again and again find reference to disastrous floods. The Flood of 1927 is the benchmark disaster, having taken out between 200 and 500 covered bridges, depending on who is doing the estimating. But in southeastern Vermont, the Freshet of 1869 for many years had that reputation. Probably the result of a spent hurricane—it took place in early October—it followed rains so intense that rivers rose 6 feet in an hour. As soon as one upstream bridge's abutments washed out or the bridge was swept off its foundations, it joined the floating mass of uprooted trees and smashed houses to become a battering ram for the next bridge downstream, and so on. Note the number of bridges in this region dating from around 1870.

Reforestation (85 to 90 percent of Vermont was denuded of trees during the sheep craze of the mid-19th century), respect for wetlands, and the construction of flood-control dams along the Connecticut River (whose headwaters extend into the northern tip of New Hampshire) have helped reduce the danger. Vermont's strong environmentalism is not simply a recent trend; the Flood of 1927 in particular was a wake-up call in that regard.

46. GREEN RIVER BRIDGE

Other and historical names: None known.
Municipality: Guilford.
Locality: Green River.
Ownership: Town.
Traffic allowed: Up to 8 tons.
Crossing: Green River and Jacksonville Stage Road.
Built: 1870.
Builder: Marcus Worden; abutments by M.H. Day.
Type: Town lattice.
Dimensions: 104 feet long.
Photography tips: ENE–WSW.

Getting there: A Vermont classic. This author has in his files a plaintive letter asking if the Green River Bridge really exists, because it was impossible to find in the tangle of poorly marked backcountry roads. A prolonged road test and the town clerk's opinion concurred: The safest route is to go from Guilford to Guilford Center to Green River. Guilford is on Route 5 and can be reached from Exit 1 on I-91. From Guilford, take the Guilford Center Road southwest about 4 miles to Guilford Center, then another 0.6 mile south to a fork. Take the road to the right, Jacksonville Stage Road, another 2.4 miles to the bridge. If you get lost, don't panic. By going east, you will eventually reach Route 5 (one of Vermont's major north–south routes) and can try again.

Green River Bridge

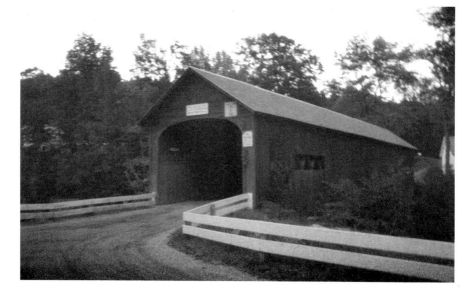

Parking: A sign says not to park within 100 feet of the bridge. This leaves the farthest part of the intersection on the east side of the bridge as about the only feasible alternative.

Notes: This bridge was built to replace one lost in the Freshet of 1869, which took out all the Green River bridges and even one end of a house by this crossing. There is a dam upstream. Signs saying POST NO BILLS and TWO DOLLAR FINE TO DRIVE IN THIS BRIDGE FASTER THAN A WALK remain. Rural seclusion has allowed the village to put its bridge to creative uses. At one time, a town derrick was stored there. Since at least the 1950s, the neighborhood has kept its mailboxes within the bridge. One theory: Even the post office has a hard time finding its way around in this neck of the woods.

47. CREAMERY BRIDGE

Other and historical names: Centerville.
Municipality: Brattleboro.
Locality: Brattleboro.
Ownership: City.
Traffic allowed: Up to 6 tons.
Crossing: Whetstone Brook and Guilford Street.
Built: 1879; walkway and slate roof added 1917.
Builder: Team of 13 local builders and suppliers: B.A. Clark, C.F. Thompson, S.N. Herrick, J.A. Church, Thomas Mitchell, D.W. Miller, L.G. Pratt, A.H. Stowe, H.C. Winchester, W.H. Fisher, John Hood, J.N. Herrick, and T.P. Knight.
Type: Town lattice.
Dimensions: 80 feet long, 16 feet wide, 9.2 feet high at trusses, 11.7 feet high at center.

Creamery Bridge

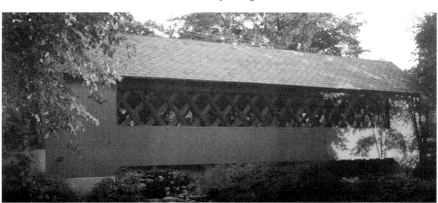

Photography tips: NE–SW; afternoon better (access to shooting site); painted red; can get to stream from ENE corner of bridge.

Getting there: From Exit 2 on I-91, take Route 9 west a little more than 0.3 mile, and the bridge will be close to the highway on the left (south).

Parking: There's plenty at a space called Living Memorial Park, on the south side of Route 9 just east of the bridge.

Notes: It's easy to see why the town put a walkway on this bridge, with all the traffic zooming about. Be careful while exploring. (At one point early in this century, a boy was paid $2 a year to tend oil lanterns in the bridge at night.) The traffic is high because Guilford Street connects Route 5 with Western Avenue, in effect acting as a bypass route between the south and west sides of the city. It's a tribute both to the bridge (which still has its authentic form) and to the town that it survives as the only covered bridge visible from Route 9.

The name Creamery refers to the former Brattleboro Creamery. Creameries were the milk plants of the milk-can era, before stainless steel bulk tanks and milk trucks transformed dairying, putting many small farms and local creameries out of business.

The Creamery Bridge was built to replace one lost in a November 1878 freshet. The cost was $1037.80, lower than the estimate of well-known Greenfield, Massachusetts, bridge builder A.H. Wright, the selectmen reported to the town. Also, the local carpenters used spruce, which was somewhat better than the hemlock Wright specified in his bid, and some of the timbers were a half inch thicker.

In the 1960s this bridge became known nationally for its Christmas decorations, which included Santa and his reindeer on the roof.

48. HIGH MOWING FARM BRIDGE

Other and historical names: Twin Silos.
Municipality: Wilmington.
Locality: Wilmingon.
Ownership: Private.
Traffic allowed: Private.
Crossing: Unnamed tributary of the Deerfield River.
Built: 1949.
Builder: Haynes Brothers, Inc., of Wilmington.
Type: Town lattice.
Dimensions: 22 feet long, 12 feet wide.
Photography tips: NNE–SSW; contrast of small, shapely bridge and remarkable mountainside setting makes this a favorite; afternoon best.
Getting there: Follow Route 9 to Wilmington. Take Route 100 north 0.5 mile to where Stowe Hill Road angles off to the right, going uphill as it leaves

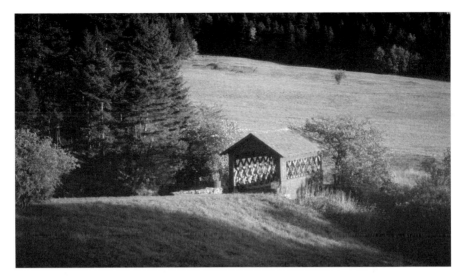

High Mowing Farm Bridge

Route 100. (Stowe Hill Road is 0.4 mile north of the Pettee Memorial Library.) Take Stowe Hill Road about 1.2 miles, and the bridge should be visible in the fields downhill to the south.

Parking: There's adequate shoulder space on Stowe Hill Road. The bridge's owners say it's all right to park briefly in the driveway and walk into the fields to take photos; please don't try to drive onto the bridge, though.

Notes: At one time the farm with the covered bridge and the buildings across the road were part of the same property, and the twin silos across the road gave the bridge one of its names. Twin Silos later became a lodging house and then a private school. Former owner Arthur D. Pinkham had this bridge built to give access to 50 of his 500 acres that had been cleared of rocks and turned into pasture. The main users of the bridge at that time were sheep. In design, this bridge is said to have been loosely modeled on the Creamery Bridge in Brattleboro.

49. WEST DUMMERSTON BRIDGE

Other and historical names: None known.
Municipality: Dummerston.
Locality: West Dummerston.
Ownership: Town.
Traffic allowed: Closed for repairs in 1993.
Crossing: West River and the East-West Road.
Built: 1872.
Builder: Caleb B. Lamson.

Type: Town lattice.

Dimensions: 280 feet long, in two spans.

Photography tips: WNW–ESE; great side and bottom shots possible.

Getting there: Not hard, since the bridge is right by Route 30, seven miles north of that highway's junction with Route 5 in downtown Brattleboro.

Parking: A parking lot on the Route 30 side serves visitors, including swimmers who come there in the summer.

Notes: The Freshet of 1869, mentioned in connection with the Green River Bridge (see No. 46), broke a previous covered bridge in two, a quarter mile upstream from this one. Townspeople argued long and hard over where to site the new bridge and 3 years later spent $7777.08 to put up a good one—much more than the $2000 or less usually spent on covered bridges at that time. Caleb Lamson directed the construction of what is now the longest covered bridge in highway use entirely within Vermont when he was just 22. (He is said to have already been a skilled carpenter in his teens.) But a problem with the falsework—the scaffolding propping up the bridge during construction— nearly cost him his life. He was standing atop the partially built bridge, halfway across the river, when the props collapsed. He avoided being crushed by waiting to see which way the bridge would go before jumping—but even so, he landed on rocks in the stream and permanently damaged his back. A young man watching the construction work was not so fortunate: He waited too long, and a timber struck his head and killed him.

The bridge has recently been the subject of a major restoration. It was closed in November 1993, and after May 1994 a temporary steel Mabey bridge

West Dummerston Bridge

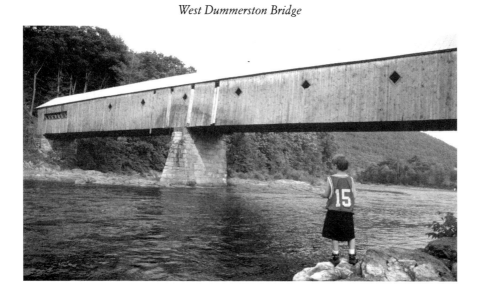

helped townspeople avoid what would otherwise have been a 15-mile detour. In December 1994, a special Town Meeting approved spending up to $621,000, of which 10 percent would be paid locally. Jan Lewandoski, of Stannard, did emergency repairs, using cables and braces to correct the bridge's sideways lean. Fay, Spofford, and Thorndike, of Bedford, New Hampshire, were hired to do the engineering for the major repairs.

50. WILLIAMSVILLE BRIDGE

Other and historical names: None known.
Municipality: Newfane.
Locality: Between Williamsville and South Newfane.
Ownership: Town.
Traffic allowed: Up to 10 tons.
Crossing: Rock River and Dover Road.
Built: Most sources say around 1870; a number of local informants told the *Brattleboro Reformer* in the 1920s that it was older than an 1837 bridge then standing in the area.
Builder: Eugene P. Wheeler.
Type: Town lattice.
Dimensions: 117.9 feet long, 16.8 feet wide, 9.5 feet high at trusses, 11.8 feet high at center.
Photography tips: ENE–WSW.

Williamsville Bridge

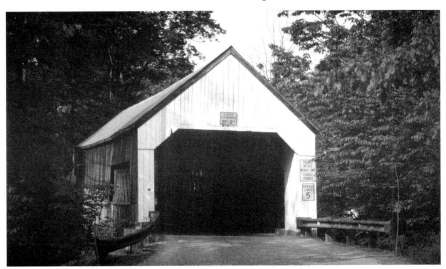

Getting there: Head north on Route 30 after passing the West Dummerston Bridge (No. 49). Route 30 makes a sweeping turn to the left (west). Then look for a road to the left—Williamsville Road—just before a concrete-and-steel bridge. Take Williamsville Road 1.9 miles to where it ends in a T-intersection. Go left. This is Grimes Hill Road; there should be a fire station 0.1 mile along the way. About 0.3 mile to the west of the T-intersection, at a fork in the road, go left onto Dover Road. The bridge is 0.3 mile from the fork.

Parking: There's a good turnoff through the bridge, on the east side of Dover Road, about 100 feet from the bridge.

Notes: This is a troubled bridge, slowly but surely being pounded to pieces by ski area and truck traffic. It's on a class 2 road; in Vermont, class 1 roads are state highways, class 3 roads are the usual local roads, class 4 roads are unmaintained but locally owned trails, and class 2 roads are major connectors between highways. The recent Vermont Agency of Transportation study recommended looking into relocating this bridge for preservation purposes and replacing it, due to the inability to enforce load restrictions and the likelihood of vehicular collisions. Immediate repairs alone were estimated at about $100,000. Steel beams were added beneath the floor at one point, but were replaced with wooden beams again in 1980. To be more visible to drivers at night, the bridge's portals are painted white, as they have been for about 70 years.

51. SCOTT BRIDGE

Other and historical names: None known.
Municipality: Townshend.
Locality: Between Townshend and West Townshend.
Ownership: State Division for Historic Preservation.
Traffic allowed: Closed; state historic site since 1955.
Crossing: West River and closed section of Back Side Road.
Built: 1870; concrete pier added under main span 1980–81.
Builder: Harrison Chamberlain; pier added by Robert Farley.
Type: Town lattice with added arch, plus two kingposts with Howe-type metal rods for verticals.
Dimensions: 276 feet overall; 166-foot Town lattice is one of three spans.
Photography tips: ENE–WSW.
Getting there: No problem. The bridge is about 50 feet west of Route 30, easily visible even at night, 1.5 miles south of Route 30's junction with Route 35 in Townshend. To reach the west side of the bridge, cross the West River on the Army Corps of Engineers dam just north of the bridge, and turn left at the T-intersection onto State Forest Road. The road to the dam is a little less than 1 mile north of the bridge on Route 30.
Parking: There's a designated turnoff with a historical sign on the east side. Turnoffs are adequate on the west side.

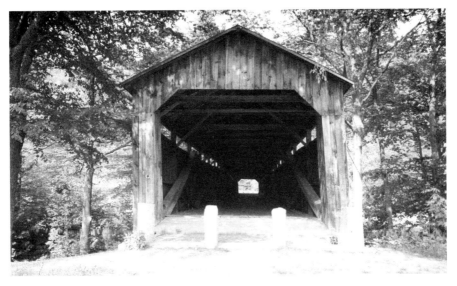

Scott Bridge

Notes: This goofy, lovable bridge is a joy to visit, combining interesting construction, a big river's best swimming hole, and even the chance to picnic on a sandy "beach" directly under the west end of the bridge. In engineering terms, it's a piece of high comedy. Its Town lattice is Vermont's longest single span (the West Dummerston Bridge, No. 49, is two-span). Because the stress was so great, a Burr-type arch was added later for extra support. The lattice's first roof fell in and had to be replaced (a town report shows $11 was paid to clear away the fallen roof). The two kingpost sections, originally not covered but given a roof in 1873, were added to make a two-span section across a dry gully on the west side, meaning the Scott Bridge is in effect a patchwork of two bridges. With time, the long span's weight made the arch go negative—actually bend up at the ends—imperiling the structure's survival. The local selectmen were ready to burn it for lack of the nearly $20,000 needed for repairs, and gladly handed it over to the state, with chairman Aubrey Stratton being instrumental in the transfer.

The Scott Bridge, named for the Henry Scott dwelling that used to be at the west end, was built following the Freshet of 1869, which destroyed a bridge somewhat to the south. The 1870 bridge cost $5200 and used 51,514 board feet of lumber. The kingpost roof cost $207.03. The Flood of 1927 threatened to wash out the western pier, but the undermining of the banks was stemmed by dumping in the rocks from several stone walls. The flood was said to have improved the swimming hole.

A 1937 publication by the *Brattleboro Reformer* recounts the following incident in connection with the Scott Bridge: "Many years ago Seth Allen of West Townshend was hired to reshingle part of it. Allen was given to doing things

somewhat differently from anyone else, and he decided to do part of his work by moonlight. He used no stagings, and unless one happened to see him on the roof there was no sign of activity. Late one moonlit night, Leslie Lowe, who lived on the west hill, drove back from Townshend village behind his old horse, Jerry. All was silent as he entered the darkness of the bridge. Suddenly, when he was about halfway across, hammering began above his head. What it was, Lowe could not imagine, and Jerry gave him no time to puzzle it out. The old horse decided quickly and finally that the devil was after him, and he started [running] at top speed. There ensued one of the wildest rides Leslie Lowe ever took, and had not the hill road finally winded Jerry, he might have been running until morning."

The trip across the Townshend Dam is worth taking, and can be spooky when the impoundment is dry. One can only imagine the farmsteads that once occupied the flood-control area—just as one can only imagine the covered bridges lost in the Freshet of 1869 and others. But there was a survivor: a covered bridge from the so-called Victorian Village, which was rescued when it was moved to the Vermont Country Store (see No. 54).

52. KIDDER HILL BRIDGE

Other and historical names: None known.
Municipality: Grafton.
Locality: Grafton; formerly led to Bear Hill District.
Ownership: Town.
Traffic allowed: Up to 8 tons.
Crossing: South Branch (of Saxtons River) and Kidder Hill Road.
Built: 1870.
Builder: Unknown.
Type: Modified kingpost.
Dimensions: 67 feet long, 10 feet wide, 11.5 feet high at trusses, 12 feet high at center.
Photography tips: NNW–SSE.
Getting there: The northern end of Kidder Hill Road is a stone's throw from the intersection of Routes 121 and 35 in the village of Grafton. Take Route 35/121 west, and just across a concrete-and-steel bridge, turn left onto Kidder Hill Road. The bridge is about 0.2 mile down that road.
Parking: The best spot is just beyond the bridge, but the shoulders on Kidder Hill Road are adequate.
Notes: This was yet another of the bridges on this tour built after the Freshet of 1869 devastated the valley. In its heyday, this bridge held the weight of wagonloads of soapstone from a quarry and finishing mill on Bear Hill to the south. Recently it made headlines when a massive community effort led to a

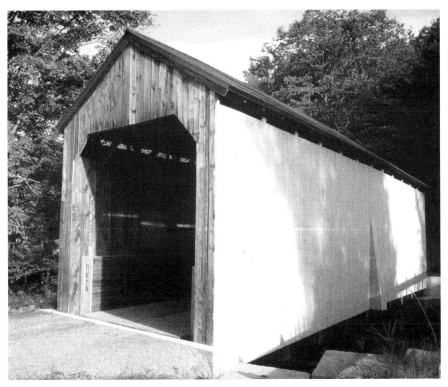

Kidder Hill Bridge

complete restoration. Voters approved $28,000 in tax appropriations, appeals to individuals brought in $42,000, there were grants from the Grafton Improvement Association and the Windham Foundation, and Vermont Agency of Transportation money made up the rest of the $160,000 renovation cost. F.W. Whitcomb did the restoration work, while Dion & Stevens handled the engineering. On September 3, 1995, about 100 residents gathered to celebrate the bridge's reopening with speeches, a chicken dinner, and music by the Turkey Mountain Window Smashers.

In the restoration, the structure was strengthened to carry fire trucks and other heavy loads by adding two glue-laminated beams. These are the two lighter-colored items that look like storage cases or protective barriers on the sides of the interior between the roadway and the trusses. The use of Glulam timbers—the trade name is used generically among bridge builders—has sparked controversy. Covered-bridge preservationists say this modern combination of wood fiber and resin spoils a bridge's authenticity. Others say Glulam is a reasonable compromise, better than adding steel beams, given the impossibility of finding replacement timbers as strong as those from the old-growth trees present earlier in the state's history (see Introduction).

53. HALL BRIDGE

Other and historical names: Osgood.
Municipality: Rockingham.
Locality: Saxtons River.
Ownership: Town.
Traffic allowed: Up to 4 tons.
Crossing: Saxtons River and Paradise Hill Road.
Built: Original bridge probably built around 1870; destroyed by overloaded truck in 1980; authentic replacement in 1982.
Builder: Original builder unknown; replacement by Milton S. Graton and his associates.
Type: Town lattice.
Dimensions: 120.5 feet long, 11.7 feet wide, 10.6 feet high at trusses, 14.2 feet high at center.
Photography tips: SW–NE; riverside access at both corners on the Route 121 side, but steep.
Getting there: From Grafton, go east on Route 35/121, and continue on Route 121. The bridge will be easily visible on the left about a mile after passing through the village of Saxtons River. More precisely, from the junction of Route 5 with Routes 12 and 121 in Bellows Falls (there's a stoplight), take Route 121 west 3.2 miles (the road should pass under I-91 at the 1.7-mile point). The bridge should be immediately to the right.

To reach the Victorian Village Bridge, which begins the next tour's series of bridges (see No. 54), continue west on Route 121 after the Hall Bridge, and after 1.4 miles turn right on Pleasant Valley Road. Route 103 is 4.7 miles away, and the Victorian Village Bridge is 0.6 mile to the right (southeast). This can save a lot of trouble backtracking and dealing with Route 5 traffic.

Parking: This is one of the worst. The land across the bridge is private and posted against trespassing; it might be possible to ask permission to park (the landowner could not be contacted). One solution: Drive through the bridge, turn around, come back through, and park on the far right of the paved, triangular entranceway, where other vehicles coming to the bridge are unlikely to hit you.

Notes: Like other bridges along the Saxtons River, the Hall Bridge was probably built after the Freshet of 1869. The name Barber Park is sometimes associated with it, but local sources say this is probably a confusion with its longtime role: giving people access to Barber Park, a recreation center once reached by trolley as well.

In 1980, an overweight truck came onto the bridge, which started making alarming noises. The driver stopped, got out, and ran for his life. Had he kept going, the bridge might have survived, according to Eric Gilbertson, for many years the head of Vermont's Division for Historic Preservation, who arrived at the scene soon after the incident. It was the only time he ever saw a Town

lattice truss fail, as opposed to a truck going through weak flooring (see Introduction).

A settlement with the trucking company's insurance firm allowed the town to contract with the late Milton S. Graton of Ashland, New Hampshire, for a replacement covered bridge. An absolute stickler for authenticity, Graton even insisted on hauling the new bridge's trusses onto the falsework spanning the stream by the old method: a team of oxen.

As with Woodstock's Middle Bridge, also built by Graton Associates (see No. 68), the result was a monument to the continuing viability of wooden bridges. Somewhat narrower and somewhat taller than most covered bridges, the Hall Bridge has some of the feeling of covered railroad bridges, and some of their strength. The 4-ton traffic limit is intended to reduce wear and tear more than to reflect the bridge's actual carrying capacity. The state's bridge consultants estimated the floor could hold 22,000 pounds, while Town lattice trusses generally can support 40,000 pounds. As one Vermont Agency of Transportation official said, "That thing would probably take a Sherman tank."

Also on this tour

IN GRAFTON, THE **Cheese Company Bridge** is one of the most photographed bridges in Vermont, although it's only a small, wood-covered stringer bridge. One of its authentic attractions is a circus poster, of the kind long since scraped off Vermont's authentic covered bridges. It's next to the Grafton Village Cheese Company (which sells Covered Bridge Cheese through a store chain), crossing the South Branch of the Saxtons River, although it does not carry vehicular traffic. From the junction of Routes 121 and 35, go west to the Old Tavern, turn left onto Townshend Road, and go 0.5 mile. An information center is along the way, as well as the headquarters of the Windham Foundation, the historic preservation group behind much of what a traveler sees in Grafton (see tour introduction).

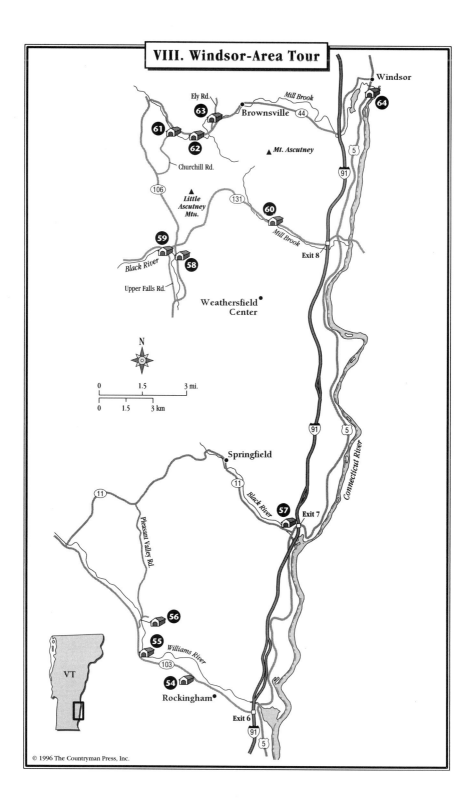

Windsor

64

Ely Rd.
63
Mill Brook
Brownsville 44

61
62

Mt. Ascutney

Churchill Rd.

5

91

106

Little
Ascutney
Mtn.

131

60

Mill Brook

59

Exit 8

Black River

58

Upper Falls Rd.

Weathersfield
Center

N

0 1.5 3 mi.

0 1.5 3 km

Springfield

11

11

Black River

57 Exit 7

Pleasant Valley Rd.

Connecticut River

91 5

56

55 Williams River

VT

103

54

Rockingham

Exit 6

91
5

VIII. Windsor-Area Tour

A S YOU MOVE north along the Connecticut River, the Green Mountain landform region narrows somewhat and, for the first time, you encounter the area geologists know as the Vermont Piedmont. More hilly than mountainous, it lent itself to the development of small farms and small towns in the river valleys that form part of the Connecticut River Basin.

The bridges along this route have been chosen so that starting in the Bellows Falls area of Rockingham, it will be possible to see three bridges along Route 103, swing back through Springfield to see a bridge and historic site near the Connecticut River on Route 11, then go north on Routes 11 and 106 to the three bridges in Weathersfield (one on Route 106, two on Route 131 to the east), continue north up Route 106 to find three bridges to the east on Route 44, and end with the magnificent Cornish-Windsor Bridge across the Connecticut. This somewhat arbitrary collection of bridges can be divided into segments by going up the Connecticut River Valley to pick and choose branch routes (Route 103, Route 131, Route 44), but the foothill countryside generally makes for a more interesting drive.

Those more focused on engineering may find themselves lingering in Bellows Falls, Springfield, and Windsor. Bellows Falls—noteworthy as the site of the first major wooden bridge in the country in 1785 (see Introduction)—still has the rocky bend in the river that stopped boat traffic until a canal was built. The power from the falls there, now dammed, made this an industrial center as well as a major crossroads. The **Great Falls Regional Chamber of Commerce** (802-463-4280) has prepared a brochure that helps visitors find Indian petroglyphs, the Bellows Falls Historical Society's **Adams Old Stone Gristmill Museum**, the **Rockingham Free Library and Museum** (802-463-4270), a powerhouse visitors center near a fish ladder for migrating salmon,

railroad structures, historic houses, and even a 1920s Worcester Lunch Car Company highway diner. Of special note is the nearby **Rockingham Meeting House,** dating from 1785. Timber framed like the covered bridges and barns, and like the European cathedrals before them, the meetinghouse has been described as "a Medieval structure in Puritan-style clothing." Ask the chamber of commerce about the annual pilgrimage to this site each August.

In Springfield, still a center of the machine tool industry, the Black River dropped 100 feet in about an eighth of a mile, providing waterpower for numerous industries. The **Springfield Art and Historical Society** has a museum there (802-885-2415).

Windsor has the restored **Old Constitution House** (802-672-3773), formerly Elijah West's Tavern, where on July 8, 1777, delegates from the future 14th state adopted the constitution for an independent Republic of Vermont. (It was the first American constitution to ban slavery, institute manhood suffrage without property or income requirements, and establish a system of public schools.) Perhaps of greater relevance to the covered-bridge era is the **American Precision Museum** (802-674-5781), located in a former armory and machine shop, which will help evoke the surge of inventiveness in early-19th-century America that included unprecedented advances in wooden-bridge design (see Introduction). It's part of a Windsor Village Historic District that also includes a state crafts center at **Windsor House** (802-674-6729), which honors Vermont inventiveness in a different way.

En route, the **Vermont Country Store** has a restored gristmill next to its private covered bridge (see No. 54), and the state-owned **Baltimore Bridge** (No. 57) is part of a site that includes a restored and furnished one-room schoolhouse. In Weathersfield Center, the **Reverend Dan Foster House and the Old Forge** (802-263-5230) opens for the summer and fall.

54. VICTORIAN VILLAGE BRIDGE

Other and historical names: Depot.
Municipality: Rockingham.
Locality: Rockingham.
Ownership: Private.
Traffic allowed: Cars.
Crossing: Parking lot road and unnamed brook.
Built: 1872; dismantled in 1959; modified and rebuilt in 1967.
Builder: Harrison Chamberlain; rebuilt by Aubrey Stratton.
Type: Modified kingpost (Howe-type iron centerposts); originally queen-post.
Dimensions: Unknown.
Photography tips: NW–SE.
Getting there: The three Rockingham township bridges are closely strung

Victorian Village Bridge

together, and all are close to Route 103 on their side roads. Starting at the junction of I-91 and Route 103, look for the Rockingham Meeting House on the left (west) after 1.1 miles. At 1.9 miles down Route 103, you'll pass a town garage with a five-bay garage and two sheds on the right. After 2.3 miles, you'll come to the Vermont Country Store on the left, and the Victorian Village Bridge is visible on the lane off the parking lot.

Parking: Ample commercial parking lot.

Notes: Vrest Orton, founder of a series of shops and a mail-order business by the name of the Vermont Country Store, happened to be chairman of the Vermont Historic Sites Commission, predecessor of the Division for Historic Preservation, when the Army Corps of Engineers was building a flood-control dam and reservoir in Townshend (see Scott Bridge, No. 51). He was able to rescue the Depot Bridge from the reservoir area. The army engineers numbered its pieces and took it apart, after which it was stored on the farm of Aubrey Stratton, at that time a Townshend selectman. When the Vermont Country Store's Rockingham outlet started construction in 1966, the bridge was transferred to that site. It now leads to a restored early-19th-century gristmill, complete with authentic 42-inch grinding stones (brought from France as ballast in sailing ships). The waterwheel at the mill was the last made by the last US manufacturer of such wheels, just before the Pennsylvania firm went out of business.

55. WORRALL BRIDGE

Other and historical names: None known.
Municipality: Rockingham.
Locality: Bartonsville.
Ownership: Town.
Traffic allowed: Up to 8 tons.
Crossing: Williams River and Williams Road.
Built: Around 1870.
Builder: Sanford Granger.
Type: Town lattice.
Dimensions: 82.5 feet long, 14.4 feet wide, 9.2 feet high at trusses, 11.9 feet high at center.
Photography tips: SW–NE.
Getting there: Follow Route 103 4.7 miles northwest of its junction with I-91. Turn right on Williams Road. Worrall Bridge is 0.1 mile from the turn. This bridge is just west of the Victorian Village Bridge (No. 54) on Route 103; for more detailed directions, see No. 54.
Parking: A small turnoff is on the west side of the bridge; there are also turnoffs on both sides of the road on the east side (the owner of the house near the northeast corner of the bridge said it's okay to use the spot next to the northeast corner).
Notes: This is another Freshet of 1869 bridge, according to 1937 research by the *Brattleboro Reformer*. That story predicted the imminent end of the bridge, since a flood in 1936 had washed away much of the earth around one abutment and had caused other damage. Today, the wooden ramp bridging the flood erosion is still there, an unusual feature among Vermont's covered bridges. The swimming hole use also dates back to that period. The bridge's portals are notable for their large overhang and Granger's effort to make the sides resemble classical pillars.

56. BARTONSVILLE BRIDGE

Other and historical names: None known.
Municipality: Rockingham.
Locality: Bartonsville.
Ownership: Town.
Traffic allowed: State consultants recommend a 3-ton limit.
Crossing: Williams River and Lower Bartonsville Road.
Built: 1870.
Builder: Sanford Granger.
Type: Town lattice.

Dimensions: 159 feet long, 14.7 feet wide, 8.8 feet high at trusses, 11.1 feet high at center.

Photography tips: WSW–ENE; very good streambed access.

Getting there: At 5 miles northwest of the intersection of I-91 and Route 103, turn right onto the road to Lower Bartonsville to the north. The Bartonsville Bridge is 0.3 mile down, just across railroad tracks. This bridge is just west of the Worrall Bridge along Route 103. For an overview of the driving instructions, see No. 54.

Parking: Use the parking lot on the west side of the railroad, to the north of the road.

Notes: A magnificent span, this is one of the state's longest. This bridge, like the Worrall Bridge (No. 55), was constructed after a previous bridge vanished in the Freshet of 1869. Here, that flood also took out a Rutland Railroad station and several houses. This has been a tough valley for covered bridges. Rockingham, which now has three of its original covered bridges, at one time had 17 of them, including railroad bridges, according to a 1973 National Register of Historic Places nomination for the Worrall Bridge by researcher Hugh Henry. The Saxtons River Bridge was the most recent casualty, felled in October 1980 by a truck overload. That incident may have helped save the Bartonsville Bridge. It was closed in 1982, partly because of repeated violations of its 5-ton weight limit, and extensively repaired in 1983 by Bancroft Construction of South Paris, Maine, so it could take truck traffic.

A small concrete-railing bridge between the covered bridge and Route 103 is—like a larger structure farther west on Route 103, just before the intersec-

Bartonsville Bridge

tion with Route 11—typical of 1930s construction. Many such Depression-era public works bridges dot the Vermont landscape, further evidence of the ravages of the Flood of 1927. Today, so many of those six-decade-old concrete-and-steel bridges are calling out for replacement, together with old all-metal bridges, that state bridge funds are literally overtaxed. That in turn has been a continuing problem for those seeking funds to repair and maintain covered bridges. The age-old contest between floods and bridges goes on.

57. BALTIMORE BRIDGE

Other and historical names: None known.
Municipality: Springfield.
Locality: Springfield.
Ownership: State Division for Historic Preservation.
Traffic allowed: None possible; off road.
Crossing: Unnamed brook.
Built: 1870.
Builder: Granville Leland, superintendent; Dennis Allen, framer.
Type: Town lattice.
Dimensions: 37 feet long.
Photography tips: SE–NW.
Getting there: From Exit 7 on I-91, go south on Route 5 and almost immediately go west on Route 11. The bridge is about 0.9 mile from the interstate, on the north side of Route 11, easily visible.

Baltimore Bridge

Parking: No problem: state historic site.

Notes: At one time this bridge crossed Great Brook in North Springfield, one of a pair of bridges over that stream. It was on the main road to the tiny mountain town of Baltimore, hence its name. An old book on the bridges of Windham County commented that in its former location it had "a gaunt and neglected appearance." It's now showered with attention.

It was closed by the town in 1967, at which point it was "badly twisted" and leaking onto its bottom carrying timbers, according to a book by Milton S. Graton, the Ashland, New Hampshire, covered-bridge builder. He put in a bid to restore it, but the town rejected the figure as being too low—perhaps underestimating how much experience he had and how efficient his team had become. Two years later, former US Senator Ralph Flanders headed a committee to restore the Baltimore Bridge and move it to a new site, next to the Eureka Schoolhouse on Route 11. Vermont's oldest surviving schoolhouse, Eureka had been in use from 1785 to 1900 in the Eureka Four Corners section of the town. A committee of local citizens had worked with the Vermont Board of Historic Sites to move it to the more accessible location in 1968. Flanders had been instrumental in that move as well: He took the schoolhouse down and stored it in his barn when it had deteriorated to the danger point.

Graton Associates undertook an extensive restoration, and in 1970 moved the bridge 7 miles to its new site after removing its roof so it would clear other bridges en route. The stones for its new abutment were salvaged from the old crossing—a typical Graton touch. His price for the job: $10,000, which the local committee insisted on raising to $10,500.

The restored schoolhouse is furnished with period chairs, desks, pictures, and blackboards, effectively evoking another side of life in the classic covered-bridge era.

58. TITCOMB BRIDGE

Other and historical names: Stoughton.
Municipality: Weathersfield.
Locality: Perkinsville.
Ownership: Private.
Traffic allowed: Off road; private.
Crossing: Schoolhouse Brook and an unnamed farmstead road.
Built: Around 1880.
Builder: James F. Tasker.
Type: Multiple kingpost.
Dimensions: 48 feet long.
Photography tips: WNW–ESE; afternoon best because of trees.
Getting there: From Exit 8 on I-91, take Route 131 west to its junction with Route 106. Go 0.3 mile south. On the east side of Route 106, almost

Titcomb Bridge

opposite the Weathersfield Elementary School, the bridge should be visible, far back in a field next to a forest.

Parking: A farm road through the field to the bridge is level enough for passenger cars, and the Titcomb family welcomes visitors to use it so they can get closer to the bridge. Please do not attempt to cross the bridge; turning around in the field should not be a problem.

Notes: Originally the Stoughton Bridge spanned the North Branch of the Black River in lower Perkinsville, only a few miles south of its present location. But the 1959–60 Black River Flood Control Project, which created the North Springfield Lake Flood Control Reservoir, threatened to obliterate it. Local architect Andrew Titcomb said he had a place for it on his land, a decision he said was motivated both by a love of covered bridges and because he had long wished to span a stream on his property. The work of moving and restoring the bridge went partly to Milton Graton and Associates, of Ashland, New Hampshire, and partly to local builder Neil Daniels. Titcomb's son said he remembered classes being halted at the elementary school to watch the bridge go by. Milton Graton, whose company had been hired by the Perini Corporation, the general contractor for the dam project, also moved out the Stoughton House, built around 1790, to which the Stoughton Bridge had led. Lake waters now cover the Stoughton family farmyard, where Revolutionary War General Henry Knox stopped to rest his men and oxen while hauling 59 Fort Ticonderoga cannons to drive the British fleet out of Boston Harbor.

The small but quite authentic bridge preserves several metal advertising signs. Regarding visitors, Andrew Titcomb said, "They're very welcome, because covered-bridge people don't leave messes. You don't have to worry about them." Words to live up to, folks.

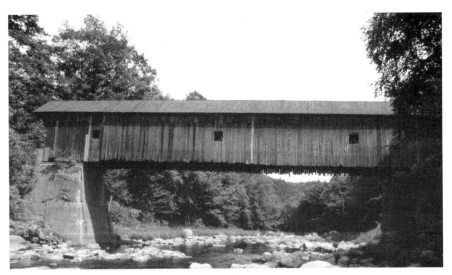

Upper Falls Bridge

59. UPPER FALLS BRIDGE

Other and historical names: Downers.
Municipality: Weathersfield.
Locality: Downers Four Corners.
Ownership: Town.
Traffic allowed: Up to 3 tons.
Crossing: Black River and Upper Falls Road.
Built: 1840.
Builder: James F. Tasker.
Type: Town lattice.
Dimensions: 120 feet long, 14.6 feet wide, 9.4 feet high at trusses, 12 feet high at center.
Photography tips: NE–SW; good river access, especially via the path on the southwestern corner.
Getting there: From the junction of Routes 106 and 131, take Route 131 west. Upper Falls Road is about 0.3 mile west of the junction. The bridge is about 0.1 mile south of Route 131.
Parking: There is a large parking lot on Route 131, just east of the entrance to Upper Falls Road. Also, Upper Falls Road forms a T-intersection just to the south of the bridge, with a triangular graveled area that offers plenty of turnoff room.
Notes: This bridge was extensively restored in 1975–76 by Milton Graton and Associates, of Ashland, New Hampshire. They rebuilt the trusses, raised the bridge 2.5 feet so water would not flow in and damage the timbers, and reframed the floor system with heavier timbers. It survives as a bridge with a

number of noteworthy features: interesting buttresses for bracing against crosswinds; portals with more than the usual amount of classic architectural styling; old ads inside; an inscription that apparently dates to 1906; a pleasant path to the river; and perhaps the finest fieldstone abutment work of any Vermont covered bridge, once one reaches the riverbed. The other stone walls just upstream from the bridge once supported mills, long since casualties of the valley's floods. Covered bridges can be victimized by floods in many ways: In 1959–60, Weathersfield lost four of its seven to the Black River Flood Control Project dam in North Springfield. This is the same dam that played a role in the histories of the Titcomb Bridge (No. 58) and the Salmond Bridge (No. 60).

60. SALMOND BRIDGE

Other and historical names: None known.
Municipality: Weathersfield.
Locality: Weathersfield.
Ownership: Town.
Traffic allowed: Up to 6 tons.
Crossing: Sherman Brook and Henry Gould Road.
Built: Around 1875.
Builder: James F. Tasker.
Type: Multiple kingpost.
Dimensions: 53 feet long, 14.7 feet wide, 8.3 feet high at trusses, 11.7 feet high at center.
Photography tips: WSW–ENE.
Getting there: Geographically, Sherman Brook is in the valley between Mount Ascutney to the east—a major peak (elevation 3150 feet) that commands this part of the Connecticut River Valley—and Little Ascutney (elevation 1720) to the west. From the junction of Routes 106 and 131, Henry Gould Road is 2.4 miles east, on the north side of the highway. It's easy to zip by; a pasture on the north side of Route 131 with an amazing number of rocks, 0.2 mile before the turn, is a good sign to slow down. The bridge is only 0.1 mile along Henry Gould Road, which has an apparent fork to the left that on closer inspection is only a break in a stone wall for a farm road. If you go too far, the next road to the north—Ascutney Notch Road, 0.2 mile farther on— leads to the other end of the Salmond Bridge. Just go 0.1 mile and turn left at the four-way intersection.
Parking: There's a turnoff on the east side of the bridge, the south side of the road; it also serves a bridge-side picnic area.
Notes: Unusually wide for a bridge of its length, the Salmond Bridge was roomy enough for one Model T Ford to turn around inside when the driver found his way blocked by snowdrifts, according to Andrew Titcomb (see No. 58), a member of a local group that helped restore the bridge.

This is another bridge rescued from the Army Corps of Engineers flood-control project in 1959–60 that created the North Springfield Lake Flood Control Reservoir. According to a *Rutland Herald* report, Weathersfield had obtained state and federal funds to move the Salmond Bridge and the Stoughton Bridge (now the Titcomb Bridge; see No. 58) and had found a new location in Reading, where the former bridge could replace a stringer bridge between two houses. But then a Reading selectman convinced the board to reject the offer, although it came at no cost to that town. "It was on the road to the spot—when it was stopped," said Weathersfield's Joseph Stoughton. Instead, the bridge went to the Amsden section of Weathersfield, to a location near the town garage, where it lost its floor, acquired eight windows and imitation redbrick siding, and was pressed into service as an equipment shed. "A good servant had been exposed to a shameful end," wrote Ashland, New Hampshire, covered-bridge builder Milton S. Graton in a 1978 book.

But in the mid-1980s, a Committee for the Restoration of the Salmond Covered Bridge headed off the idea of having it house a glass-recycling center at the town dump. In 1986, a 92–79 vote at Town Meeting gave approval to use $10,000 in federal revenue-sharing money toward the eventual $32,825 cost of restoring and moving the bridge to its present site—despite the town's $107,000 deficit. On a revote in May, after a hot debate, the decision was reaffirmed 117–60. A state grant of $2500 and donations made up the rest of the cost. Wright Construction of Mount Holly dismantled, moved, and reassembled the bridge, and on October 27, 1986, the town's first town manager, Karl Stevens, led his pair of oxen across to help dedicate it. Former

Salmond Bridge

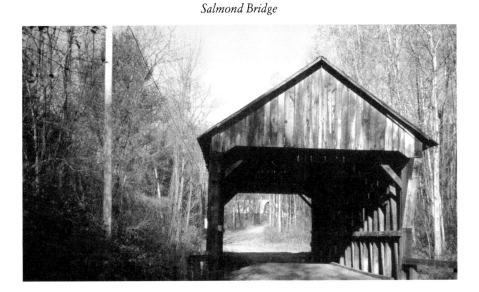

longtime town clerk Victoria Salmond sent her best wishes from Florida, and Stoughton, 83, who remembered swimming beneath the bridge back before 1700 acres of Weathersfield were flooded by the dam, glumly predicted a flood would someday take the bridge because there wasn't a cement wall at the turn of the brook to ward off high water. The nearby park and nature trail were created in 1987, on land donated by former town clerk Betty Murray in memory of her husband, C.A. Murray. The bridge committee, whose chairperson, Dorothy Grover, had led the fight for the bridge as a selectman, celebrated the park's dedication by rustproofing the bridge's roof with plastic sealant.

61. BEST BRIDGE

Other and historical names: Swallows.
Municipality: West Windsor.
Locality: Brownsville.
Ownership: Town.
Traffic allowed: Up to 6 tons.
Crossing: Mill Brook and Churchill Road.
Built: 1889. This date is sometimes mistakenly given as 1890 because the bridge is mentioned in a town report of 1890, which itemized 1889 expenses. A

Best Bridge

memoir by longtime resident Mary Beardsley Fenn mentions seeing the date 1889 neatly chiseled into the bridge.

Builder: A.W. Swallows.

Type: Tied arch.

Dimensions: 37.4 feet long, 12.7 feet wide, 9.5 feet high at trusses, 12.5 feet high at center.

Photography tips: ENE–WSW; shots from south can link it with an old barn nearby; good side shots from both sides on south.

Getting there: This bridge is easy to miss the first time while driving east on Route 44 from the junction of Route 106. Take Route 44 east for 1.3 miles. Best Bridge is visible from the highway, in glimpses—look for the green metal roof—but the unpainted metal roof of a nearby barn tends to draw more attention. Churchill Road has two entrances from Route 44, forming a triangular green, but the western entrance is easy to mistake for a driveway. The bridge is about 0.1 mile south of Route 44.

Parking: Go across the bridge; the turnoff is on the west (right) side. An entrance to a little-used farm road is available on the east side.

Notes: This sturdy little bridge, supported by an arch of five planks bent and bolted together, in its day carried as much bovine traffic as human. Its road went over the Robinson Hill area into Weathersfield. The upper part of the bridge is simply a post-and-beam shed, standing on the deck and not carrying weight. Compare the construction to the very similar Bowers Bridge (No. 63). The West Windsor town report for 1890 has the following entry: "Cost of new covered bridge by A.W. Swallows: June 29 (1889) E.H. Spaulding, timber and nails, $119.52; W. Sykes, pins and drawing lumber, $16.11; S.F. Hammond, labor self and others, $90.00; Chas. Hastings, labor on irons, $2.75; Oct. 14 E.C. Howard & Co., bolts, $21.75." The total was given as $250.13. The amount paid to Swallows, if any, is not listed. The same town report shows that J.W. Cady was paid $1 for "snowing bridges" in 1888–89—that is, putting snow inside covered bridges so sleighs could cross.

A freshet in 1973 weakened the original stone abutments, which were then strengthened with concrete.

Mary Beardsley Fenn's memoir of living near the bridge, published in *Vermont Life* in 1980, is filled with vivid pictures of Best Bridge in an earlier time: the six Best girls, who lived in the little house nearby, decorating the knotholes and cracks in the bridge with daisies, black-eyed Susans, devil's paintbrushes, and Queen Anne's lace, especially if a wedding or funeral was to be held in town; the girls holding their own funerals in the bridge for dead birds or other animals they found; the older girls quieting fussy babies in the heat of summer by taking them in carriages to the bridge, the coolest place, and pushing them back and forth; town children coming across to sing Christmas carols for old Mr. Best, who was then 101; and paddling in the brook beneath, even though it was too small and shallow to learn to swim.

62. TWIGG-SMITH BRIDGE

Other and historical names: Garfield.
Municipality: West Windsor.
Locality: Brownsville.
Ownership: Private.
Traffic allowed: Posted for up to 40 tons.
Crossing: Mill Brook and Yale Road.
Built: Unknown.
Builder: Unknown.
Type: Town lattice.
Dimensions: Unknown.
Photography tips: NNE–SSW; farm fields give good side shots and river access.
Getting there: From its intersection with Route 106, go east on Route 44. At the 2.4-mile mark there's a crossroads with Yale Road on the right (south). The bridge should be visible in a field, about 0.1 mile to the south.
Parking: The shoulders of Yale Road north of the bridge are adequate.
Notes: Don't be fooled by the 40-ton posted limit. This is a true, historic covered bridge—or rather, half of one. Vermont developer Thurston Twigg-Smith bought a disused covered bridge from the town of Hyde Park in the late 1960s or early 1970s, and had it divided in two for use as entranceways for two planned developments. The Yale Heights project in the Brownsville section of

Twigg-Smith Bridge

West Windsor (which, incidentally, is a separate township from Windsor) proceeded as planned, although it is now under different, local ownership. The other bridge half is in South Pomfret (see No. 70). That development didn't make it through the permit process, and the land was sold to Laurance Rockefeller, who combined it with the rest of the Suicide Six ski area's land. The Pomfret bridge is known to neighbors as the Smith Bridge, while the West Windsor bridge is known as the Twigg-Smith Bridge at the town office— so the name was divided in two as well.

Note the rebuilt roof bracing, which now has a greater central clearance so that construction vehicles can pass to and from the housing development. The odd-looking pipe at the southern end of the bridge is part of a so-called "dry hydrant," a rural fire protection device for areas without municipal water systems and regular hydrants. One end is an intake pipe that accesses a body of water, in this case Mill Brook; the other other is a pipe with a coupling that connects to a hose from a pumper truck. Especially in winter, when ponds and even streams can have a thick cover of ice, a dry hydrant can save a volunteer fire department precious minutes. The wonder is that more of Vermont's covered bridges don't have such devices at the ready.

63. BOWERS BRIDGE

Other and historical names: Brownsville.
Municipality: West Windsor.
Locality: Brownsville.
Ownership: Town.
Traffic allowed: Posted for up to 6 tons and 10 feet in height.
Crossing: Mill Brook and Ely Road.
Built: Around 1919.
Builder: Unknown.
Type: Tied arch.
Dimensions: 45.3 feet long, 12.2 feet wide, 9 feet high at trusses, 11.4 feet high at center.
Photography tips: S–N.
Getting there: Not easy. The most direct road to the bridge, Ely Road, goes north from Route 44, about 0.6 mile from the road leading to the Twigg-Smith Bridge (see No. 62). A town highway facility—with a garage, sand piles, et cetera—is on both sides of the road where the turn to the bridge angles off Route 44. The bridge is 0.3 mile down Ely Road.

Alternatively, if you go another 0.1 mile along Route 44 past the town garage, you'll see another road going north, just to the east of a concrete-and-steel bridge. This road goes 0.8 mile, paralleling Route 44 and Mill Brook for part of its length, and reaches a four-way intersection. The bridge is 0.1 mile south of that intersection.

Parking: A turnoff and disused road entrance are near the south side of the bridge.

Notes: The Bowers Bridge historically served farms in the Rowe Hill and Sheddsville areas of West Windsor. Its portal and roof have had a hard time with truck traffic, at one point in 1983 suffering damage from two collisions in a few weeks. As with Best Bridge (see No. 61), the laminated plank arch carries the bridge's load; the superstructure is a non–load bearing post-and-beam shed.

64. CORNISH-WINDSOR BRIDGE

Other and historical names: Windsor-Cornish.
Municipality: Cornish, New Hampshire, and Windsor, Vermont.
Locality: Cornish and Windsor.
Ownership: New Hampshire Department of Transportation.
Traffic allowed: Up to 10 tons; posted for 9 feet, 2 inches on Vermont side.
Crossing: Connecticut River and Cornish Toll Bridge Road in New Hampshire; Bridge Street continues the Cornish Toll Bridge Road into Vermont.
Built: 1866.
Builder: James F. Tasker of Cornish, New Hampshire, and Bela J. Fletcher of Claremont, New Hampshire.
Type: Town lattice.

Cornish-Windsor Bridge

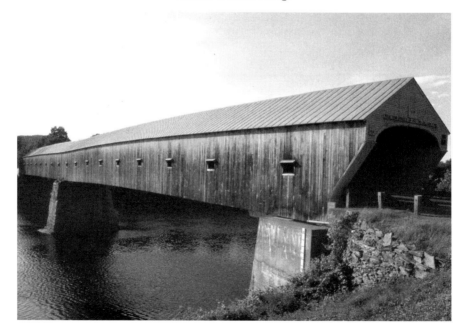

Dimensions: Sometimes given as 465 or 460 feet long, with 6 feet beyond the Vermont riverbank belonging to Vermont, but the New Hampshire Department of Transportation lists it as 449.4 feet long, 34 feet wide (19.5 feet roadway), with a maximum vertical clearance of 12.75 feet. The two spans are 204 feet and 203 feet long.

Photography tips: SW–NE; morning somewhat better, due to surroundings and parking situation.

Getting there: From its junction with Route 44 in Windsor, take Route 5 south 0.3 mile to where Bridge Street goes east. At this intersection with a stoplight, the bridge is visible down Bridge Street 0.3 mile away.

Parking: In Vermont, park in spaces near Route 5, since the immediate vicinity of the bridge is thickly settled. Better is to drive through the bridge and turn right onto New Hampshire Route 12A, where a dedicated parking lot with good interpretive signs is within easy walking distance of the bridge.

Notes: This is a bridge of national and even international significance, recalling the immense wooden bridges that once spanned American coastal rivers (see Introduction). In 1970, the American Society of Civil Engineers designated it a National Historic Civil Engineering Landmark. Today it is the longest wooden bridge in the United States, and the longest two-span covered bridge in the world.

This was the fourth bridge at the crossing, previous bridges having been constructed in 1796, 1824, and 1850. Floods destroyed them all. The *Vermont Journal* for March 3, 1866, told the story of the third bridge's demise during a winter warm spell: "The pressure of ice against the toll-bridge was such that, when the water began to fall, at about 5 o'clock Sunday morning, the superstructure, in one solid mass, was lifted from the piers and abutments and carried down the river about a hundred rods, striking the bridge of the Sullivan Railroad. Three of the four spans of this bridge—nearly 400 feet in length—were instantly taken off the abutments and carried down the river. Part of the toll-bridge lodged on the island. About 4 o'clock, on Sunday afternoon, part of the railroad bridge passed Brattleboro, having gone over 50 miles in little over 10 hours."

The contract for Tasker and Fletcher (who had helped build the third bridge) specified a bridge higher over the water, using spruce for timbers rather than hemlock, with the lower chords (carrying beams) 11 inches wide instead of 10 inches. They were allowed to use "such portion of the old bridge as they may find on Horace Weston's land," but only with the bridge corporation's approval.

The new bridge was framed in a meadow north of Bridge Street on the Vermont side and moved into place before the end of 1866. Like most Connecticut River bridges, it had been and continued to be a toll bridge, with the tollhouse first at 45 Bridge Street, then at 42 Bridge Street. Agitation to make the bridge toll free began as early as the 1880s, but it was only in 1943 that the practice was discontinued. In 1936, the proprietors agreed to sell out

for $22,000 ($20,000 from New Hampshire and $2000 from Vermont), but tolls continued to pay back the appropriation and maintenance costs. During World War II gas rationing, however, it cost more to collect tolls than people paid. A special bill in the New Hampshire Legislature finally freed the bridge, the last on the river to have collected tolls.

There were major repairs in 1887 (under Tasker), in 1892, in 1925, in 1938, in 1954–55 (when it was closed for pier, floor, and side work), and in 1977.

In the mid-1980s, the time had again come for major repairs, which led to a battle royal between preservationists and New Hampshire state engineers. (New Hampshire paid about $4,450,000 for the project, while Vermont paid only about $200,000, since New Hampshire's western boundary is the Vermont shoreline of the Connecticut River.) The purists wanted Milton S. Graton of Ashland, New Hampshire, to do the job, something he said he could do for about $2.5 million while keeping the bridge open most of the time. But Graton's old-fashioned approach—which included handshake agreements rather than contracts and an insistence on old-time materials and techniques—didn't sit well with the decision makers. One New Hampshire transportation official defended the decison to use replacement glue-laminated timbers by saying the original bridge had been built from "a gut feeling that it would or would not work," as he told the *Rutland Herald*. "Our engineering analysis said it should have dropped into the river." David Wright, president of the National Society for the Preservation of Covered Bridges, said, "There's no question the original techniques and material would still work now."

In the end, Chesterfield Associates of Long Island erected three 80-foot towers to support the bridge and used glue-laminated timbers, although every attempt was made to preserve the bridge's original appearance. About half of the original timbers were replaced, the project manager told the *Rutland Herald*.

After being closed for 2½ years, it reopened in December 1989, just in time for the ceremonies to double as a site for a protest against the Seabrook, New Hampshire, nuclear power project. On hand at the opening were Norman Pickering of Southampton, New York, a classical violist who had made a violin from red spruce salvaged from the bridge. After he informed the contractors that the strong, knot-free wood was of great value to instrument makers, they stopped burning it and made it available to anyone who wanted it. Merton Fletcher, 80, of Lebanon, New Hampshire, the great-grandson of bridge builder Bela Fletcher, had found another use for the discarded wood: He built a model of the bridge, which was displayed in Windsor following the opening. Vermont governor Madeleine Kunin said that the spirit of craftsmanship embodied in the bridge is "what New England is all about."

IX. Woodstock-Area Tour

WOODSTOCK HAS BEEN hosting visitors since the late 1800s, when mineral springs drew summer residents. Eventually, it came to be one of the adopted homes of the Rockefeller family. In historic preservation, money counts, and Woodstock has benefited from the relationship. Aside from the downtown historic district itself, the attractions include the **Dana House,** which is a museum run by the **Woodstock Historical Society** (802-457-1822), and the **Billings Farm and Museum** (802-457-2355). As an accompaniment to covered-bridge visits, the Billings Museum's exhibits and displays on the history of Vermont agriculture deserve a five-star rating. These bridges served farmers more than anyone else, and it will be far easier to imagine their way of life after a stop at this wonderful Woodstock site. For understanding the natural context of the bridges, the exhibits and nature trails at the **Vermont Institute of Natural Science** (802-457-2779), also in Woodstock, can be particularly helpful. Their Raptor Center (eagles, owls, and hawks, oh my) is unforgettable.

The itinerary starts with two bridges in Hartland, near Route 5, the great north–south route of the Connecticut River Valley, then takes you to Route 4, southern Vermont's best-developed east–west highway, as the central artery. The bridges are highly diverse: a unique "mongrel" truss bridge in Taftsville east of Woodstock; a modern but authentic Town lattice next to the Woodstock green; the country's only Pratt truss bridge in West Woodstock; a unique homemade truss bridge north of Woodstock; and half of a Town lattice in South Pomfret. The latter two require a short jaunt north on Route 12 from the center of Woodstock village.

Along Route 4, particularly in the Quechee area, there are group exhibition spaces for antiques that a lover of old objects could use as an excuse to

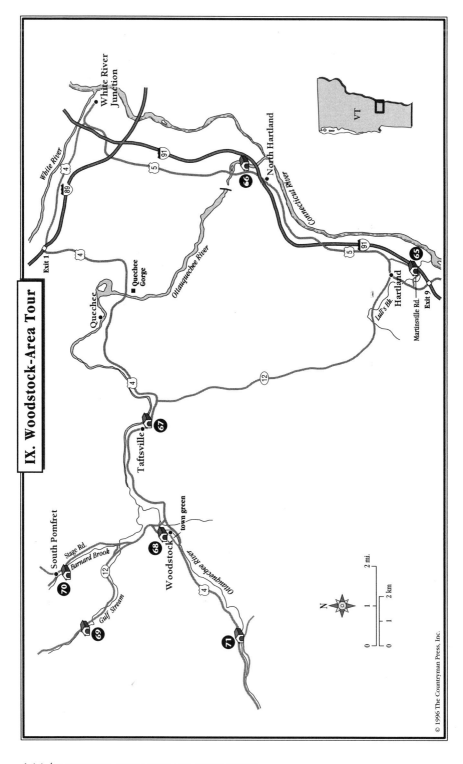

IX. Woodstock-Area Tour

White River Junction

North Hartland

Hartland

Martinsville Rd.

Exit 1

Quechee Gorge

Quechee

Taftsville

South Pomfret

Stage Rd.

Barnard Brook

Gulf Stream

Woodstock

town green

Ottauquechee River

White River

Connecticut River

Ottauquechee River

Lull's Bk

Exit 9

VT

N

2 mi.

2 km

1

1

0

0

© 1996 The Countryman Press, Inc.

spend an extra day in the area. The bridge on Route 4 at Quechee Gorge, while not covered, is one of Vermont's sights, spanning a precipitous ravine whose river can be reached by moderately difficult trails. Farther west, but worth the drive, the restored **Plymouth Notch Historic District** (802-672-3773) in Plymouth is a state-owned site that includes the President Calvin Coolidge homestead, a one-room schoolhouse, a barn with farming exhibits, a church, a general store, a cheese factory, farmhouses, a historic cemetery, and more. It's been called "a Yankee Brigadoon" because of its time-capsule preservation of life in a tiny village of the horse-and-buggy era.

65. MARTINSVILLE BRIDGE

Other and historical names: Martin's Mill.
Municipality: Hartland.
Locality: Martinsville.
Ownership: Town.
Traffic allowed: Up to 5 tons.
Crossing: Lull's Brook and Martinsville Road.
Built: 1881.
Builder: James F. Tasker.
Type: Town lattice.
Dimensions: 135 feet long, 16.2 feet wide, 10 feet high at trusses, 12.3 feet high at center.
Photography tips: WSW–ENE; midafternoon best because of ravine setting and trees.
Getting there: From Exit 9 on I-91, go 0.4 mile north on Route 5 and turn right onto Martinsville Road. Or from the junction of Routes 12 and 5 in Hartland, go south on Route 5 for 0.6 mile and turn left. Martinsville Road is near the base of a hill. It winds 0.6 mile, mainly between houses, then reaches the seemingly secluded bridge (I-91's embankment rises just beyond the bridge).
Parking: There's ample room by ruins south of the bridge.
Notes: This was once a very busy bridge, as the former Connecticut River Turnpike relied on it to cross Lull's Brook. Also, the F.P. Martin Sash and Blind Shop stood to the west of the road into the 1950s, and the Martin family (Ernest and sons Earl and Ernest) had a sawmill on the east side that operated using waterpower until 1960. A shaft in a tunnel under the road transmitted power to the sawmill from a turbine in a building near the sash and blind shop. According to a recent Hartland town clerk, who remembered his father getting shavings from the woodworking shop, a concrete bin–like structure beside the road on the south side of the bridge used to have a building on top where sawdust was blown from the lumber mill. People coming to get sawdust could back up under the building to have a load delivered.

The site's mill history dates back at least to 1823, when "39 hands" raised a gristmill there, according to an old account book. There were two large water-wheels, one 28 feet in diameter, one 30 feet across. When the mill burned in 1839, 54 local people pledged amounts ranging from $1 to $25, plus pledges of timber and labor, to help owner Lewis Merritt rebuild. The mill later became a woolen factory, then in 1878, under Frank Martin's ownership, it started making sashes, blinds, and turbine pipe—in competition with a shop owned by Martin's brother. A concrete dam in Lull's Brook dates from years after the Flood of 1927, which washed out the prop-and-rafter dam (a wall propped by wooden struts) that Ernest Martin was using.

Today, the extensive concrete ruins appear to have become a hangout at times for local youths, to judge by graffiti and other remains. A personal recommendation would be to visit this bridge only in the daytime.

66. WILLARD BRIDGE

Other and historical names: Willard's; North Hartland.
Municipality: Hartland.
Locality: North Hartland.
Ownership: Town.
Traffic allowed: Up to 5 tons; 12-foot clearance posted.

Willard Bridge

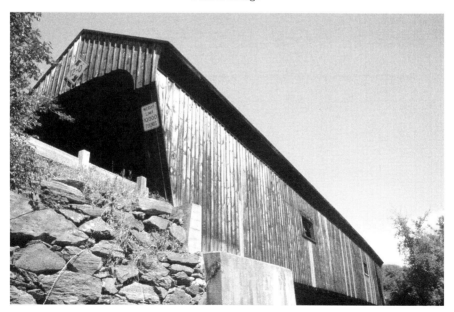

Crossing: Ottauquechee River and Mill Road.

Built: 1870, according to town reports.

Builder: Unknown.

Type: Town lattice.

Dimensions: 128 feet long, 15.8 feet wide, 10.8 feet high at trusses, 13 feet high at center.

Photography tips: WSW–ENE; great shots with waterfall, especially when ice forms in the winter (see parking instructions).

Getting there: The road to the bridge goes east from Route 5, just south of where Route 5 goes under I-91. (From I-91, take Exit 9 and go north on Route 5 to Mill Road.) About 0.2 mile after you turn off Route 5, there's a somewhat complicated street intersection in which Mill Road goes both left and right, and Depot Road goes right just after Mill Road goes left. Stay all the way left on Mill Road, and the bridge will appear almost immediately after you pass a hydroelectric station.

Parking: There's a good turnoff on the right while approaching the bridge and a path from it to the river. A nearby sign warns canoeists, anglers, et cetera, to expect fluctuating water levels when a horn sounds. But the most interesting place to park is reached by a side road just beyond the bridge, turning right (south). It leads to the base of the waterfall just downstream from the bridge.

Notes: At one time there were two covered bridges at this site, a queenpost bridge from an island in the river to the southern bank having been replaced in 1938. The Flood of 1927 did not destroy the bridges, but it did demolish the Ottauquechee Woolen Company, which had a four-story mill beyond the two bridges. The windows on the remaining bridge were an innovation during 1953 repairs; previously, the sides had been tightly boarded to keep horses from shying at the sight of the river and falls below.

67. TAFTSVILLE BRIDGE

Other and historical names: None known.

Municipality: Woodstock.

Locality: Taftsville.

Ownership: Town.

Traffic allowed: Up to 8 tons.

Crossing: Ottauquechee River and River Road.

Built: 1836.

Builder: Solomon Emmons III.

Type: Unique "mongrel" combination of queenpost, kingpost, and arch elements.

Dimensions: 189 feet long in two spans (southerly 89 feet, northerly 100

feet), 15 feet wide, 9.1 feet high at trusses, 10.6 feet high at center.

Photography tips: WSW–ENE; wide variety of good side shots possible, with red color adding interest.

Getting there: Take Exit 1 off I-89, and drive west on Route 4. Or from the Hartland bridges, take Route 12 north to where it ends at the intersection with Route 4. Turn left (west) and go 0.5 mile; the bridge is on your right. It's next to Route 4, east of Woodstock in the small village of Taftsville.

Parking: Find a place to the side of Route 4 (near the Taftsville Country Store), and walk down to the bridge after crossing Route 4, a very busy crossing. Or drive through the bridge, turn left, and park on the shoulder of River Road.

Notes: By documentary evidence, this is Vermont's third oldest covered bridge (the Pulp Mill Bridge in Middlebury, No. 16, is 1808–1820, and the Village Bridge in Waitsfield, No. 30, is 1833). Emmons, a local builder, may have added the arches—10 planks on one side and 12 on the other, an observer may note—at a later date to strengthen the substantial bridge, which is more than 20 feet wide counting the trusses. One source says the four main carrying beams, 12 by 18 inches in size, were spliced together from eight huge local trees. A bad lean was corrected in the 1920s. Metal reinforcement for the roof bracing was added during 1952–53 repair work, with Miller Construction of Windsor using the frozen river as a platform to jack up the closed bridge for truss, foundation, and floor repairs. The red paint arrived in 1959–60, along with a tin roof. More repairs were necessary in 1993, after a 12-foot-high box

Taftsville Bridge

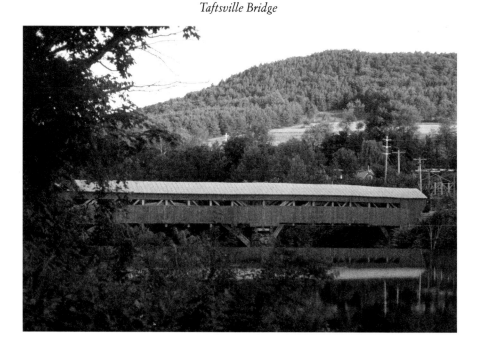

van owned by a local plumbing supply company smashed four horizontal collar trusses near the roof, scattering chunks of timbers through the bridge and dislodging a section of the siding before it stopped.

A local history entitled *Taftsville Tales* notes the arrival of a Solomon Emmons in 1793 as one of the village's first settlers. Blacksmith Stephen Taft and his sister Prudence arrived from Massachusetts in 1793; Prudence would marry Solomon Emmons Jr. Soon Stephen Taft dammed the river, began a sawmill and shops, and, with relatives, gave the settlement the names Tafts Mills, Taft Flat, and, eventually, Taftsville. The Tafts and Emmonses built several bridges that floods destroyed (the earliest settlers used a ford or rafts). Solomon Emmons III built the 1836 bridge at a cost of $1800, of which $1050 was for stonework (he built the central pier) and the rest for the covered bridge itself. Solomon Emmons III kept the bridge in repair until his death, then his son Edwin took over the job.

Originally, Taftsville was at the corner of four towns, and the bridge ownership was apportioned thusly: Woodstock 18/40ths, Hartland 3/40ths, Pomfret 8/40ths, and Hartford 11/40ths. This cumbersome system was abolished by legislative action in 1851, which altered the town lines of Hartford and Pomfret and gave Woodstock 15 acres from Hartland together with the responsibility for the bridge.

Local memories of the bridge included its use for running races, boxing matches, and shelter during showers, back in the days when its walls held advertisements for Castoria and Kickapoo Indian Sagawa.

68. MIDDLE BRIDGE

Other and historical names: Union Street.
Municipality: Woodstock.
Locality: Woodstock village.
Ownership: Town.
Traffic allowed: Up to 8 tons.
Crossing: Ottauquechee River and Union Street.
Built: 1969.
Builder: Milton S. Graton.
Type: Town lattice.
Dimensions: 139 feet long, 14.2 feet wide, 10.4 feet high at trusses, 14 feet high at center.
Photography tips: ESE–WNW; river access possible from northwestern corner, but not recommended for those with weak ankles. Late-afternoon side shots can be very nice.
Getting there: Take Route 4 to where it circles the green in the center of Woodstock. River Street is just north of the green, and the bridge is less than 0.1 mile from the green, visible from Route 4.

Parking: Park at the green, since this is a densely populated area.

Notes: Visitors to Woodstock are often amazed to learn this is a modern bridge. Its construction was one of the culminating points of Milton Graton's career as "the last of the covered-bridge builders," as he somewhat prematurely described himself in the title of an autobiographical memoir. It was also of historic significance, being the first major authentic-style covered bridge constructed in New England in this century. Its example has since led to other new-old bridges—and to a realization that such structures are by no means outdated.

The new covered bridge was to replace the iron Union Street Bridge, condemned in 1965. The Vermont Agency of Transportation insisted that Graton design a bridge to carry 15 tons, although the statutory load limit would be 8 tons, and have an ample height clearance. This done, Graton ordered 75,000 board feet of Douglas fir from Oregon, dried it carefully in his Ashland, New Hampshire, shop to avoid splitting, and leveled a 150-by-30-foot area of crushed gravel near the shop for assembling the bridge's trusses. He found two dozen white oak trees near Woodstock for making treenails for the Town lattice (see Introduction) and had the Walker Company in New Ipswich, New Hampshire, produce 1400 of them. Finding drills good enough to make absolutely straight holes was a chore, but by welding two together (to eject wood chips better), that job was done. Milton and his sons Arnold and Stanley did the work of driving treenails into trusses, which took 20 to 54 blows for each of the 700 treenails per truss. At the site, gin poles (guyed, leaning poles to pull an object up with cables) had to bring the trusses into position, since a

Middle Bridge

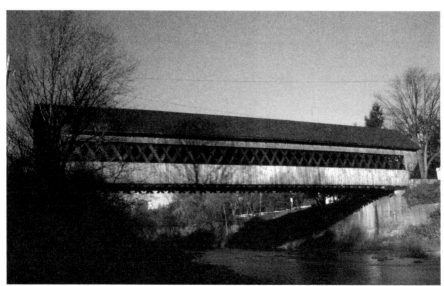

neighbor refused to allow jacking on his land. Finally, with support cribbing in the stream and a wooden track for rollers built on Union Street, the assembled bridge was pulled over the river by Ben and Joe, two local oxen, to the delight of hundreds of spectators. An engineer later wrote to Graton and said, "Milton, in removing a metal bridge and replacing it with a wooden bridge, you have made bridge-building history."

But the controversy that attended the decision in favor of a wooden bridge—the selectmen and a bridge committee had made the decision after Town Meeting, not wishing to risk a public vote—came back to haunt it. On May 11, 1974, during the local fire department ball, local arsonists soaked the bridge in gasoline and set it ablaze. (They were later caught and given suspended sentences.) But the firemen got there fast and put the fire out within 20 minutes, using water from the river. Graton came back, and, after some sandblasting and replacement of mainly nonessential boards, the bridge went back into service in 1976.

69. FRANK LEWIS BRIDGE

Other and historical names: None known.
Municipality: Woodstock.
Locality: Woodstock.
Ownership: Private; farm vehicles.
Traffic allowed: Private.
Crossing: Gulf Stream.
Built: 1981.
Builder: Frank G. Lewis "and my tractor."
Type: Unique personal combination of kingpost and lattice elements.
Dimensions: 40 feet long.
Photography tips: ENE–WSW; Lewis said he doesn't mind people taking pictures; morning is best because of a hill.
Getting there: From the junction of Routes 4 and 12 in the center of Woodstock, go north on Route 12 for 3.7 miles. The bridge is set back in a field, on the left (west) side of the road. This is on one of the few straight stretches along that part of Route 12. The house is on the east side and the barn is on the west, which Lewis said is not true of any other nearby residence.
Parking: Alongside Route 12.
Notes: The family saying about Frank G. Lewis was: "Grandpa, he can make anything out of wood." In 1981, when he was 61, he put together a bridge for his animals and machinery that has more of the spirit of the great 19th-century covered-bridge builders than many more historic structures. Lewis would probably have had a good talk with the unknown builder of the two bridges in Thetford or with Nicholas Powers, who late in life put together a model of an irregular truss that he never had the chance to try. A comparison

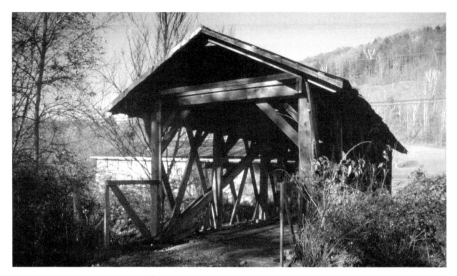

Frank Lewis Bridge

between this bridge and the Thetford bridges, particularly the Union Village Bridge (No. 72), would be fascinating for anyone with an engineering turn of mind. Roughly to describe Lewis's conception, it involves an irregular lattice somewhat resembling a Town lattice, sandwiched between two sets of king-postlike diagonals. Lewis developed it entirely on his own. It's a new variation on a theme of arch-plus-framework that goes back through Burr to Palladio (see Introduction).

The process of construction was also a classic of Vermont living. Lewis happened to be working at the time for a company that bought a lot of plywood, which came in bundles with scrap lumber (known as dunnage) protecting the sheets from being damaged by the binding. Lewis scrounged as much dunnage as he could, and now it constitutes the bulk of the bridge.

70. SMITH BRIDGE

Other and historical names: Garfield.
Municipality: Pomfret.
Locality: South Pomfret.
Ownership: Private.
Traffic allowed: Private; farm vehicles.
Crossing: Barnard Brook and farm road.
Built: 1870; reconstruction in 1973.
Builder: Reconstruction by H.P. Cummings Construction Company.
Type: Town lattice.
Dimensions: 36 feet long.

Photography tips: SW–NE; morning is best because of a hill.

Getting there: From the junction of Routes 4 and 12 in the center of Woodstock, go 1.1 miles to where Route 12 forks left. Take the right fork, Stage Road. Or, from the Frank Lewis Bridge, drive south on Route 12 and take a paved road to the left with signs to South Pomfret (Stage Road). Go 1.8 miles, and you'll see the bridge set back in a field to the left. It's nearly obscured by trees in summer, but it's definitely visible, just south of the line of houses in the South Pomfret village area. As a northern reference point, the South Pomfret Post Office is at another fork 0.2 mile farther north along Stage Road.

Parking: Alongside Stage Road.

Notes: This is the other half of the former Garfield Bridge of Hyde Park, Vermont, divided by developer Thurston Twigg-Smith Jr. for use as entrances to two planned developments. It is now used by a farmer who rents some of the land associated with the Suicide Six ski area, since the development in South Pomfret did not work out as planned. The complete story of the two bridges is with the account of the Twigg-Smith Bridge in West Windsor (see No. 62).

71. LINCOLN BRIDGE

Other and historical names: None known.
Municipality: Woodstock.
Locality: Westerdale.

Lincoln Bridge

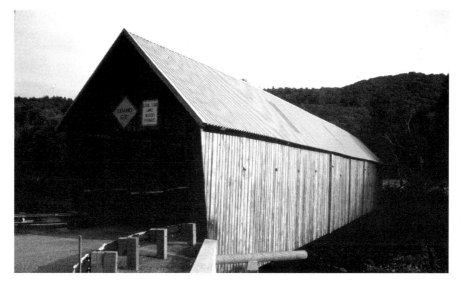

Ownership: Town.

Traffic allowed: Up to 8 tons; 10-foot vertical clearance.

Crossing: Ottauquechee River and Fletcher Hill Road.

Built: 1877.

Builder: R.W. Pinney and B.H. Pinney.

Type: Modified Pratt tied arch.

Dimensions: 136 feet long (according to state bridge consultants; sign at bridge says 134 feet), 13.6 feet wide, 9.2 feet high at trusses, 10.9 feet high at center.

Photography tips: NE–SW; preservationists may detest the institutional green baked-enamel roof and green skylights but should remember that the alternative roof colors were red and blue.

Getting there: This bridge is virtually impossible to miss, since it's just to the south of Route 4 with no buildings nearby. From the east, it's 3.2 miles west of the town green and Middle Bridge (see No. 68) in the center of Woodstock. If you are coming from the east, it is 4.9 miles west of the junction of Routes 4 and 100A.

Parking: A good turnoff and path to the river are through the bridge on the left side.

Notes: This is a bridge of national significance, the only one in the country where the builders attempted to use the complex wood-and-iron truss devised by T. Willis Pratt. (His legacy can be seen in Vermont in the designs of many all-metal bridges, where his ideas were easier to implement.) These were local builders (R.W. Pinney was from Bridgewater, and B.H. Pinney from Wood-stock) working 33 years after Pratt patented his truss.

When the bridge underwent a major restoration in 1988, lovers of authentic bridges were livid to discover that the selectmen had specified green fiberglass panels for the roof—the kind used to make chicken coops, one opponent said. "Honky-tonk," local bridge enthusiast Frank Teagle told the *Rutland Herald,* adding that putting steel supports under the bridge was "absolutely treasonous." The local board stood firm, pointing out that the bridge sees heavy traffic from adjacent Route 4, and the previous lack of visibility inside the bridge had led to near collisions with cyclists taking shelter there during rainstorms.

One story is that this bridge was originally the Billings Bridge, crossing the Ottauquechee River in Woodstock where a metal bridge on Route 12 now leads toward the **Billings Farm and Museum.** The present Lincoln Bridge was said to have been washed off its foundations, after which it was purchased by someone in West Woodstock and moved there. This could not be confirmed in any historical account.

Also on this tour

IN THE QUECHEE section of Hartford, just north of Route 4 on the road to the Quechee Lakes development (from the east, turn right at a blinking yellow light not far past Quechee Gorge), a particularly well crafted bridge cover and walkway was built in 1970 by the Quechee Lakes Development Corporation, over a steel stringer bridge strong enough to carry construction traffic. The 90-foot, 12-ton-limit, 13.6-foot-clearance bridge is much photographed (SW–NE; late afternoon best), and the concrete walkway just beyond it gives an unusually close look at a dam and waterfall still used for hydroelectric power generation. Park after driving through the bridge.

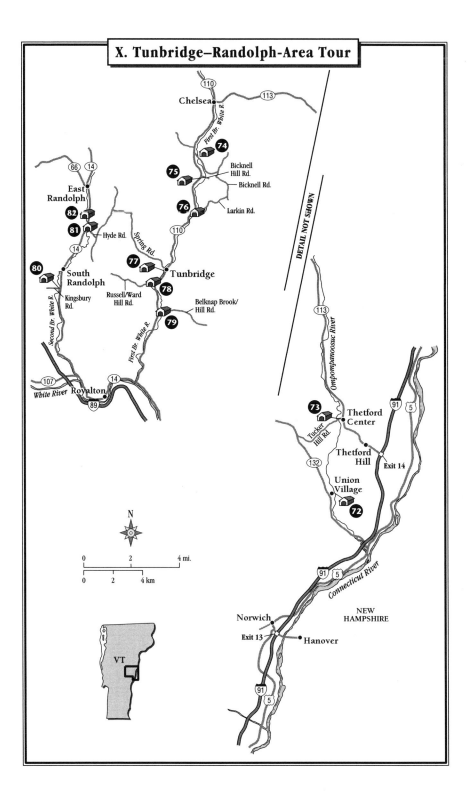

X. Tunbridge–Randolph-Area Tour

Chelsea

110
113

First Br. White R.

74

75

Bicknell
Hill Rd.

Bicknell Rd.

66 14

East
Randolph

82

81

Hyde Rd.

Spring Rd.

76

Larkin Rd.

110

77

Tunbridge

80

South
Randolph

Kingsbury
Rd.

Russell/Ward
Hill Rd.

78

Belknap Brook/
Hill Rd.

79

Second Br. White R.

First Br. White R.

DETAIL NOT SHOWN

Ompompanoosuc River

107

White River Royalton

14

89

113

73

Thetford
Center

91 5

Tucker
Hill Rd.

Thetford
Hill

Exit 14

132

Union
Village

72

N

0 2 4 mi.

0 2 4 km

Connecticut River

NEW
HAMPSHIRE

VT

91 5

Norwich

Exit 13 Hanover

91
5

X. Tunbridge-Randolph-Area Tour

For many years, Orange County was one of the very few US counties without a single traffic light. But that doesn't mean it's remote, wild territory. Attractively proportioned, the Vermont Piedmont (as geographers call most of the area east of the Green Mountains) has long invited settlement. The valleys that run through this part of the Piedmont happen to be on a uniquely human scale—a farm or two wide—and the hills cradling the rivers are modest, rounded, and unintimidating. The farming communities have been prosperous enough, historically, to allow the creation of striking and highly differentiated barns, whose presence perfectly complements that of the covered bridges. The two Thetford bridges are unique and placed in unusual ways, but the Tunbridge-Chelsea and Randolph bridges follow the same pattern: They all cross a placidly winding stream in a peaceful valley. Driving up and down Orange County—this tour is arranged to go north on Route 5 to Thetford, west to Chelsea on Route 113, south through Tunbridge on Route 110, then north through Randolph on Route 14—can be hypnotically lovely. Later in his life, Robert Frost enjoyed cruising around the countryside looking at farms and fantasizing about buying this one or that one and living there. Travelers along this route may find themselves sharing such dreams.

72. UNION VILLAGE BRIDGE

Other and historical names: None known.
Municipality: Thetford.
Locality: Union village.
Ownership: Town.
Traffic allowed: State consultants recommend no more than 4 tons; posted for 10-foot, 6-inch clearance.
Crossing: Ompompanoosuc River and Academy Road.
Built: 1867.
Builder: Unknown.
Type: Multiple kingpost with kingpost arch.
Dimensions: 111 feet long, 13.7 feet wide, 9.4 feet high at trusses, 11.2 feet high at center.
Photography tips: WNW–ESE; river access possible after going across bridge, but the banks are steep.
Getting there: From the junction of Routes 5 and 132, take Route 132 northwest 2.4 miles to a fork. Take the right fork, Academy Road, 0.5 mile, and you'll see the bridge on your right. (Academy Road goes through the bridge, while another road continues straight ahead about 0.1 mile to where it dead-ends at the site of the Union Village Dam.)
Parking: There are turnoffs before going through the bridge.
Notes: Guessing by the massive timbers, the combination of arch and framing, and the boxed-X style of roof bracing in the two Thetford bridges, they were probably built by the same person. Whoever it was had a gift for ingenious construction; these are both magnificent structures. They are the survivors among seven covered bridges that were once in Thetford. The Union Village Bridge preserves some of its original dry stone abutment work (though it's capped with concrete) on the west side.

73. THETFORD CENTER BRIDGE

Other and historical names: Sayers.
Municipality: Thetford.
Locality: Thetford Center.
Ownership: Town.
Traffic allowed: Up to 8 tons; posted for 11-foot clearance.
Crossing: East Ompompanoosuc River and Tucker Hill Road.
Built: Unknown.
Builder: Unknown.
Type: Haupt.
Dimensions: 127 feet long, 18.1 feet wide, 9.7 feet high at trusses, 11.4 feet high at center.

Photography tips: ENE–WSW; river access is possible on the east side, and although it's steep, it might be worth it, due to the presence of a large cascade waterfall.

Getting there: From Exit 14 on I-91, go west on Route 113 through the aptly named Thetford Hill section of the town. Then in the valley on the other side, 2.2 miles from the interstate exit, in Thetford Center, take a left on Tucker Hill Road. The bridge is about 0.2 mile from that turn.

Parking: The best turnoff is through the bridge on the left.

Notes: This is usually cited as the only Vermont bridge to use the truss patented by Herman Haupt (see Introduction), although some say the diagonals are framed more like those in the Bath Bridge in Bath, New Hampshire, which is listed as having a Burr arch that might have been a model. In any case, it is an ingenious and ambitious structure, like the Union Village Bridge (see No. *12*), which may have had the same builder. Perhaps the massiveness of the bridge was overly ambitious: In 1963, four steel beams were added underneath to help it carry heavy traffic, the original stone abutments were capped and in one case faced with concrete, and a reinforced concrete pier was added at midspan.

Thetford Center Bridge

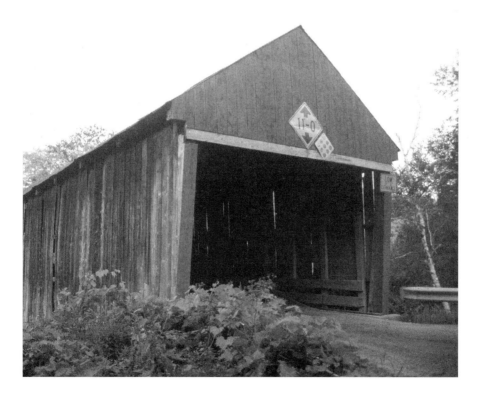

74. MOXLEY BRIDGE

Other and historical names: Guy.
Municipality: Chelsea.
Locality: Chelsea.
Ownership: Town.
Traffic allowed: Up to 4 tons; posted for 10-foot, 6-inch clearance.
Crossing: First Branch (of the White River) and Moxley Road.
Built: 1883.
Builder: Arthur C. Adams.
Type: Queenpost.
Dimensions: 56.2 feet long, 14 feet wide, 7.4 feet high at trusses, 10.7 feet high at center.

Photography tips: NW–SE; midafternoon is best; good paths to the river are on both sides of the bridge.

Getting there: From the junction of Routes 113 and 110 in Chelsea, go south on Route 110 for 2.5 miles. Moxley Road goes off to the left (southeast), and the bridge is about 0.1 mile from Route 110. Moxley Road is 0.2 mile south of the junction of Route 110 and Randolph Road, for those who have come east that way from the Randolph area. (The Chelsea Road–Randolph Road route is a better east–west connector than maps make it appear.)

Parking: Turnoffs are on both sides of the bridge.

Notes: The queenpost bridge served many local Vermont builders well, especially in northern Vermont, its design being familiar from barn construction. Here, the queenpost gets support from kingpost-type diagonals in the center. This is a so-called "skewed" bridge, placed across the stream on a slant rather than at a right angle so that its actual shape is trapezoidal.

75. FLINT BRIDGE

Other and historical names: None known.
Municipality: Tunbridge.
Locality: North Tunbridge.
Ownership: Town.
Traffic allowed: State consultants recommend no more than 5 tons.
Crossing: First Branch (of the White River) and Bicknell Hill Road.
Built: 1845.
Builder: Unknown.
Type: Queenpost.
Dimensions: 87.4 feet long, 14.8 feet wide, 8.3 feet high at trusses, 11.4 feet high at center.

Photography tips: W–E; river access is possible at all points but complicated by steep slopes or brush.

Flint Bridge

Getting there: This bridge is about 0.1 mile east of Route 110, just south of the Chelsea-Tunbridge line, which should be marked by a state sign. It's about 0.7 mile south of the Moxley Bridge in Chelsea, or 3.2 miles south of the junction of Routes 110 and 113.

Parking: There are turnoffs at the southwest corner of the bridge and at a traffic island on the east side.

Notes: This bridge is very similar in construction to the Moxley Bridge (No. 74), and may have been a model for the latter. The Flint Bridge is the oldest among the six bridges along this 7-mile stretch of Route 110. A restoration in 1969 (cable and stringer floor supports added; foundations capped with concrete) earned federal praise as an "outstanding example of functional preservation of an historic structure." On sunny days, the light shining through the side boards creates spectacular patterns.

76. LARKIN BRIDGE

Other and historical names: None known.
Municipality: Tunbridge.
Locality: North Tunbridge.
Ownership: Town.
Traffic allowed: Up to 8 tons; state consultants recommend no more than 6 tons.
Crossing: First Branch (of the White River) and Larkin Road.
Built: 1902.
Builder: Arthur C. Adams.

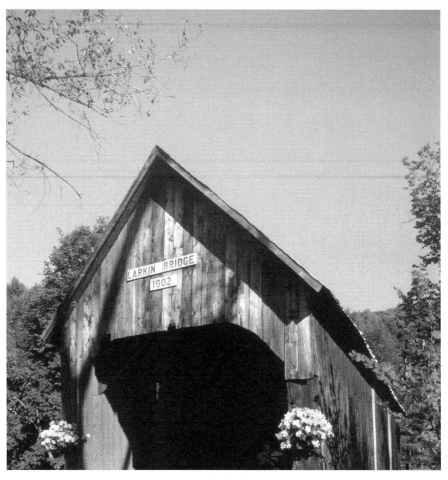

Larkin Bridge

Type: Multiple kingpost.

Dimensions: 68 feet long, 13.2 feet wide, 7.2 feet high at trusses, 9.8 feet high at center.

Photography tips: SE–NW.

Getting there: On Route 110, go 1.9 miles south of the Flint Bridge, or about 1 mile north of the village area of North Tunbridge, and the bridge is about 0.1 mile to the east. It's easily visible coming from the north; you have to look back coming from the south.

Parking: Go through the bridge for turnoffs where road swings to the left.

Notes: This is not only the newest of the Tunbridge-Chelsea bridges, but it is also one of very few in Vermont built in the 20th century, not counting authentic reproductions in recent years. The three Randolph bridges (Nos. 80, 81, and 82) are younger, dating from 1904.

77. MILL BRIDGE

Other and historical names: Spring Road; Hayward; Noble.
Municipality: Tunbridge.
Locality: Tunbridge.
Ownership: Town.
Traffic allowed: Up to 3 tons; posted for 11-foot, 4-inch clearance.
Crossing: First Branch (of the White River) and Spring Road.
Built: 1883.
Builder: Arthur C. Adams.
Type: Multiple kingpost.
Dimensions: 72.1 feet long, 16 feet wide, 10.1 feet high at trusses, 12 feet high at center.

Photography tips: S–N; the dam and swimming hole to the east of the bridge include remarkably swirled and striated rock formations.

Getting there: This bridge is at the northern end of the Tunbridge village area, about 0.1 mile west of Route 110. The road to the bridge is roughly 0.1 mile south of the post office (which is on the west side of Route 110, like the bridge).

Parking: It's tricky with private property, and a road beyond the bridge is so close that there's a mirror inside the bridge to help avoid accidents. It's best to park on the west side of Route 110, just south of the triangular intersection of Route 110 and Spring Road, and walk down.

Mill Bridge

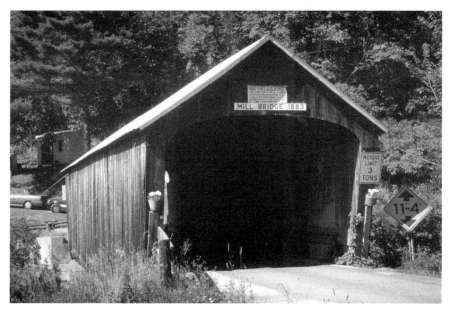

Notes: This is a nice local swimming hole, by a bridge preserved well enough to have some of the old advertisements inside. Located in an area subject to frequent flooding, it was raised to a higher elevation in the 1970s. The bridge stands next to a 19th-century mill district (gristmill, sawmill, blacksmith shop) that's the National Register of Historic Places. Several of the mill buildings have since been converted into residences.

A sign on the bridge—the misspelling in its next to last line left uncorrected—stands as a testimony to local frugality:

> ONE DOLLAR FINE
> FOR A PERSON TO DRIVE A HORSE
> OR OTHER BEAST FASTER THAN
> WALK OR DRIVE MORE THAN ONE
> LOADED TEAM AT THE SAM TIME
> ON THIS BRIDGE.

Misspelled or not, "If it ain't broke, don't fix it."

78. CILLEY BRIDGE

Other and historical names: Lower.
Municipality: Tunbridge.
Locality: Tunbridge.
Ownership: Town.
Traffic allowed: State consultants recommend no more than 3 tons.
Crossing: First Branch (of the White River) and Ward Hill Road.
Built: 1883.
Builder: Arthur C. Adams.
Type: Multiple kingpost.
Dimensions: 66 feet long, 16.2 feet wide, 8.2 feet high at trusses, 10.7 feet high at center.
Photography tips: ESE–WNW.
Getting there: From the intersection of the road to the Mill Bridge and Route 110, go south on Route 110 for 0.8 mile, passing the Tunbridge Fairgrounds (to the west of Route 110). The road to the Cilley Bridge comes immediately after a cemetery. The bridge is 0.2 mile down Ward Hill Road (the name according to the town office; the state's bridge consultants say Town Highway 45 or Russell Road.)
Parking: There's an okay turnoff next to Route 110 and a good turnoff through the bridge, in front of a gated farm road.
Notes: Low hills, a farmer's field, red farm buildings, fish breaking the surface of a placid fly-angler's stream—in all, a classic farm-country bridge. The Cilley family is still represented in town.

79. HOWE BRIDGE

Other and historical names: None known.
Municipality: Tunbridge.
Locality: South Tunbridge.
Ownership: Town.
Traffic allowed: Up to 8 tons; posted for 10-foot clearance.
Crossing: First Branch (of the White River) and Belknap Brook Road.
Built: 1879.
Builder: Ira Mudget, Edward Wells, Chauncey Tenney.
Type: Multiple kingpost.
Dimensions: 74.5 feet long, 13.1 feet wide, 9.4 feet high at trusses, 11.6 feet high at center.

Photography tips: NW–SE; mid- to late afternoon is best because of trees, and to catch the light on the best portal.

Getting there: Easy to spot, since the bridge is within 100 feet of Route 110 on the east side. It's 1.3 miles south of the intersection of the road to the Cilley Bridge and Route 110. From the south, Belknap Brook Road is 1.1 miles north of the Orange-Windsor county line and roughly 0.5 mile north of the village of South Tunbridge. (Belknap Brook Road is also known as Hill Road and, officially, as Town Highway 60.)

Parking: The Howe family, whose members live on both sides of Route 110 by the bridge, are sympathetic to the needs of bridge lovers. ("We have our own pictures, too," said one.) Park in the driveways (not on the lawns), and come to the house to make yourself known. If you're in a hurry, drive through

Howe Bridge

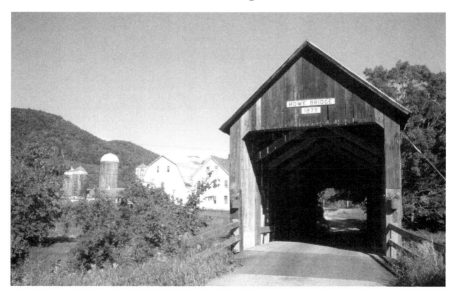

the bridge to turn around, come back across, and park on the extreme right of the paved triangular area connecting the side road and Route 110.

Notes: The Howe family often puts tubs of flowers at the western portal, making it one of the most attractive covered-bridge entrances in the state. The farm not only includes several massive timber-framed barns, but it also preserves many of the outbuildings that all too typically are allowed to fall into ruin on hard-pressed Vermont farms. While not identified as an Agricultural Historic District, this farm alone outclasses some areas that have been awarded the designation.

For many years, the Howes have kept a ladder inside the bridge. Asked why, two members of the family independently gave the identical answer: "It's always been there." One could wish no less for the entire farmstead.

80. KINGSBURY BRIDGE

Other and historical names: Hyde.
Municipality: Randolph.
Locality: South Randolph.
Ownership: Town.
Traffic allowed: Up to 4 tons.
Crossing: Second Branch (of White River) and Kingsbury Road.
Built: 1904.
Builder: Unknown.
Type: Multiple kingpost.

Kingsbury Bridge

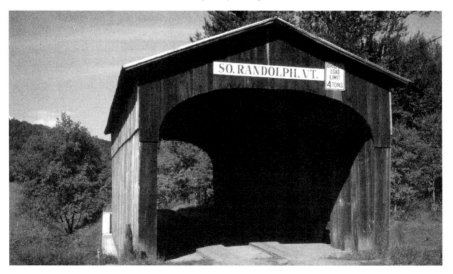

Dimensions: 46.1 feet long, 16 feet wide, 12 feet high at center.

Photography tips: ESE–WNW; there's river access from all corners; morning is best (there's a sign on the east portal); farm silos to the north make a nice background.

Getting there: From the junction of Routes 110 and 14, go west on Route 14. At the intersection of Routes 14 and 107, go north on Route 14 for 4.5 miles. An octagonal library building is 0.4 mile from the bridge, which is very close to Route 14 on the west side and highly visible.

Parking: There's a good turnoff on the Route 14 side of the bridge.

Notes: Built in 1904, this and Randolph's other two bridges (Nos. 81 and 82) are among the youngest of the older generation of Vermont covered bridges.

81. GIFFORD BRIDGE

Other and historical names: C.K. Smith.
Municipality: Randolph.
Locality: East Randolph.
Ownership: Town.
Traffic allowed: Up to 3 tons.
Crossing: Second Branch (of the White River) and Hyde Road.
Built 1904.
Builder: Unknown.
Type: Multiple kingpost over multiple kingpost.

Gifford Bridge

Dimensions: 45.7 feet long, 12 feet high, 7.7 feet high at trusses, 10.7 feet high at center.

Photography tips: WSW–ENE; afternoon is best because of a hill; there's river access from all corners.

Getting there: From the Kingsbury Bridge (see No. 80), go north on Route 14 for 2.8 miles and turn right (east) onto Hyde Road. From East Randolph (and the junction of Route 66), go south on Route 14 for 1.7 miles to Hyde Road. Heading south, the bridge is easily visible from Route 14, but going north it's shielded from view by a house until after you've passed it, so keep an eye out for the turn to the right.

Parking: There's an okay turnoff on the right before crossing the bridge; a better one is through the bridge and on the left (a former logger's landing area).

Notes: The unusual truss design, with a top layer of larger multiple king-posts over a layer of smaller multiple kingposts, has suggested to some that there was originally an uncovered kingpost bridge at the site, which was later expanded and roofed. Due to inevitable truck traffic, the Vermont Agency of Transportation's bridge consultants have recommended a bypass bridge at this crossing so the wooden structure could be safely preserved. The Gifford family is well known in the area's history, and has given its name to Randolph's hospital.

82. BRALEY BRIDGE

Other and historical names: Upper Blaisdell; Johnson.
Municipality: Randolph.
Locality: East Randolph.
Ownership: Town.
Traffic allowed: Up to 8 tons; posted no trucks or buses.
Crossing: Second Branch (of the White River) and Braley Covered Bridge Road.
Built: 1904.
Builder: Unknown.
Type: Multiple kingpost over multiple kingpost.
Dimensions: 38.4 feet long, 13.9 feet wide, 8 feet high at trusses, 10.5 feet high at center.
Photography tips: ESE–WNW; afternoon is best because of trees; good river access.
Getting there: Tricky and dangerous. Braley Covered Bridge Road (which may be called Blaisdell Road in some sources), not clearly marked as such, dives downward quite steeply to the west of Route 14, so it's easy to sail right by and not know it's there. Look for a white highway sign saying the posted

Braley Bridge

limit is 16,000 pounds. From the junction of Routes 14 and 66, it's 0.9 mile south on Route 14. A cemetery is on both sides of the road within 0.1 mile of the turn. The bridge is 0.1 mile down the side road. The real problem is heading back. Word at the town office: "Be careful coming out (onto Route 14). We had a fatal down there last year." Sight distances along Route 14 are not great, cars come fast, and if you have any doubts about your ability to get a car in motion after stopping on a hill, park along Route 14 and walk down.

Parking: A good turnoff is through the bridge and on the left. The road is private after that, but there's room to turn around.

Notes: This one's in somewhat better shape than it looks because steel beams were added underneath in 1977. Like the Gifford Bridge (No. 81), its structure of larger multiple kingposts over smaller multiple kingposts suggests it may have been an open bridge at the start and was given greater height and a roof later. Don't be surprised if the fowl from a nearby homestead serve as a welcoming committee.

Also on this tour

WHILE NOT A covered bridge, the **Floating Bridge** in Brookfield is one of the wonders of Vermont and is dearly beloved by bridge enthusiasts. Brookfield being the next town north of Randolph, it's not hard to reach: From the junction of Routes 14 and 65 in East Brookfield, take Route 65 west for 2.2 miles. Around 1819, according to Herbert Wheaton Congdon, local resident Luther Adams and neighbors put a log bridge across the ice of Sunset Lake, in part because Daniel Belknap had broken through the ice and drowned not long before. They built the bridge so it would float when the ice was gone, an idea that worked well enough for the town to take over maintenance of the bridge in 1826. In 1884, Orlando Ralph tried putting kerosene barrels underneath instead of just adding more logs once the ones in place got waterlogged. Flotation of that sort has been used ever since for the nearly 300 foot structure. The current bridge, built by the Vermont Agency of Transportation, is the Floating Bridge's seventh incarnation. Heed signs saying not to take up commercial parking spaces when stopping to see it.

XI. Montpelier–Area Tour

THIS GROUPING OF bridges is meant to center on Montpelier, the smallest of the nation's state capitals, and to radiate out to nearby areas. Route 12 to the south takes you to Northfield's six bridges; Route 302 reaches a bridge in Barre (which is pronounced like "Barry," not like "bar"); Route 2 leads the way to bridges in Marshfield and East Montpelier; and a road leading off northbound Route 12 accesses a private bridge in a historic area of Calais.

Central to Montpelier's downtown historic district is the gold-domed 1859 **State House.** As ornate in its Corinthian interior as on its Doric exterior, it does double duty as a museum. Guides are available (802-828-2228) to show off marble floors, painted portraits, a wall painting of the Civil War Battle of Cedar Creek, memorabilia, and of course the (dare we say it?) stately legislative chambers. Native Vermonters sometimes shake their heads on seeing for the first time this grandiose focal point—which, architecturally speaking, turns the state's traditional frugality inside out and whose occupants are sometimes said to do so financially, as well. But visitors are likely to marvel at the accessibility of even the highest levels of government, and the degree to which a citizen legislature still remains in control.

For the historically minded, the **Vermont Historical Society** museum and library (802-828-2291) are a must. The museum brings to life Vermont's multicultural past through all sorts of collections: furnishings, clothing, tools, handbills, games, and more. The library has not only books, including a number on covered bridges, but also genealogical resources, periodicals (naturally including its own fine *Vermont History* magazine), maps, photographs, manuscripts, oral history tapes, broadsides and posters, and more. Some of the Vermont Historical Society's decorative arts collection will eventually be on

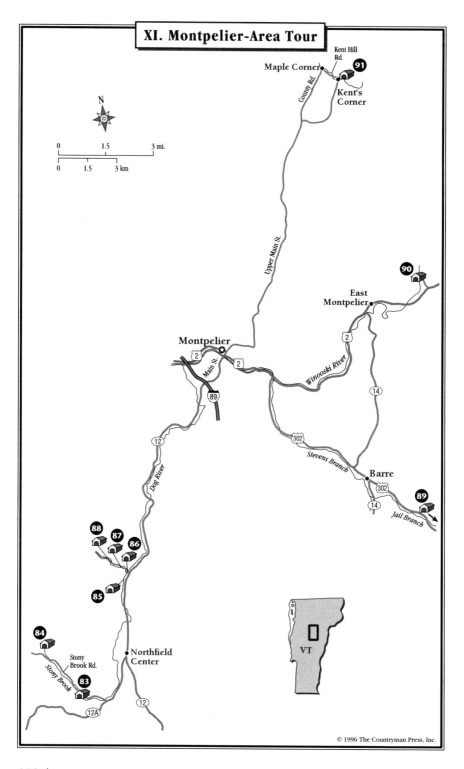

XI. Montpelier-Area Tour

N

0 1.5 3 mi.

0 1.5 3 km

Kent Hill
Rd.

Maple Corner

91

Kent's
Corner

County Rd.

Upper Main St.

90

East
Montpelier

2

Montpelier

2 2

Main St.

Winooski River

89

14

12

302

Stevens Branch

Dog River

Barre

302

14

89

Jail Branch

88 87

86

85

VT

84

Stony
Brook Rd.

Northfield
Center

Stony Brook

83

12A 12

© 1996 The Countryman Press, Inc.

view at the **Kent Tavern Museum,** a few miles north of Montpelier at Kent's Corner (see entry on the Kent's Corner covered bridge, No. 91). Downtown Montpelier also has the **T.W. Wood Art Gallery** (802-828-8743), with its permanent collection of historic Vermont art and rotating exhibits often featuring Vermonters.

Noteworthy for bridge lovers: Due partly to the city's railroad heritage, a cluster of magnificent historic steel bridges spans the Winooski River. It may be trespassing to walk them, but a lot of people do, especially if the otters are playing in the water below. Yes, otters at the capital. In Vermont, nature is never far away.

Nearby Barre has its own historic district, a museum at the **Aldrich Public Library** (802-476-7550), and a **Rock of Ages Corporation** (802-476-3115) granite-working museum. Rock of Ages also offers a look underneath Vermont, with a free guided tour of the world's largest granite quarry, and a train ride (fee) to its deepest. The artistry of generations of granite carvers makes Barre's **Hope Cemetery** unique. Rocks are never far away in Vermont, either. The rock cuts along the nearby stretches of the interstate and other major highways are considered artistic resources by many central Vermont residents, and recent years saw a fierce battle over plans—now abandoned—to trim them back for safety reasons.

83. MOSELEY BRIDGE

Other and historical names: Stony Brook.
Municipality: Northfield.
Locality: Southwest of Northfield Center.
Ownership: Town.
Traffic allowed: Up to 8 tons.
Crossing: Stony Brook and Stony Brook Road (Town Highway 8).
Built: 1899.
Builder: John Moseley.
Type: Modified kingpost.
Dimensions: 36.5 feet long, 16.2 feet wide, 10.8 feet high at trusses, 12.9 feet high at center.
Photography tips: SE–NW; best path to river at SE corner of bridge.
Getting there: From the intersection of Routes 12 and 12A in Northfield Center, take Route 12A south for 1.6 miles—just beyond a railroad overpass—and go right onto Stony Brook Road. (If you see a golf course, you've gone roughly a half-mile too far.) About 0.2 mile from Route 12A, Stony Brook Road forks. Take the left fork and go another 0.6 mile to the bridge.
Parking: A turnoff on the left before the bridge serves a riverside picnic area.
Notes: The first John Moseley in Northfield was born in 1801, according

to the town office, so the builder of this bridge may actually have been John Moseley II. This is said to have been the last kingpost bridge built on a public highway in Vermont, in 1899. The kingposts come only partway up the sides of the bridge. Five steel support beams were added during a major reconstruction in 1971, and the original stone abutments were faced and capped with concrete in 1990. Although it has no pool deep enough for a swimming hole, the picnic area downstream from the bridge makes this a particularly nice place to stay awhile and get a sense of a covered bridge's natural environment.

84. CHAMBERLIN BRIDGE

Other and historical names: None known.
Municipality: Northfield.
Locality: Southwest of Northfield Center.
Ownership: Private.
Traffic allowed: Private, pedestrian.
Crossing: Unnamed tributary of Stony Brook.
Built: 1956.
Builder: Mahlon Chamberlin.
Type: Kingpost.
Dimensions: 22 feet long.
Photography tips: WNW–ESE; afternoon is best.
Getting there: Can be tricky. From the Moseley Bridge (see No. 83), continue on Stony Brook Road 2.6 miles (following the road involves taking it

Chamberlin Bridge

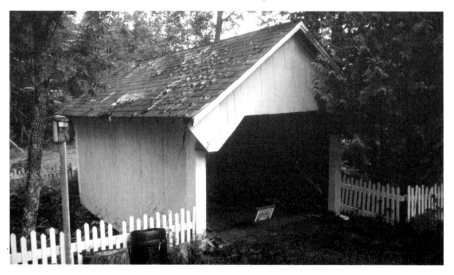

north at a brown house). The yellow-and-white structure is to the right of the road, beside the house.

Parking: Along Stony Brook Road.

Notes: Ask people in Northfield how many covered bridges there are, and informants may disagree, some saying five and some saying six. This is the sixth. Except for bridge-memory collectors and obsessive photographers, this small, simple, and ordinary structure could be skipped (although it does illustrate Vermonters' woodworking skills and the continuing viability of wooden truss bridges for carrying lesser traffic across smaller streams). Its main use at present seems to be as a walkway and wood-storage area.

85. SLAUGHTER HOUSE BRIDGE

Other and historical names: Slaughterhouse.
Municipality: Northfield.
Locality: Northfield Falls.
Ownership: Town.
Traffic allowed: Up to 8 tons.
Crossing: Dog River and Bailey Street.
Built: Around 1872.
Builder: Unknown.
Type: Queenpost.
Dimensions: 59.6 feet long, 11.7 feet wide, 9.2 feet high at trusses, 10.8 feet high at center.

Slaughter House Bridge

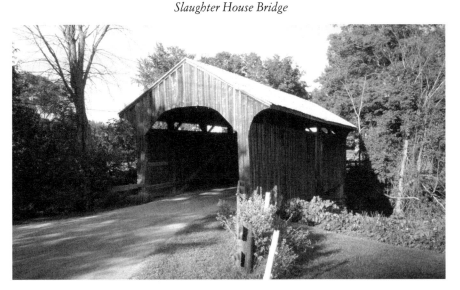

Photography tips: SW–NE.

Getting there: Bailey Road can be maddeningly difficult to find because it's small and slopes downhill to the west of Route 12. It's possible to know almost exactly where it is and still go back and forth until the light finally dawns: "Oh! That thing like a driveway between the two mailboxes must be a side street." A white sign saying there is a 16,000-pound limit is more visible than the sign saying BAILEY ST., and there's a 35-mile-per-hour speed limit sign on the other side of Route 12. Coming from the north, the turn is 0.3 mile from the turn for the other three Northfield Falls bridges (see Nos. 86, 87, and 88), and comes after the third house beyond the restaurant and motel (west of Route 12). The bridge is 0.1 mile from the highway.

Parking: There's a good turnoff in front of the bridge, on the left, with a path to the river.

Notes: Across the bridge, the road dead-ends. An abandoned road to the right leads to a falls area. The bridge's name came, as might be expected, from a slaughterhouse that was once in the vicinity.

86. STATION BRIDGE

Other and historical names: Northfield Falls.
Municipality: Northfield.
Locality: Northfield Falls.
Ownership: Town.
Traffic allowed: Up to 8 tons; posted for 12-foot clearance.

Station Bridge

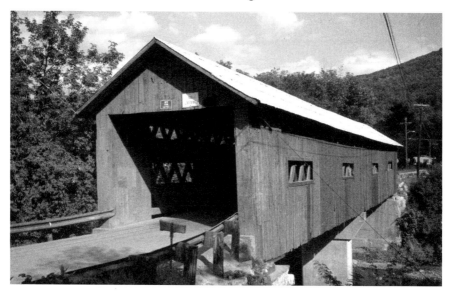

Crossing: Dog River and Cox Brook Road.
Built: Around 1872.
Builder: Unknown.
Type: Town lattice.
Dimensions: 137 feet long, in two spans of 68.5 feet, 15.9 feet wide, 10.6 feet high at trusses, 12.7 feet high at center.
Photography tips: NNW–SSE.
Getting there: This bridge and its two companions can be reached by turning off Route 12 to the west of the main intersection in Northfield Falls. This intersection has School Street going east, slightly offset from Cox Brook Road going west. A key landmark is a three-story wooden building in commercial use, with a sign saying CROSS BLOCK 1892; Cox Brook Road starts just to the north of this building.
Parking: Owners said it's okay to park in lots at the west side of the bridge. But a better strategy might be to park at the lot for the Second Bridge (see No. 87) and walk to them both.
Notes: This and the Second and Third Bridges (Nos. 87 and 88) are three red jewels strung on the same necklace, all within 0.4 mile of each other on Cox Brook Road. The Station and Second Bridges can be included in the same picture, the only place in New England where this is the case. Don't miss the sign: SPEED LIMIT / HORSES AT A WALK / MOTOR VEHICLES / 10 MILES PER HOUR. The name Station came from the presence of a railroad depot nearby. In 1963, four steel beams and a central pier were added to make sure the wooden bridge could cope with its heavy traffic load.

87. SECOND BRIDGE

Other and historical names: Newell; Lower Cox Brook.
Municipality: Northfield
Locality: Northfield Falls.
Ownership: Town.
Traffic allowed: Up to 8 tons.
Crossing: Cox Brook Road and Cox Brook.
Built: Around 1872.
Builder: Unknown.
Type: Queenpost.
Dimensions: 56.6 feet long, 15.7 feet wide 10 feet high at trusses, 12.6 feet high at center.
Photography tips: WNW–ESE.
Getting there: About 0.1 mile west of Station Bridge (see No. 86).
Parking: After crossing the railroad on Cox Brook Road, use the parking lot on the north side, between the railroad and a side road.
Notes: Although a bit adventurous to take, side shots are possible from a

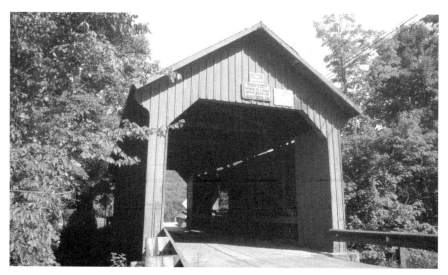

Second Bridge

pasture at the southwest corner. Don't disturb the horses. This bridge, like the other two on this road, was strengthened by steel beams during the 1960s.

88. THIRD BRIDGE

Other and historical names: Upper Cox Brook.
Municipality: Northfield.
Locality: Northfield Falls.
Ownership: Town.
Traffic allowed: Up to 8 tons.
Crossing: Cox Brook and Cox Brook Road.
Built: Around 1872.
Builder: Unknown.
Type: Queenpost.
Dimensions: 51.5 feet long, 13.4 feet wide, 11.2 feet high at trusses, 12.5 feet high at center.
Photography tips: S–N.
Getting there: From the Second Bridge, go about 0.2 mile west on Cox Brook Road.
Parking: Turnoffs are on the right side of the road after you go through the bridge.
Notes: The family that lives nearby has allowed this bridge to be used as a swimming hole for more than 40 years. They would appreciate being asked if people want to go on the land. This bridge had four steel beams added for support in 1966.

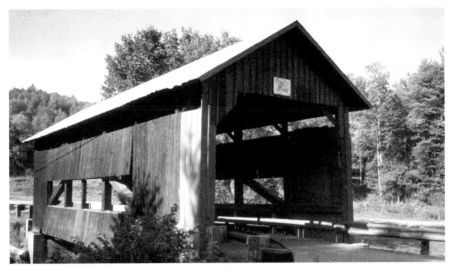

Third Bridge

89. ROBBIN'S NEST BRIDGE

Other and historical names: None known.
Municipality: Barre Town.
Locality: East Barre.
Ownership: Private.
Traffic allowed: Private.
Crossing: Jail Brook and private road near Route 302.
Built: 1962 and 1964.
Builder: Robert R. Robbins.
Type: Queenpost.
Dimensions: 56.5 feet long; 12.7 feet wide; 11-foot clearance.
Photography tips: NE–SW; afternoon is best because of trees; side shots from the river are feasible.
Getting there: From the junction of Routes 14 and 302 in the middle of Barre (where Elm Street goes north), go east on Route 302 for 2.1 miles. The bridge is very close to Route 302, clearly visible, on the south side.
Parking: There's plenty across the street at a large turnoff (avoid taking up patrons' spaces near the restaurant).
Notes: A notice at the bridge invites people to park but points out that the land beyond the bridge is private property. The signs explain that it was built by Robert R. Robbins to access land beyond it, with the footings and framework built in 1962 and the siding put on in 1964. "The design and appearance of the bridge duplicate in all important details an earlier bridge, located about 100 feet downstream, but destroyed by the Flood of 1927." The frame is of Douglas fir from California, shipped via the Panama Canal to New Jersey

before coming to Vermont, but the siding is Vermont lumber. The trusses were built on the ground nearby and lifted into position by a crane. "Keeping with the early-American theme, the house on the hill behind the bridge was built entirely of logs." The new owners of the property put steel beams under it in the early 1990s, along with other restoration work, as the bridge was becoming unstable.

For decoration, there's a replica of an old-time rates-of-toll notice: four-horse carriage or sleigh 25¢, two-horse 15¢, one-horse 10¢, a score of cattle 25¢, a score of sheep 12¢, a score of hogs 12¢, a cart or wagon 18¢, a horse and rider 6¢, a tied horse 6¢, a person on foot 2¢, persons going to church FREE.

Another posting, echoing an unwritten but traditional rule for Vermont barns, could apply to any covered bridge: NO SMOKING—THE DANGERS ARE CLEAR AND OBVIOUS.

90. COBURN BRIDGE

Other and historical names: Cemetery.
Municipality: East Montpelier.
Locality: East Montpelier.
Ownership: Town.
Traffic allowed: Up to 8 tons; posted for 9-foot clearance.
Crossing: Winooski River and Coburn Bridge Road.
Built: 1840s, according to a town history; 1851, according to a 1970s nomination for the National Register of Historic Places.

Coburn Bridge

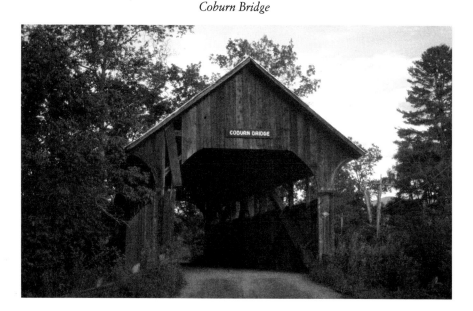

Builder: Larned Coburn.

Type: Queenpost.

Dimensions: 69.2 feet long, 13.4 feet wide, 9.5 feet high at trusses, 11.2 feet high at center.

Photography tips: SE–NW; river access at all points.

Getting there: From the northern junction of Routes 14 and 2 in East Montpelier, take Route 2 east for 2 miles to a crossroads. Go left (north) on the Coburn Bridge Road for 0.7 mile.

Parking: Turnoffs are on both sides of the bridge. Stay off the road, although it may seem secluded: Three of four corners of the bridge were banged up on one visit, indicating truck and/or farm-equipment traffic.

Notes: Larned Coburn wanted the main road to go nearer his place, so he offered to build the town a bridge if the route was changed. The offer was accepted. Today, this is a back road, with Cate Farm and the Cate Cemetery in the neighborhood (hence one historic name for the bridge). If you see the name Onion River on signs in this area, that's because the name Winooski is from the Abenaki meaning "wild onion"—a reference to wild edibles that still grow in some areas of Vermont and are still gathered. The Coburn Bridge was reconstructed in 1972–73, and given support beneath from three steel beams.

91. KENT'S CORNER BRIDGE

Other and historical names: None known.

Municipality: Calais.

Locality: Calais.

Ownership: Private.

Traffic allowed: Private.

Crossing: Curtis Brook and homestead path.

Built: 1994.

Builder: Jan Lewandoski, reconstructing stringer bridge built 1963 by Ralph Weeks.

Type: Kingpost.

Dimensions: 22 feet long.

Photography tips: E–W.

Getting there: To look at a map, there seems no way out of navigating a tangle of back roads. Actually, it's far easier than might be suspected. From Route 2, take Route 12/Main Street north into Montpelier (crossing a concrete-and-steel bridge just after that turn). There's a traffic light at the 0.2-mile point; keep going northward. In another 0.3 mile, turn right; this is Upper Main Street, and the Main Street School will appear on the left in 0.1 mile. Upper Main Street will swing to the left (north) and become County Road in Calais—a good paved road that serves as a local artery. At 9.3 miles after the turn onto Upper Main Street, take Kent Hill Road right (east) 0.7

mile to Kent's Corner. (If you find yourself in Maple Corner, you've gone 0.1 mile too far north on County Road; turn around and turn left to get onto Kent Hill Road.) The bridge is behind the first house on the left, going east from the crossroads on Kent Hill Road.

Parking: Best is at Kent's Corner, at the brick building across from the barn—the Kent Tavern, now the state-owned Kent Museum. If you must park by Kent Hill Road, please avoid the lawns.

Notes: Ask permission before trying to find the bridge, which is behind the house and can't be reached by car.

This bridge's history starts with a children's book author, Louise Kent, who wrote under the pen name Mrs. Appleyard. "She wanted to have a little covered bridge," said Town Clerk Eva Morse, "so Ralph [Weeks] went and toggled one up for her. He was a great toggler." For those not familiar with the expression, a toggler is "someone who fixes things, and sometimes with a piece of string. There are a lot of us around. Maybe it's a Vermont term." It certainly would apply to Frank G. Lewis (see No. 69) and to the builders of several imitation covered bridges mentioned at the ends of this book's tours.

When Kurt Janson and Eileen Murray bought part of the former Kent property in 1990, they found the bridge in poor repair. "We felt it was something worth replacing," Janson said. Rather than toggle it back into shape, they decided to pay tribute to Weeks's work by hiring Stannard, Vermont, timber framer and covered-bridge expert Jan Lewandoski, who has in many respects assumed the late New Hampshire builder Milton S. Graton's mantle as a preserver and creator of authentic-style wooden bridges. The kingpost bridge

Kent's Corner Bridge

that Lewandoski built near Kent's Corner is one of three that he has constructed, the rest being in other states. His workmanship is also evident in the rebuilt Halpin Bridge in Middlebury (see No. 17), among other repair jobs. He served as one consultant for the Vermont Agency of Transportation's major evaluation of highway covered bridges in 1993–94. As for the Kent's Corner Bridge, "We've been told it's the smallest covered bridge in the state that's a real covered bridge," Janson said.

For a visitor, the bridge might be a sidelight during an expedition to see the Kent Museum once the state opens it—hopefully in the late 1990s. The private Aldrich Memorial Association is also trying to restore a sawmill in the neighborhood.

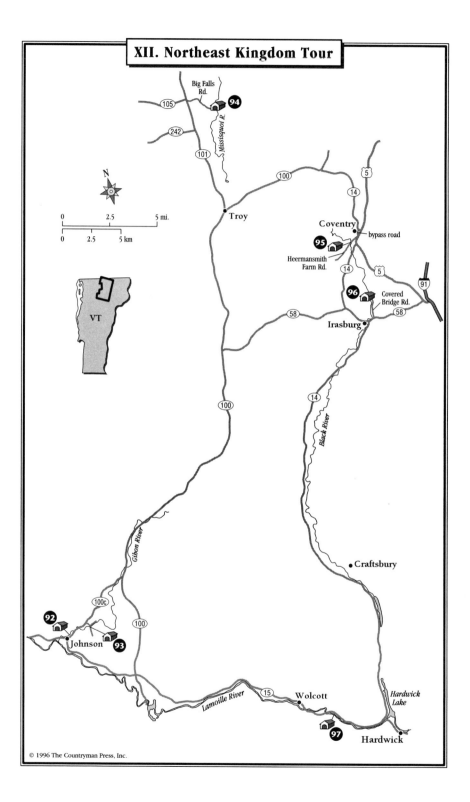

XII. Northeast Kingdom Tour

Big Falls Rd.

105

242

101

Missisquoi R.

94

N

0 2.5 5 mi.

0 2.5 5 km

VT

100

14

5

Troy

Coventry

bypass road

95

Heermansmith Farm Rd.

14

5

96

Covered Bridge Rd.

91

58

58

Irasburg

100

14

Black River

Gibou River

Craftsbury

100c

100

92

Johnson 93

15 Wolcott

Lamoille River

Hardwick Lake

97

Hardwick

© 1996 The Countryman Press, Inc.

XII. Northeast Kingdom Tour

WITH THIS EXPEDITION, we enter a region of Vermont known as the Northeast Kingdom. As Castleton State College geographer Joseph Taparauskas put it, this is "a vernacular region," which can't be defined in any systematic way, but instead combines physical, social, and cultural characteristics. Anchoring the perception that this is a unique part of the state is a geologically distinct northeastern highland area, into which this bridge tour will penetrate. Socially, one might consider the 1980 US Census map that Harold A. Meeks includes in *Time and Change in Vermont: A Human Geography,* which shows 42 towns in the state with 15 percent or more of the families below the poverty line, half of them clustered in the upper northeast corner. Farming and logging have been the traditional livelihoods. Neither has been lucrative, especially in a frostbitten zone that comes closest to the disgruntled description of Vermont's climate as "nine months of good hard winter and three months of damn poor sledding."

But this area can be as rich culturally as it is poor in other respects. The old Vermont, the "real Vermont," survives here: stubborn, sometimes cantankerous, always independent and fiercely proud. "The last true peasant society in North America," one anthropologist living and working in the Northeast Kingdom called it. Inhabitants still sometimes plant by the moon and know spells; it is entirely appropriate that the headquarters of a group dedicated to dowsing, the art of finding water or making other decisions with a divining rod or pendulum, is located in Danville. The old Vermont accent, erased in most regions by the omnipresence of television culture, can still be heard, along with the scream of the panther, the grunt of the moose, and the cry of the loon. Natives may not be loquacious, but they are apt to have strong survival skills, and tales to tell if the occasion arises.

Artists are survivors, too, and often come to northern Vermont to take refuge from the overheated cities. In Glover, the internationally known **Bread and Puppet Theater** has turned a barn into a museum of their work (802-525-3031), which might stand as a symbol for all the other creative types hiding out in the hills. A respect for individuality and even eccentricity is part of the reason why so many inventions originated in northern New England—including, of course, covered-bridge designs.

In a Hollywood movie, views of this countryside would be overladen with mood music, so as to create an appropriate emotional tone. A visitor to the bridges will see far more along the way with some verbal mood music in mind. The novels of Howard Frank Mosher, especially *Northern Borders* and *Where the Rivers Flow North,* will add immeasurably to anyone's appreciation of what lies below the surface. Read Wolcott poet David Budbill's Judevine poems (the village is fictional, although several area landmarks bear a similar name), or Barton poet Leland Kinsey's *Family Drives,* with its often harrowing tales of growing up in the region. Many other writers could be named here, including such internationally known figures as Galway Kinnell (connections with Sheffield) and Hayden Carruth (connections with Johnson). Go back to Robert Frost's "The Witch of Coos," which applied to Vermont as well as to New Hampshire, and "A Servant to Servants," about the Lake Willoughby area.

In one of Budbill's Judevine poems, he and a Kingdom native are cutting trees in the fall foliage season, on one of those clear days when it's possible to look across the region's broad valleys to distant but seemingly neighboring peaks. He writes, "That's when Arnie, Arnie the Wretched, the Ugly, the Stupid, / the Drunk, the Outlaw, the Poor— / that's when Arnie said, / 'Lookit 'at. 'At's why ah live here.'" There may well be times when a visitor, transported by the excuse of a distant covered bridge into the almost hallucinatory beauty of this landscape, might wish to trade economic security for more of such glimpses.

92. POWER HOUSE BRIDGE

Other and historical names: School Street.
Municipality: Johnson.
Locality: Johnson village.
Ownership: Town.
Traffic allowed: Was limited to 3 tons; recently closed to traffic.
Crossing: Gihon River and School Street.
Built: 1872.
Builder: Unknown.
Type: Queenpost.
Dimensions: 63 feet long, 14 feet wide, 9.5 feet high at trusses, 11.8 feet high at center.

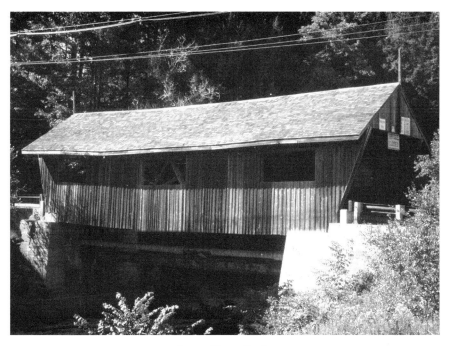

Power House Bridge

Photography tips: E–W; morning is best because the nearby highway makes a poor background to afternoon shots.

Getting there: From the junction of Routes 15 and 100C in Johnson, take Route 100C northeast 0.4 mile. The bridge is clearly visible to the left of the highway.

Parking: Turnoff by highway.

Notes: This bridge was added when the town extended School Street across the Gihon River to connect with the road to North Hyde Park. Its present name comes from the hydroelectric generating station built in 1895 upstream of the bridge, where the river goes through a series of picturesque waterfalls. In its early years, the bridge was a favorite place for students at the Johnson Normal School (the teachers college that has since grown and been renamed Johnson State College) to indulge in the forbidden practice of smoking. The old custom of swains kissing their sweethearts in covered bridges is said to have been particularly well observed by the college students.

There have been several major reconstructions. In 1960, voters authorized use of a special bridge fund of about $4000, the structure having seriously deteriorated for at least 5 years. Wilmer Locke of Waterville put in a new abutment, approaches, and floor. Cole Contracting undertook another reconstruction in 1962. The state's recent covered-bridge survey recommended strengthening the flooring to carry 15 to 18 tons due to trucks using School Street as a shortcut. With the bridge sagging, local officials closed it on a temporary basis.

93. SCRIBNER BRIDGE

Other and historical names: DeGoosh.
Municipality: Johnson.
Locality: East Johnson.
Ownership: Town.
Traffic allowed: Up to 8 tons.
Crossing: Gihon River and Loop Road (Town Highway 33).
Built: Unknown; cover may have been added around 1919.
Builder: Unknown.
Type: Queenpost.
Dimensions: 47.8 feet long, 12.4 feet wide, 9.3 feet high at trusses, 12 feet high at center.
Photography tips: NE–SW.
Getting there: From the junction of Routes 15 and 100C, go northeast 1.5 miles and turn right. After 0.3 mile, the bridge will be to the right.
Parking: There's a good turnoff after you go through the bridge, near a field from which to take side pictures.
Notes: The half-height walls of this bridge, together with historical documents found by state consultants, indicate that originally this was a pony bridge, without sidewalls and a roof. Leroy Scribner once had a farm near the bridge, and there was a Sam Scribner in the neighborhood, as well. Later, nearby farmer Ellsworth DeGoosh's name was for a time associated with the bridge.

Like the Power House Bridge (see No. 92), this bridge fell into disrepair in the 1950s. DeGoosh is said to have even been nervous about driving his cows across. Wilmer Locke of Waterville, who also worked on the Power House Bridge, did $3600 worth of repairs in 1960. The south-end abutment was inscribed at this time with the initials "IW" (name unknown), "ETD" (DeGoosh), and "R Richards 1960" (Town Clerk Roger Richards). Robert L. Hagerman interviewed Gordon Davis, the road commissioner at the time, who said he put the inscription there as a joke.

94. RIVER ROAD BRIDGE

Other and historical names: School; Upper.
Municipality: Troy.
Locality: Troy.
Ownership: Town.
Traffic allowed: Up to 8 tons.
Crossing: Missisquoi River and Big Falls Road.
Built: 1910.
Builder: Unknown.

Type: Town lattice.

Dimensions: 92.5 feet long, 11.9 feet wide, 9.7 feet high at trusses, 9.9 feet high at center.

Photography tips: E–W; there's good access to the river, via a path, from the northwest corner of the bridge.

Getting there: From the junction of Routes 105, 242, and 101 in Troy (Routes 105 and 242 come in concurrently from the north), go about 0.1 mile south on Route 101, then left 1.1 miles. Coming from the south, head north on Route 101 from its junction with Route 100 in the village area of Troy. After about 4 miles and just after you cross a stream, look for the turn to your right.

Parking: There's a good turnoff on the west side of the bridge; wide spots in the road beyond the bridge can also serve.

Notes: While not completely secluded—there's a farm beyond the east end of the bridge—this quiet site would be a good candidate for a picnic stop, especially if the north-flowing river is low and its sandbar is available.

The design of this bridge is unique among Vermont covered bridges. The lattice has three chords per truss rather than four (the customary upper intermediate chord is absent), the lattice members are pegged with one treenail rather than the more usual two, and the steep gable roof with its wide overhang is also distinctive.

River Road Bridge

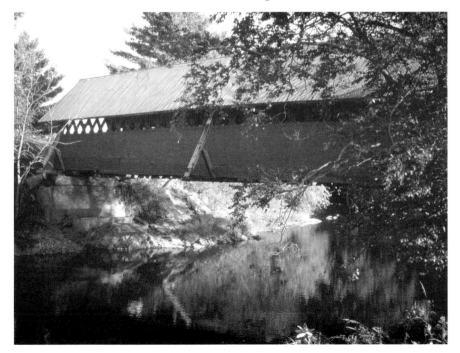

95. ORNE BRIDGE

Other and historical names: None known.

Municipality: Irasburg.

Locality: On the edge of the village of Coventry, near the Irasburg town line.

Ownership: Town.

Traffic allowed: State consultants recommend no more than 4.5 tons.

Crossing: Black River and Heermansmith Farm Road.

Built: Either 1879 or 1881.

Builder: Either E.P. Colton (1879) or J.D. Colton (1881).

Type: Paddleford.

Dimensions: 86 feet long, 14.7 feet wide, 8.9 feet high at trusses, 11.7 feet at center.

Photography tips: W–E; afternoon is best because of a hill to the east, with sunset especially fine; good river access.

Getting there: The best route is through Coventry (pronounced CAHV-in-tree, not CUV-un-tree), a bypassed village just south of the northern junction of Routes 14 and 5 (which run concurrently past Coventry on the bypass). Take either of two roads off the bypass into the village, which is west of the bypass. The central green is the village's main feature. On its southwest side a hill rises, with a church. Heermansmith Farm Road, the road to the bridge, runs south to the right of that church. The bridge is 0.6 mile from the cannon on the green.

Parking: Roadside turnoffs.

Notes: This is one of Vermont's few Paddleford-truss bridges and is distin-

Orne Bridge

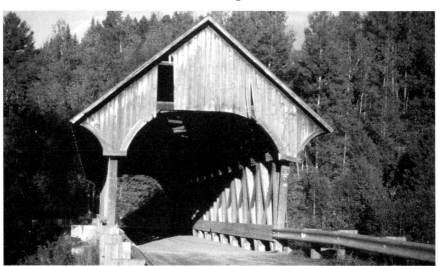

guished by retaining its original structure and remaining in highway use. The road on which it's located is known locally as "the back road to Irasburg" in Coventry, and "the back road to Coventry" in Irasburg. Partway along it, a road splits off to the Heerman Smith Inn. Members of the family of early settler Frederick Heerman—who came from Leipzig, Germany, in 1802—have had an inn there since 1807. Its current name, and that of the road to the bridge in Coventry, reflects a union of the Heerman and Smith families two generations ago. The entire valley west of Coventry was at one point called Heerman Valley, since Frederick's son Hartson owned almost all the land, including a sawmill at the waterfall behind the inn that would continue to 1927.

96. LORD'S CREEK BRIDGE

Other and historical names: None known.
Municipality: Irasburg.
Locality: Irasburg.
Ownership: Private.
Traffic allowed: Private.
Crossing: Black River and farm road.
Built: 1881.
Builder: Unknown; possibly Colton family (see No. 95).
Type: Paddleford.
Dimensions: 50 feet long.
Photography tips: E–W.

Lord's Creek Bridge

Getting there: From the southern junction of Routes 14 and 58 in Irasburg village, go 0.5 mile east on Route 58 to where Covered Bridge Road, listed on some maps as Old Dump Road, goes to the left (north). The bridge is on the left side of that road, about 0.7 mile up.

Parking: Along Covered Bridge Road.

Notes: This rare Paddleford-truss bridge used to span Lord's Creek south of Irasburg village. A concrete-and-steel bridge was built there in the 1950s, after the old bridge's abutment washed out. In 1958, dairy farmer Joseph Leblond moved the covered bridge to his farm.

97. FISHER BRIDGE

Other and historical names: Chubb or Chub.
Municipality: Wolcott.
Locality: Wolcott.
Ownership: State.
Traffic allowed: Railroad.
Crossing: Lamoille River and railroad line.
Built: 1908.
Builder: St. Johnsbury and Lamoille County Railroad, at that time owned by the Boston & Maine Railroad.
Type: Town-Pratt, double lattice.
Dimensions: 103 feet long.
Photography tips: NNW–SSE.
Getting there: From Route 15's junction with Route 14 in Hardwick, it's about 2.9 miles west. The bridge is easily visible perhaps 100 yards south of Route 15, in an open area, perched on the railbed, near the Wolcott-Hardwick town line.
Parking: There's a dedicated parking area south of Route 15; it includes a small building with rest rooms and an interpretive sign.
Notes: Still a heavyweight contender, this bridge demonstates what the Town lattice could do in its time, especially with T. Willis Pratt's modifications. It is especially strong for being made of southern yellow or "hard" pine, with oak treenails. The full-length cupola, the only one of its kind, helped carry away smoke, especially during the era of steam engines. (Sparks from such engines could also be a problem and accounted for the fiery deaths of a significant number of covered railroad bridges.) Originally, it was part of a 96-mile route between St. Johnsbury to the east and Swanton to the west; for a bridge lover's heartbreaker, go to the Swanton site where a multi-span covered railroad bridge burned in the early 1990s. The Wolcott bridge drew its name from nearby families: first the Chubbs (actual spelling), then the Fishers, particularly farmer Christopher "Crit" Fisher, whose land bordered the tracks and crossing in the early 1900s. At one point, visitors looked for the

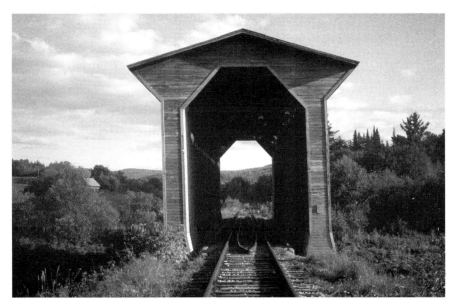

Fisher Bridge

inscription "A NO 1" at the east end on the north side, supposedly the mark of Leon Ray Livingston, who called himself "The King of the Hoboes, Who Traveled 500,000 Miles for Only $7.61," as one of his self-published broadsides put it.

This bridge was saved—at a time when another in Wolcott and one in Cambridge were lost—due to a 1968 arrangement between the Lamoille County Development Council and the Vermont Board of Historic Sites, the predecessor of today's Division for Historic Preservation. To ensure that the wooden bridge could carry modern traffic, new piles were driven into the river and two steel beams were added underneath the bridge, resting on the new foundations. The state paid $9000 and the Development Council $5000 to cover the $14,000 in extra costs. A St. Johnsbury & Lamoille locomotive broke the red tape at the reopening ceremony October 17, 1968; later, the rail line adopted the Fisher Bridge as a logo for some of its cars, with the designation "The Bridge Line." Some of the wooden beams removed during this process found a creative use: Local resident Russell Martin turned them into furniture, with each item bearing a brass nameplate indicating its origin.

XIII. Upper Connecticut River Basin Tour

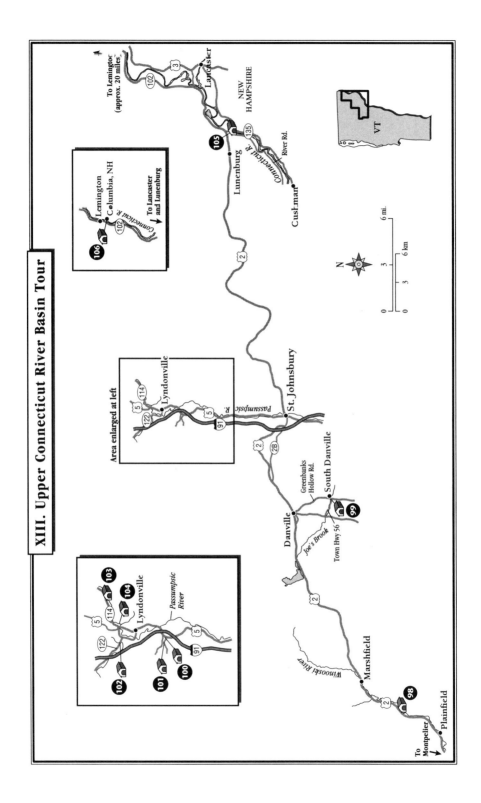

XIII. Upper Connecticut River Basin Tour

HAT WAS SAID at the start of Tour XII about the Northeast Kingdom applies equally here, or perhaps with greater force. Those who have seen the locally produced movie of Howard Frank Mosher's novel about a north country logger, *Where the Rivers Flow North,* will have a special insight into this corner of Vermont, where land ownership is dominated by the timber holdings of major paper corporations. (The relationship depicted in the story may also suggest Indian Joe and his wife; see No. 99, the Danville covered-bridge entry.) There are unorganized townships here; Warren's Grant, Avery's Gore, and Lewis are all officially roadless, although backcountry logging roads and traditional family deer-season camps are characteristic features of the landscape.

Harold A. Meeks, in *Time and Change in Vermont: A Human Geography,* observes that, in Vermont, "the largest area of granite is not the Vermont Piedmont, but is in the Northeast Highlands, a high and wild region that geologically is an extension of New Hampshire's White Mountain mass. Here isolated mountains reach altitudes of 3000 feet or more without any particular pattern. Soils are poor and thin, winter conditions are rigorous, and most of the land is inaccessible except by logging trails, which crisscross much of Essex County. This area is still frontier Vermont . . ."

This was the last part of Vermont to be settled, aside from towns like Peacham, Danville, Cabot, Walden, and Hardwick, which took their impetus from the Revolutionary War Bayley-Hazen Military Road. Customs in abeyance elsewhere survived longer here, or still remain. Perhaps the most dramatic instance of this was in Lyndon, still home to five covered bridges, where a group of horse-racing enthusiasts gained permission in 1908 from the village trustees to use Main Street as a racetrack on winter Saturday after-

noons. The Driving Club continued the practice every year through 1956 except 1918 (World War I). Driving clubs started in Glover, Barton, Newport, and St. Johnsbury, and their members often came to test their horses on the Lyndon quarter mile.

No cash prizes, just ribbons. No starting gates, just a handbell. Yet often a thousand people would gather to watch the sleighs or sulkies go barreling down the thoroughfare in the heats and finals, two at a time. The recent town history, *Lyndon: Gem in the Green,* comments, "Given the number of races held, it is little short of a miracle how few accidents occurred . . . Perhaps most astonishing, a main thoroughfare in the center of a community was closed to traffic each Saturday for eight or ten weeks without any protest from the community." Anything to keep cabin fever at bay. It's worth noting that 2 years before the races ended, in 1954, only 66 percent of Vermont farms had tractors, and only 11,000 of 16,000 had trucks. One suspects the numbers were even lower in the Northeast Kingdom, where farmers knew that horses would always start in the winter—and sometimes finish first on Saturday afternoons.

After going through Lyndon, this covered-bridge route skirts the great forested region by heading up the Connecticut River Valley as far as Lemington. Members of the 251 Club, the group whose ambition is to pass through each and every Vermont political unit, will of course push on to Canaan, the state's northeast corner town just north of Lemington. Vermonters weary of the winters sometimes remind themselves that latitude 45 degrees, Vermont's border with Quebec, is only half as far north as it is possible to go.

St. Johnsbury, a few miles south of Lyndon on I-91, is the northeast corner's largest community. The invention of the platform scale there in 1830 by Thaddeus Fairbanks not only brought a thriving industry, but it also led to the construction of many buildings now part of the downtown historic district. The **Fairbanks Museum and Planetarium** (802-748-2372) is a fine natural science center, the **St. Johnsbury Athenaeum** (802-748-8291) has a permanent art collection strong in the Hudson River School, and the **Maple Grove Maple Museum** (802-748-5141) interprets the maple sugaring tradition. "St. J," as Vermonters sometimes call it, is now a cultural center, as is Lyndon, with its state college. If parts of the Northeast Kingdom seem lonely, you'll find a warm welcome there.

98. MARTIN BRIDGE

Other and historical names: Orton.
Municipality: Marshfield.
Locality: Closer to Plainfield than Marshfield.
Ownership: Private.
Traffic allowed: None possible; deteriorated.
Crossing: Winooski River.
Built: Unknown.
Builder: Harry Martin.
Type: Queenpost.
Dimensions: 45 feet long; 10 feet, 10 inches wide.
Photography tips: NW–SE.
Getting there: The bridge is plainly visible in a field about 100 feet south of Route 2, east of Plainfield and not far west of Montpelier. Look for a large barn with two cupolas just west of the bridge on the north side of Route 2.
Parking: There's a good turnoff from Route 2 at the entrance to a disused farm road.
Notes: This was always a private bridge, according to former town clerk Ruth Orton. It was first known as the Martin Bridge (the name still on it), then the Orton Bridge, when the Orton family came into possession of the land and the twin-cupola Orton Barn across the way, which Harry Martin also built. (The 1963 book *Covered Bridges Can Talk* reports that Herman Townsend built the bridge in 1890, but author Lewis A. Harlow gives no source for this.) Now that an out-of-state owner has the land, the bridge has taken back its first name. According to longtime resident Hap Hayward, the bridge got a new roof about 15 years ago. But its floor has holes, all the wood is weathered, and the wooden farm gate in the middle of the bridge—presumably to keep animals on one side of the river—no longer appears usable. (Harlow mentions such a gate, so it could be more than 30 years old—and it looks it.) For photographers, the uniformly silvered wood offers a special opportunity . . . but for how long?

99. GREENBANKS HOLLOW BRIDGE

Other and historical names: None known.
Municipality: Danville.
Locality: South Danville.
Ownership: Town.
Traffic allowed: Up to 8 tons.
Crossing: Joe's Brook and Greenbanks Hollow Road.
Built: 1886.

Builder: Unknown.

Type: Queenpost.

Dimensions: 74.4 feet long (two spans), 13.5 feet wide, 9.3 feet high at trusses, 12.3 feet high at center.

Photography tips: NE–SW.

Getting there: From Route 2, in the center of Danville at the green, three roads go south. The westernmost soon turns and connects with the other two. The easternmost intersects with Greenbanks Hollow Road after 0.9 mile. Here, take the right fork and drive 1.8 miles to the bridge. The center road gets there, too: When you reach a crossroads, turn left and take Town Highway 56 east to South Danville and also to the bridge. The bridge is located right at the intersection with Greenbanks Hollow Road, Hastings Road, and Town Highway 56. Town Highway 55, a dead-end road, angles to the right off Town Highway 56 shortly before the bridge.

Parking: Past Hastings Road, on the opposite side of Town Highway 56 from the bridge, there is a wide turnoff near mill ruins.

Notes: In 1840 Benjamin Greenbanks came from England, then the world's leader in producing woolen cloth, to start a large-scale factory. The five-story woolen mill he built was one of the biggest in New England, employing at its height about 45 men, women, and children. A fire in 1885 destroyed not only the mill, but also a store, several farms, and a covered bridge, to which the present bridge is the successor. The mill was never rebuilt.

According to Herbert Wheaton Congdon, the bridge was originally uncovered, with the roof added later. It shares a regional style with Lyndon's bridges,

Greenbanks Hollow Bridge

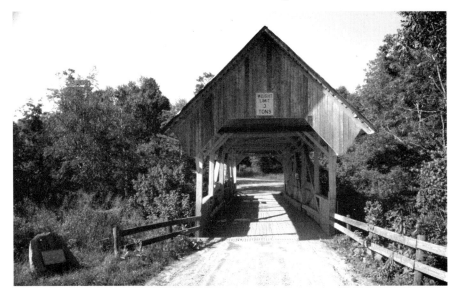

which usually have "open upper walls, extended eaves, projecting gable ends, and portals framed either with diagonal upper corners or arches, each complemented by similar forms under the eaves," to quote the National Register of Historic Places nomination by Hugh Henry. Around 1970 it acquired several modern accoutrements: two steel beams under the deck and a concrete pier in midstream.

The name Joe's Brook, like that of Joe's Pond in Danville, comes from Indian Joe, whose story is commemorated by the Joe's Pond Memorial Bridge in West Danville, on the south side of Route 2 not far from its intersection with Route 15. The statue there of the Lone Sentry of Joe's Pond honors a member of the St. Francis village of the Abenaki who lived from 1745 to 1819. Wounded as a youth during one of the tribe's frequent and frequently bloody raids on the early settlers of the Passumpsic Valley, he was cared for in a settler's home and urged to stay on. He returned to his tribe, but when raids were planned in his former friends' area, he would steal away and forewarn them. Discovered in the act by his suspicious tribesmen, he fled to an island in the pond that now bears his name. When his betrothed, Molly, was found alerting the settlers as well, Joe came and took her away with him to the island. They escaped various attempts at retribution, and in the days after the Revolutionary War, when peace brought more settlers, they often exchanged fish and game for goods brought by the new inhabitants. Learning that George Washington was going to revisit some of his war camps on the Hudson, Joe and Molly declared that they would go see the Great White Father. They returned with a letter from him awarding a pension of $70 a year. Thus established, the pair lived out their lives hunting and fishing around Joe's Pond and nearby Molly's Pond and dealing with the consequences of the activities of their ne'er-do-well son, Toomalek, who in the end was officially executed for murder in Newbury by his fellow tribesmen. Indian Joe is buried in the Caledonia County town of Newbury, where a monument reads: "Erected to the memory of Old Joe, the friendly Indian guide, who died February 19, 1819." A marker by the 1977 memorial bridge in West Danville states that is was "Erected in honor of all those past and present who contributed to the spirit of this community." Although only a walkway, it's worth mentioning as one of the county's best-loved covered bridges.

100. SCHOOL HOUSE BRIDGE

Other and historical names: School House on name plate; spelled Schoolhouse in town history.

Municipality: Lyndon.

Locality: Lyndon Corner.

Ownership: Town.

Traffic allowed: Bypassed and blocked.

Crossing: South Wheelock Branch (of the Passumpsic River) next to South Wheelock Road.

Built: 1879.

Builder: Plans by J.C. Jones; framing and superintending by Lee Goodell; abutments by John Clement.

Type: Queenpost.

Dimensions: 42 feet long.

Photography tips: WNW–ESE; afternoon is best because of a tree.

Getting there: Take I-91 in St. Johnsbury, then exit in Lyndon. From the junction of I-91 and Route 5, take Route 5 south. The first right after the interchange, about 0.1 mile away, is South Wheelock Road. The top of the bridge is actually visible from Route 5, less than 0.1 mile along South Wheelock Road, on the left side.

Parking: Cross the modern bridge on South Wheelock Road, and turn left into the parking lot by the bridge.

Notes: Trusses are boarded inside and out and only visible through one broken area. According to the July 31, 1896, issue of the local *Vermont Union,* John Clement built the abutments for 30 Lyndon bridges.

The first bridge at this crossing served a new, brick schoolhouse constructed in 1871–72. A hail of criticism descended on the uncovered bridge. In the *Vermont Union* for October 4, 1872, editor Charles M. Chase declared, "The most extravagant piece of work we have seen in a long time is the new bridge over the branch, where Wilmarth is building the schoolhouse road. If the penny wise and pound foolish policy is not in that job illustrated to the

School House Bridge

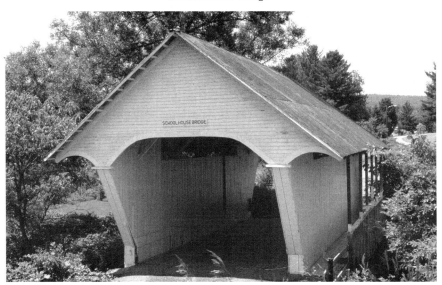

satisfaction of all beholders, it never will be. Look at it. If it cost *anything,* the town would be cheated. When the town of Lyndon learns that public improvement work worth doing at all is worth doing *well,* it will be one good step in the direction of economy." A week later, an editorial inveighed: "The next first class photographer who comes this way is requested to aim his camera at the new bridge (if that is what you call it) east of the school house. Barnum wants it as a specimen of the architecture of the dark ages." And so on. But in the December 12, 1879, issue—when the present bridge was in place—Chase commented, "The new bridge on School Street is completed and is a job well done." Chase's son John B. Chase, who succeeded him as editor of what became the *Vermont Union-Journal,* noted in 1931: "The bridge had its hardest test in the 1927 flood, when it was tipped up till the chances looked about 100 to 1 that it was going out, but it stood the onslaught of the rushing water and debris piled against it. As the water went down, the bridge gradually settled back into place, little if any damaged."

101. CHAMBERLIN MILL BRIDGE

Other and historical names: Sawmill; Whitcomb.
Municipality: Lyndon.
Locality: Lyndon Corner.
Ownership: Town.
Traffic allowed: Up to 5 tons.

Chamberlin Mill Bridge

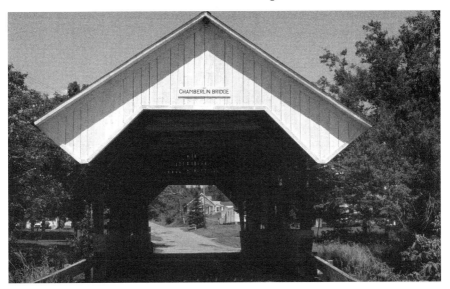

Crossing: South Wheelock Branch (of the Passumpsic River) and Little York Road (Town Highway 58, renamed 1995).

Built: Unknown; covered in 1881.

Builder: Cover by W.W. Heath.

Type: Queenpost.

Dimensions: 66.1 feet long, 16.5 feet wide, 9.2 feet high at trusses, 12.3 feet high at center.

Photography tips: N–S.

Getting there: Very close to School House Bridge (see No. 100). Exiting the parking lot for that bridge, go left (west) on South Wheelock Road. Take the second left—a little more than 0.3 mile from the School House Bridge—and the Chamberlin Mill Bridge will be visible about 0.1 mile to the left (south). It's also possible to take Troy Road 0.3 mile off Route 5 and reach the south end of Little Troy Road, very close to the bridge.

Parking: Go to the Troy Road side and use turnoffs.

Notes: Some of the original north abutment stones remain. Note the large eaves and gable overhangs to protect the open parts of the bridge below—a characteristic style of Lyndon-area bridges. There's an impressive cascade in the river to the west of the bridge and apparently a swimming hole to the east. A path goes to the streambed at the southwest corner of the bridge.

102. MILLER'S RUN BRIDGE

Other and historical names: Bradley.

Municipality: Lyndon.

Locality: Lyndon Center.

Ownership: Town.

Traffic allowed: Up to 8 tons.

Crossing: Miller's Run and Route 122.

Built: 1878; taken apart and completely restored in 1995.

Builder: Plans by E.H. Stone.

Type: Queenpost.

Dimensions: 56 feet long.

Photography tips: NW–SE.

Getting there: Take Route 5 north through Lyndonville, the downtown core of Lyndon township, making sharp turns to the left and right to head north again. Beyond the downtown area, there's a recently constructed and somewhat complicated junction of Route 5, Route 114 splitting off to the right (but ultimately heading north) and a spur of Route 122 going to the left. Take note of this intersection (the fifth Lyndon bridge is near it) and Route 114 (the fourth bridge is along it), but for now go left on the Route 122 spur. In a little more than 0.5 mile there will be a stop sign. All three roads are Route 122 (it is also

possible to take Route 122 off Route 5 south of the center of Lyndonville by going west and then north to this intersection). The bridge is visible to the left of the intersection, less than 0.1 mile away, painted white inside and out.

Parking: There's a turnoff near the above intersection.

Notes: The rehabilitation of this bridge and the restructuring of the nearby highways were all part of a state project to alleviate safety problems surrounding the last covered bridge on a state highway. In the late 1970s and early 1980s, there were two fatal accidents near the bridge, which was criticized for having unsafe approaches. When the state proposed taking it down, townspeople argued for its preservation, partly because a larger bridge might just increase the flow of heavy traffic in the neighborhood. In the end, the covered bridge was taken to pieces, thoroughly restored, and repainted; it is unusual in being completely white, but that color acts as a backdrop for motorists to see pedestrians, cyclists, and other vehicles. A side walkway keeps pedestrians and traffic separated. Local criticism now tends to be directed toward the new intersection of three highways, which is said to have seen more than its share of accidents.

Miller's Run Bridge

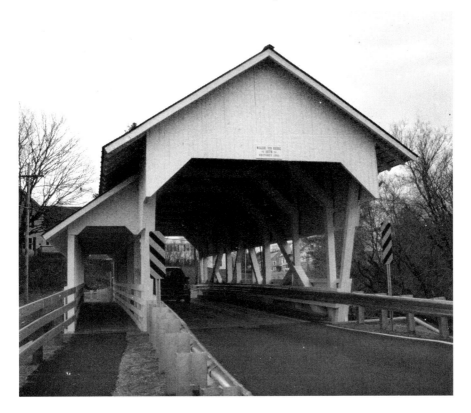

103. RANDALL BRIDGE

Other and historical names: Old Burrington.
Municipality: Lyndon.
Locality: Northeast of Lyndonville.
Ownership: Town.
Traffic allowed: Bypassed.
Crossing: East Branch (of the Passumpsic River) next to Old Burrington Road.
Built: 1865.
Builder: Unknown.
Type: Queenpost.
Dimensions: 68 feet long; 14.4 feet wide.
Photography tips: N–S.
Getting there: From the junction of Route 5, Route 122, and Route 114 north of Lyndonville (the downtown center of Lyndon township), go northeast on Route 114. At 1.6 miles, Burrington Bridge Road goes to the right. The bridge is about 0.1 mile away, visible from Route 114.
Parking: There's a good turnoff on the right side of Burrington Bridge Road before it crosses the concrete-and-steel bridge next to the covered bridge.
Notes: Even Lyndon residents will give different figures for the number of covered bridges in town. Congratulations if you made it to this one, which, like the bridge that follows, often escapes attention.

Randall Bridge

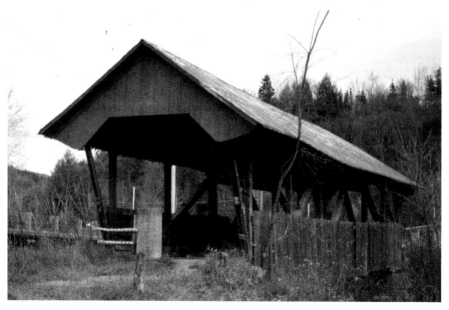

104. SANBORN BRIDGE

Other and historical names: Centre.
Municipality: Lyndon.
Locality: Lyndonville.
Ownership: Private.
Traffic allowed: Off road.
Crossing: East Branch (of the Passumpsic River).
Built: 1867.
Builder: Unknown.
Type: Paddleford.
Dimensions: 117 feet long; 17.5 feet wide.
Photography tips: NNE–SSW.

Getting there: The bridge is on the grounds of the Lynburke Motel, behind the motel, which is south of the junction of Routes 5, 114, and 122 at the north end of Lyndonville (the downtown center of Lyndon township).

Parking: Use the motel parking lot.

Notes: The owners of the motel don't mind people parking and walking around the motel to see and photograph the bridge, although it would be nice to stop in and identify yourself. This bridge was to be torn down and replaced at another crossing near Lyndonville, but many people were upset with that plan. Instead, in 1960 Armand Morin, who then owned the Lynburke Motel, had it moved and placed over the East Branch of the Passumpsic River there.

Sanborn Bridge

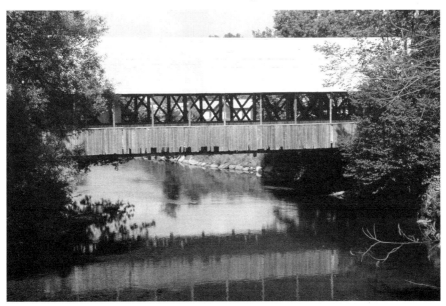

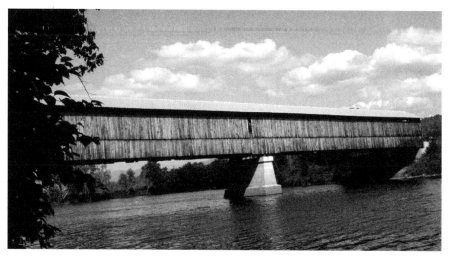

Mount Orne Bridge

It's a magnificent bridge, the best of Vermont's Paddleford trusses; those interested in engineering may compare it with the Long truss, whose boxed X's this design resembles. The interior preserves old advertisements. A room built into the interior once served as a real estate office.

105. MOUNT ORNE BRIDGE

Other and historical names: None known.
Municipality: Lunenburg, Vermont, and Lancaster, New Hampshire.
Locality: Lunenberg and Lancaster.
Ownership: All but a fraction owned by Lancaster.
Traffic allowed: Up to 6 tons; posted for 13-foot clearance.
Crossing: River Road, Connecticut River, and New Hampshire Route 135.
Built: 1911.
Builder: Unknown.
Type: Howe.
Dimensions: 266.3 feet, with clear spans of 127.3 feet and 126.4 feet; road width 14.4 feet; bridge width 20.5 feet; center clearance 13.3 feet.
Photography tips: SE–NW; good shoreline access on Vermont side, to the north.
Getting there: From the main intersection in the center of Lunenburg, continue 1.5 miles east on Route 2. Where it swings to the north, there's an intersection with a road splitting off to the south (right), with a triangular island and two entrances from Route 2. Take that road, River Road, south 0.3 mile, and the bridge will be on the left.
Parking: Turnoffs are on either side.

Notes: A toll bridge was operated at this site by the Union Bridge Company as early as the 1860s or 1870s, then a ferry connected the two sides after a logjam destroyed that bridge in 1908. For the new bridge, Lancaster and Lunenberg each contributed $2500, and subscriptions added $1678. Floor repairs were needed in 1969, after a truck loaded with road salt broke through the deck. A more extensive restoration took place in 1983, at a cost of $133,000, requiring that the bridge be shut down for 5 weeks. Lancaster, Lunenberg, the two states, and the National Park Service all contributed.

Like many Howe-truss bridges, this one had its timbers cut elsewhere for assembly at the remote site. Open under its eaves, and with many metal rods, the structure has a wind harp effect, producing an eerie moan when the wind sweeps down the Connecticut River Valley. The burn marks on the flooring come from a modern innovation in vandalism: Hot-rodders have discovered that "burning rubber" on covered-bridge boards can also burn depressions into the wood.

106. COLUMBIA BRIDGE

Other and historical names: None known.

Municipality: Lemington, Vermont, and Columbia, New Hampshire.

Locality: Lemington and Columbia.

Ownership: Mostly Columbia, since New Hampshire's border ends at the Vermont shoreline of the Connecticut River.

Traffic allowed: Up to 6 tons.

Crossing: Connecticut River between VT Route 2 and US Route 3 in New Hampshire.

Built: 1912.

Builder: Charles Babbitt.

Type: Howe.

Dimensions: 145.8 feet long; road width 14.7 feet; bridge width 20.6 feet; center clearance 13.1 feet.

Photography tips: NNW–SSE.

Getting there: About 0.3 mile south of the village center of Lemington, the bridge is just east of Route 102, which at that point runs along the Connecticut River shore.

Parking: There's an adequate turnoff on the Vermont side.

Notes: This bridge replaced one destroyed by fire in 1911. The new Columbia Bridge was extensively rehabilitated by the state of New Hampshire in 1981, the work costing $143,000. Note the full sheathing on the downstream side and the half sheathing on the upstream side so that floodwaters could move through the bridge (and push off the downstream boards).

Here, at the northernmost Connecticut River bridge linking Vermont and New Hampshire, you can skip a stone across New England's longest river.

A Checklist for Looking at Covered Bridges

• DOES THE BOTTOM of the bridge bend up slightly toward the middle? It should. This slight arch, called *camber*, usually indicates that the joints are tight and the bridge is holding its load well.

• What kind of roof does it have? Is the roof well maintained? Very few bridges still have a cedar shake roof as they probably all did when first built, but whatever the material, roof maintenance is critical to the health of the bridge. Legible remains of old advertising posters can be one sign that the bridge has been kept watertight.

• Does it appear that all the original timbers are still there, or have some perhaps been knocked away or taken out because of traffic? Many bridges have suffered because local highway workers don't always realize how every timber has its place in the original builder's design.

• Does it seem as if there have been changes in the original structure? Roof skylights, steel beams under the bridge, and windows in the sides are common modifications. Have metal pieces been added to replace missing roof braces knocked away by large vehicles?

• Standing at one end, look down the bridge so that the near opening frames the far opening. Do the two rectangles match, or has the bridge started to lean to the side? What sort of protection does it have against crosswinds? (Could the surrounding terrain, such as a narrow valley, funnel winds in a way that might strike the side of the bridge with extra force?) Sometimes extensive roof bracing is enough. Sometimes side supports, guy wires, or buttresses (visible as triangular projections from the sides of the bridge) have been used.

• How far above the river is the bridge? Are there flat areas nearby for high water to spill into, thus helping to protect the bridge against floods?

• Are the foundations still made of stones, or have they been replaced or supported by concrete? If some of the old stones are there, do they look like river rocks (which tend to be round and relatively unstable), or does it appear that the builders found or made stones that fitted together almost like bricks?

• How close is the grain in the wood of the main timbers? Slow growth and closely spaced annual growth rings are better for strength, and heartwood is stronger than sapwood. Sometimes huge trees were hand hewn in the forest because they were too heavy to drag to a sawmill; do you see adze or ax marks on any hand-hewn timbers? Do the joints in the timbers look tight? Could you slide a piece of paper between the joined surfaces? If you can look under the bridge and see the bottom chords (the main support beams at the two sides of the bridge), are they single timbers, or were several timbers spliced together?

• How many of the timbers have cracked under stress through the years? Have any actually bent, as sometimes happens? Do those all-important bottom chords seem undamaged by rot? Are they directly on the bank foundations, or are there extra timbers underneath them to help them distribute the weight (which is concentrated where the bridge meets the bank) and minimize their contact with moisture?

• What sort of flooring does the bridge have? Planks placed on end are probably of a more recent origin than wide beams.

• How safe for motorists and pedestrians does the bridge seem? Sometimes the lack of adequate sight distances (as when a road does not run straight at the bridge), a bridge's narrow width, or the presence of larger vehicles on the bridge road can cause a town to lose confidence in an old wooden bridge. Be careful not to contribute to safety problems—and perhaps the ultimate demise of the bridge—by parking inappropriately or failing to heed oncoming traffic!

Acknowledgments

THIS BOOK COULD not have been written without the help of many people who share a love of Vermont history in general and of covered bridges in particular. The author wishes to acknowledge the assistance of the following, and to apologize to anyone inadvertently omitted from the list: the College of St. Joseph the Provider, especially Dean Jerome Wyant, for sponsoring the covered-bridge course the author has taught in their Elderhostel program; Richard Sanders Allen, formerly from Round Lake, New York, and now living in Idaho, the nation's foremost covered-bridge historian, whose work remains the foundation for everyone else's writings; Jan Lewandoski of Stannard, a covered-bridge builder and restoration expert and mentor; Arnold and Stanley Graton of Ashland, New Hampshire, continuing the bridge-building tradition of their father, the late Milton S. Graton; the Brandon Free Public Library, especially interlibrary loan specialist Teri Clook Lucara; the *Rutland Herald,* for use of their files; the Division for Historic Preservation, especially director Eric Gilbertson and historic sites coordinator John Dumville; the Agency of Transportation, especially David Lathrop; David Wright of Westminster, president of the National Society for the Preservation of Covered Bridges; Pittsford town history author Jean Davies and the Pittsford Historical Society for information about Nicholas Powers and area bridges, together with Powers family descendants Robert Wood and Karen Seward; private covered-bridge owners Ethel Attar, William and Barbara Lawson, Chet Williamson, Frank G. Lewis, Andrew Titcomb, Grace Mills, Arthur and Jean Elliott, Reinhold and Eva Sell, the Vermont Country Store, and the Grafton Village Cheese Company; covered-bridge model maker Cedric Reynolds of South Burlington; local historians or informants Tordis Isselhardt of Benning-

ton, David Thomas of Arlington, Marjorie Pierce of Shrewsbury, Mary Kennedy of Brandon, Karl Devine of Ferrisburgh, Frank Thornton of Charlotte, Caroline Brown of Westford, Wilbur Branthoover of Montgomery, Mary Fenn of West Windsor, Euclid Farnham and Maxine McNamara of Tunbridge, and George Webster of Lyndon; Wilmington real estate agent Verna Gagnon and Lyndon Town Clerk David Lawrence, for personally leading the way to hard-to-find bridges; the Sheldon Museum in Middlebury; the Shelburne Museum in Shelburne; the American Precision Museum in Windsor; the Vermont Historical Society Museum in Montpelier; Town Clerks Shirley Brown of Belvidere, Timothy Corcoran of Bennington, Eva M. Morse of Calais, Mary M. Bown of Charlotte, Peggy J. Rackleff of Coventry, Nancie J. Wolfe of Danville, Janice C. Duke of Dummerston, Sheri A. Bellows of Fairfax, Gerry F. Longway of Fairfield, Barbara B. Oles of Guilford, Clyde A. Jenne of Hartland, Barbara Lawson of Irasburg, Diana Ouimette of Lemington, Trudy Ann Parker of Lunenburg, Linda Marsh of Marshfield, Mary Ann Wilson of Morristown, Sandra H. Dowley of Newfane, Laurence T. Robinson of Northfield, Rita M. Bruce of Rockingham, Gordon DeLong of Pittsford, Joyce Cameron of Salisbury, June W. Wilk of Shrewsbury, Cynthia Davis of Townshend, Lucille Cadieux of Troy, L. Angela Neill of Waitsfield, Emma M. Davis of Waterville, Carol H. Daniels of Weathersfield, Frena Phillips of Westford, Susan Manton of Wilmington, and Road Commissioner David Gilderdale of Randolph, administrative assistant Ray Gillin of Cambridge, adminstrative assistant Bill Bryant of Waitsfield; Lillian and Robert Barna of Miami, Florida, for financial and moral support; Amy and Damon T. Barna for home front support; Olex Beck of Bridgewater for logistical support; a slew of general store clerks and a passel of passersby and on-the-road residents for directions; and Mala, the author's Subaru Justy, for evading two potentially fatal traffic mishaps, never breaking down, and requiring only $622 worth of repairs after a summer and fall going up, down, and every-which-way on Vermont's roads.

Index

adze men, 14
Arlington
 Chiselville Bridge, 37-39
 West Arlington Bridge, 39-40
assembly of bridge, 14-15

Baltimore Bridge, 126, 130-131
Barre Town
 Robbin's Nest Bridge, 179-180
Bartonsville Bridge, 128-130
Bellows Falls, 26
Belvidere
 Mill Bridge, 97-98
 Morgan Bridge, 98-99
Bennington
 Henry Bridge, 35-37
 Paper Mill Village Bridge, 34-35
 Silk Bridge, 33-34
Best Bridge, 136-137
Bowers Bridge, 139-140
Braley Bridge, 168-169
Brandon
 Sanderson Bridge, 53-54
Brattleboro
 Creamery Bridge, 113-114
Brookfield
 Floating Bridge, 170
Brown Bridge, 44-45
Brown's River Bridge, 75-76
Burr, Theodore, 22
Burr arch, 22
 illustration, 19

Calais
 Kent's Corner Bridge, 181-183
Cambridge
 Gates Farm Bridge, 76-77
 Poland Bridge, 77-79
 Scott Bridge, 79-80
Chamberlin Bridge, 174-175
Chamberlin Mill Bridge, 201-202
Charlotte
 Holmes Bridge, 68-69
 Quinlan Bridge, 65-66
 Sequin Bridge, 65-66
Chelsea
 Moxley Bridge, 160
Chiselville Bridge, 37-39
Church Street Bridge, 94
Cilley Bridge, 164
Clarendon
 Kingsley Bridge, 43-44
Coburn Bridge, 180-181
Codding Bridge, 96
Columbia, New Hampshire
 Columbia Bridge, 207
Columbia Bridge, 207
Comstock Bridge, 104-105
Cooley Bridge, 49-50
Cornish, New Hampshire
 Cornish-Windsor Bridge, 140-142
Cornish-Windsor Bridge, 26, 140-142
Cornwall-Salisbury Bridge, 60
cost to erect, 26, 38, 114, 116, 137
cost to restore, 35, 60, 78, 117, 131, 135

Creamery Bridge (Brattleboro), 113-114
Creamery Bridge (Montgomery), 106-108

damage
 fire, 16, 74, 151
 floods, 16, 111
 neglect, 17
 vandalism, 16-17
Danville
 Greenbanks Hollow Bridge, 197-198
Depot Bridge, 50-51
Dummerston
 West Dummerston Bridge, 115-117

East Fairfield Bridge, 80-81
East Montpelier
 Coburn Bridge, 180-181
Emily's Bridge, 88-90
 ghost stories, 89
Enosburg
 Hopkins Bridge, 106

Fairfax
 Maple Street Bridge, 74-75
falsework, 14
Fairfield
 East Fairfield Bridge, 80-81
Ferrisburgh
 Spade Farm Bridge, 64-65
Fisher Bridge, 192-193
Flint Bridge, 160-161
Floating Bridge, 170
Frank Lewis Bridge, 151-152
Fuller Bridge, 101-104

Gates Farm Bridge, 76-77
Gibou Road Bridge, 99-100
Gifford Bridge, 167-168
Glulam timbers, 121
Gorham Bridge, 47-49
Grafton
 Kidder Hill Bridge, 120-121
Graton, Milton, 27-28, 86-87, 123, 150-151
Greenbanks Hollow Bridge, 197-198
Green River Bridge, 112-113
Guilford
 Green River Bridge, 112-113

Hall Bridge, 122-123
Halpin Bridge, 62-64
Hammond Bridge, 51-53
Hartland
 Martinsville Bridge, 145-146

Willard Bridge, 146-147
Haupt truss, 158-159
Henry Bridge, 31
High Mowing Farm Bridge, 114-115
historic preservation, 17
Holmes Bridge, 68-69
Hopkins Bridge, 106
Howe, William, 23
Howe Bridge, 165-166
Howe truss, 23
 illustration, 19
Hutchins Bridge, 100-101

Indian Joe, 199
Irasburg
 Lord's Creek Bridge, 191-192
 Orne Bridge, 190-191
iron ochre paint, 38

Jewett Brothers, 93, 99-100, 101, 104, 105, 106, 107
Johnson
 Power House Bridge, 186-187
 Scribner Bridge, 188

Kent's Corner Bridge, 181-183
Kidder Hill Bridge, 120-121
kingpost, 20
 illustrations, 19, 20
kingpost arch. See Burr arch
Kingsbury Bridge, 166-167
Kingsley Bridge, 43-44
Kissin' Bridge (Waterville), 96
Kissing Bridge (New York), 16

Lancaster, New Hampshire
 Mount Orne Bridge, 206-207
Larkin Bridge, 161-162
Lemington
 Columbia Bridge, 207
Lewandoski, Jan, 20, 27-28, 181, 182-183
Lincoln Bridge, 153-154
Locust Grove Bridge, 33-34
Long, Stephen H., 23
Longley Bridge, 105-106
Long truss, 23
 illustration, 19
Lord's Creek Bridge, 191-192
lumber from virgin forests, 13, 17
Lunenburg
 Mount Orne Bridge, 206-207
Lyndon, 196
 Chamberlin Mill Bridge, 201-202

Miller's Run Bridge, 202-203
Randall Bridge, 204
Sanborn Bridge, 205-206
School House Bridge, 199-201

Maple Street Bridge, 74-75
Marshfield
 Martin Bridge, 197
Martin Bridge, 197
Martinsville Bridge, 145-146
Middle Bridge, 149-151
Middlebury
 Halpin Bridge, 62-64
 Pulp Mill Bridge, 61-62
Mill Bridge, 97-98, 163-164
Miller's Run Bridge, 202-203
Mills Bridge, 81
Montgomery
 Comstock Bridge, 104-105
 Creamery Bridge, 106-108
 Fuller Bridge, 101-104
 Gibou Road Bridge, 99-100
 Hutchins Bridge, 100-101
 Longley Bridge, 105-106
Montgomery Bridge, 94-96
Morgan Bridge, 98-99
Morristown
 Red Bridge, 90-91
Morse Mill Bridge, 81
Moseley Bridge, 173-174
Mount Orne Bridge, 206-207
Moxley Bridge, 160

Newfane
 Williamsville Bridge, 117-118
Northfield
 Chamberlin Bridge, 174-175
 Moseley Bridge, 173-174
 Second Bridge, 177-178
 Slaughter House Bridge, 175-176
 Station Bridge, 176-177
 Third Bridge, 178

observation of bridges, 12-17, 208-209
Orne Bridge, 190-191

Paddleford, Peter, 23
Paddleford truss, 23
 illustration, 19
Palladio, Andrea, 21
Palmer, Timothy, 15, 21-22
Paper Mill Village Bridge, 34-35

pegged joints, 14, 22, 23
Permanent Bridge, 15, 22
Pine Brook Bridge, 87-88
Pittsford
 Cooley Bridge, 49-50
 Depot Bridge, 50-51
 Gorham Bridge, 47-49
 Hammond Bridge, 51-53
 town history, 51-52
Poland, Luke P., 78-79
Poland Bridge, 77-79
Pomfret
 Smith Bridge, 152-153
portals, 15
Power House Bridge, 186-187
Powers, Nicholas, 24-25, 44-45, 47
Pratt tied arch, 153-154
 illustration, 19
Pulp Mill Bridge, 26, 61-62

queenpost, 20
 illustration, 19, 20
Quinlan Bridge, 65-66

Randall Bridge, 204
Randolph
 Braley Bridge, 168-169
 Gifford Bridge, 167-168
 Kingsbury Bridge, 166-167
Red Bridge, 90-91
red paint, 38
restoration, choices, 27
River Road Bridge, 188-189
Robbin's Nest Bridge, 179-180
Robinson Bridge, 33-34
Rockingham
 Bartonsville Bridge, 128-130
 Hall Bridge, 122-123
 Victorian Village Bridge, 126-127
 Worrall Bridge, 128
roofs
 cedar, 14
 reason for, 15
Rutland
 Twin Bridge, 45-47

Salisbury
 Cornwall-Salisbury Bridge, 60
Salmond Bridge, 134-136
Sanborn Bridge, 205-206
Sanderson Bridge, 53-54
School House Bridge, 199-201

Scott Bridge (Cambridge), 79-80
Scott Bridge (Townshend), 118-120
Scribner Bridge, 188
Second Bridge, 177-178
Sequin Bridge, 67
Shelburne Museum Bridge, 69-70
Shoreham Covered Railroad Bridge, 58-60
Shrewsbury
 Brown Bridge, 44-45
Silk Bridge, 33-34
Slaughter House Bridge, 175-176
Smith Bridge, 152-153
 See also Twigg-Smith Bridge
snowing the bridge, 53
Spade Farm Bridge, 64-65
Springfield
 Baltimore Bridge, 130-131
Station Bridge, 176-177
Stowe
 Emily's Bridge, 88-90

Taftsville Bridge, 147-149
Tasker, Arnold, 23-24
Thetford
 Union Village Bridge, 158
Thetford Center Bridge, 158-159
Third Bridge, 178
tied arch, 136-137, 139-140
timber-frame construction, 18, 20, 55
Titcomb Bridge, 131-132
toll collection, 26, 141-142, 180
Town, Ithiel, 22
Town lattice truss, 22-23
 illustration, 19
Town-Pratt double lattice, 192-193
Townshend
 Scott Bridge, 118-120
treenails, 14, 101-102
Troy
 River Road Bridge, 188-189
trusses, 14
 definition of, 18
 design improvements, 21
 principle of, 18, 20
 strength of, 25
 types illustrated, 19, 20
 See also specific types of
Tunbridge
 Cilley Bridge, 164
 Flint Bridge, 160-161

Howe Bridge, 165-166
Larkin Bridge, 161-162
Mill Bridge, 163-164
Twigg-Smith Bridge, 138-139
 See also Smith Bridge
Twin Bridge, 45-47

Union Village Bridge, 158
Upper Falls Bridge, 133-134

Victorian Village Bridge, 126-127
Village Bridge, 85-87

Waitsfield
 Pine Brook Bridge, 87-88
 Village Bridge, 85-87
Warren Bridge, 84-85
Waterville
 Church Street Bridge, 94
 Codding Bridge, 96
 Kissin' Bridge, 96
 Montgomery Bridge, 94-96
Weathersfield
 Salmond Bridge, 134-136
 Titcomb Bridge, 131-132
 Upper Falls Bridge, 133-134
West Arlington Bridge, 39-40
West Dummerston Bridge, 115-117
Westford
 Brown's River Bridge, 75-76
West Windsor
 Best Bridge, 136-137
 Bowers Bridge, 139-140
 Twigg-Smith Bridge, 138-139
Weybridge
 Pulp Mill Bridge, 61-62
Willard Bridge, 146-147
Williamsville Bridge, 117-118
Wilmington
 High Mowing Farm Bridge, 114-115
Windsor
 Cornish-Windsor Bridge, 140-142
Wolcott
 Fisher Bridge, 192-193
Woodstock
 Frank Lewis Bridge, 151-152
 Lincoln Bridge, 153-154
 Middle Bridge, 149-151
 Taftsville Bridge, 147-149
Worrall Bridge, 128

Books from The Countryman Press and Backcountry Publications

The Countryman Press and Backcountry Publications, long known for fine books on travel and outdoor recreation, offer a range of practical and readable manuals.

Books on Vermont and the Outdoors

Vermont: An Explorer's Guide, Sixth Edition, by Christina Tree and Peter S. Jennison

Lake Champlain: Key to Liberty, by Ralph Nading Hill

25 Bicycle Tours in Vermont, Third Edition, by John Freidin

50 Hikes in Vermont, Fourth Edition, by The Green Mountain Club

Fishing Vermont's Streams and Lakes, by Peter F. Cammann

Explorer's Guide Series

Cape Cod and the Islands: An Explorer's Guide, by Kimberly Grant

Connecticut: An Explorer's Guide, by Barney D. Laschever and Barbara Beeching

Maine: An Explorer's Guide, Seventh Edition, by Christina Tree and Elizabeth Roundy

New Hampshire: An Explorer's Guide, Second Edition, by Christina Tree and Peter E. Randall

Vermont: An Explorer's Guide, Sixth Edition, by Christina Tree and Peter S. Jennison

The Hudson Valley and Catskill Mountains: An Explorer's Guide, Second Edition, by Joanne Michaels and Mary-Margaret Barile

Rhode Island: An Explorer's Guide, by Phyllis Meras and Tom Gannon

50 Hikes Series

Regional collections of hikes for hikers of all abilities; detailed directions, access information, and discussion of points of interest along the way. From Maine to lower Michigan.

We offer many more books on hiking, walking, fishing, and canoeing, plus books on travel, nature, and many other subjects.

Our books are available at bookstores, or they may be ordered directly from the publisher. For ordering information or for a complete catalog, please contact:

The Countryman Press
c/o W.W. Norton & Company, Inc.
800 Keystone Industrial Park
Scranton, PA 18512
http://web.wwnorton.com